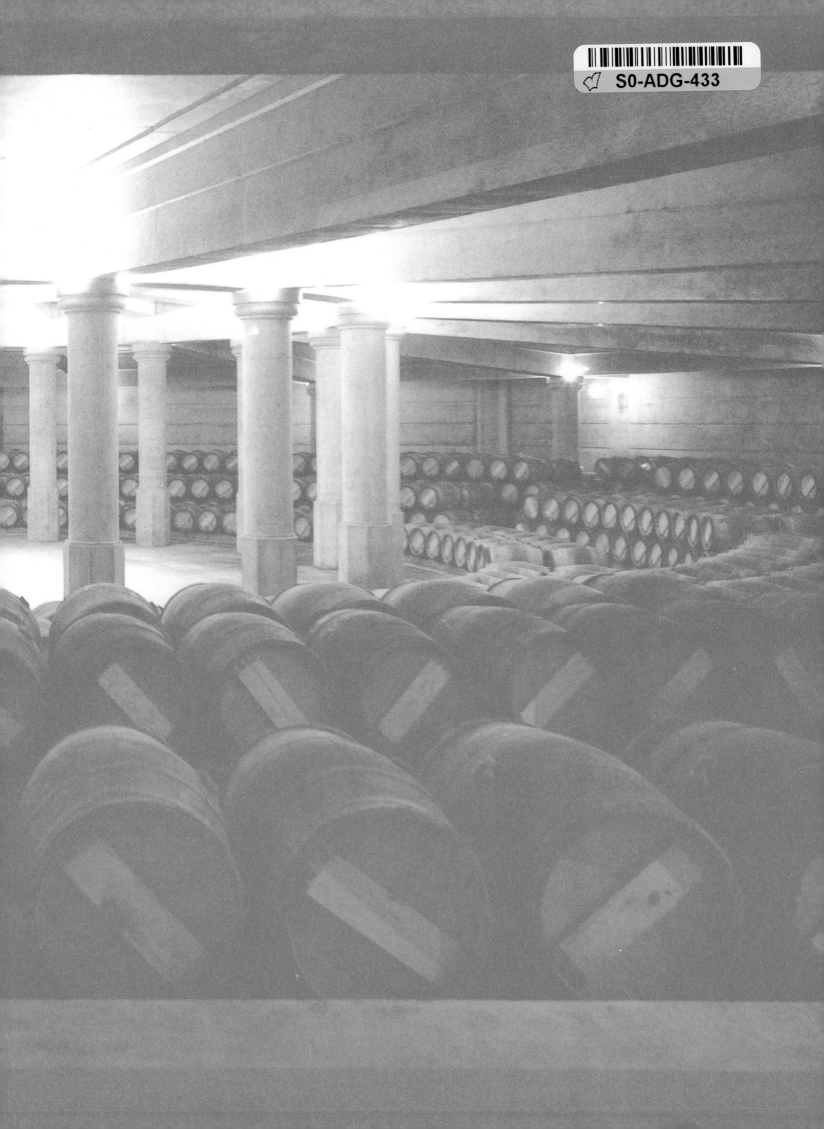

November, 2000

Alan,

Our warmest wishes for your birthday! Your good health requires that you drink every one of these - affectionately,

Oliver + Nadine

Table of contents

The best way to understand a wine region is to go there in person: stare at the horizon, wander among the vines, feel the soil crumble between your fingers. Only then does the stuff in the bottle really make sense. This is especially true of the Médoc, widely regarded as the greatest wine region of them all. To someone who has never driven along the *Route des Châteaux*, pausing to visit a world-famous cellar or contemplate the languid flow of the Gironde perhaps, the idea that adjacent properties can produce vastly different (and differently priced) wines is difficult to comprehend. At first-hand, however, the visitor can see why fine gradations of climate, altitude, grape variety and soil type are crucially important in such a marginal climate and why the best vineyards are all to be found on well-drained gravel outcrops.

In visual terms, the Médoc is not a spectacular place. Some of its châteaux, particularly Pichon-Longueville (Baron), Palmer and Margaux are impressive, even lovely buildings, but set against the vertiginous beauty of the Cape, the Douro, the Mosel or parts of California, the Médoc can seem flat and faintly uninspiring. But don't let appearances mislead. Gorges, panoramas and mountain ranges may be absent here, but there's a subtlety to the landscape that is reflected in the harmony and elegance of the best wines. Bordeaux, or Claret to give it its English name, has never been a wine that offers abundant fruit flavours or immediate sensory gratification.

Peter Knaup and Ken Kincaid understand this subtlety and express it with passion and sensitivity in these pages. Following the *Route des Châteaux* from La Lagune on the outskirts of Bordeaux to Calon-Ségur in quieter, more bucolic Saint-Estèphe, they have chosen three dozen of the Médoc's 600-odd properties and captured their essence in words and black and white photographs. All of the great names are here – the First Growths (with the exception of Haut-Brion in Pessac-Léognan) and the 'Super Seconds' – but the authors have included a few lesser-known châteaux, too. There's also a very useful summary of the grape varieties that each property has planted in its vineyards.

I've already said that there's no substitute for visiting the Médoc itself, but this book comes close. Many of the portraits are so well drawn that you can imagine yourself setting out on a warm autumn afternoon, full of expectation and child-like excitement, to visit some of the most inspirational vineyards in the world.

Tim Atkin

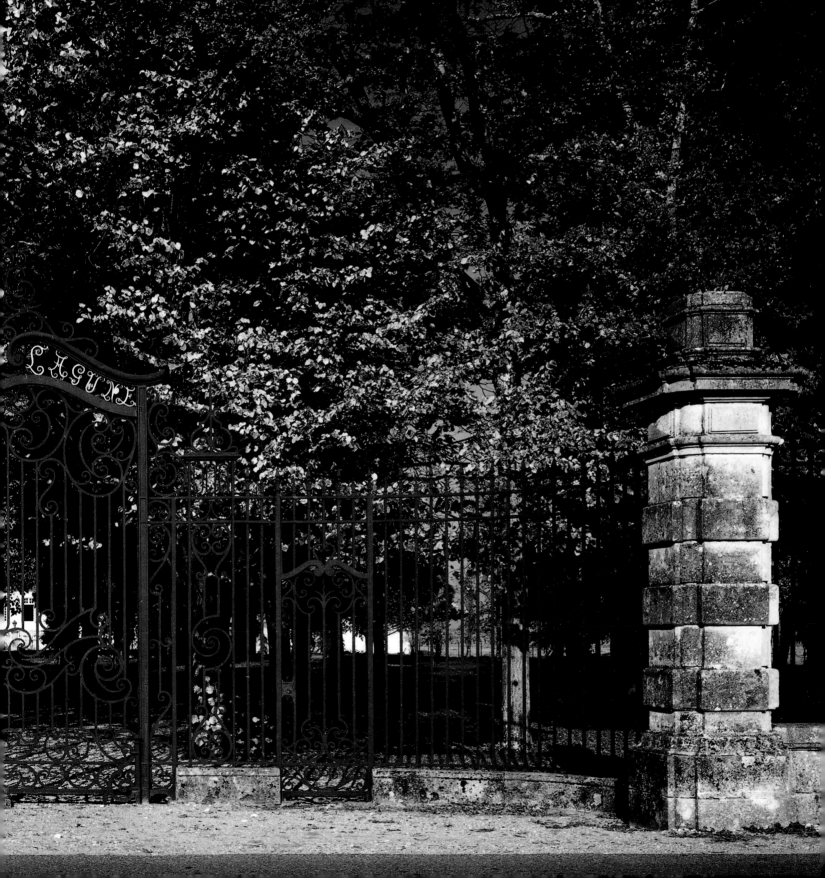

Appellation
HAUT-MÉDOC

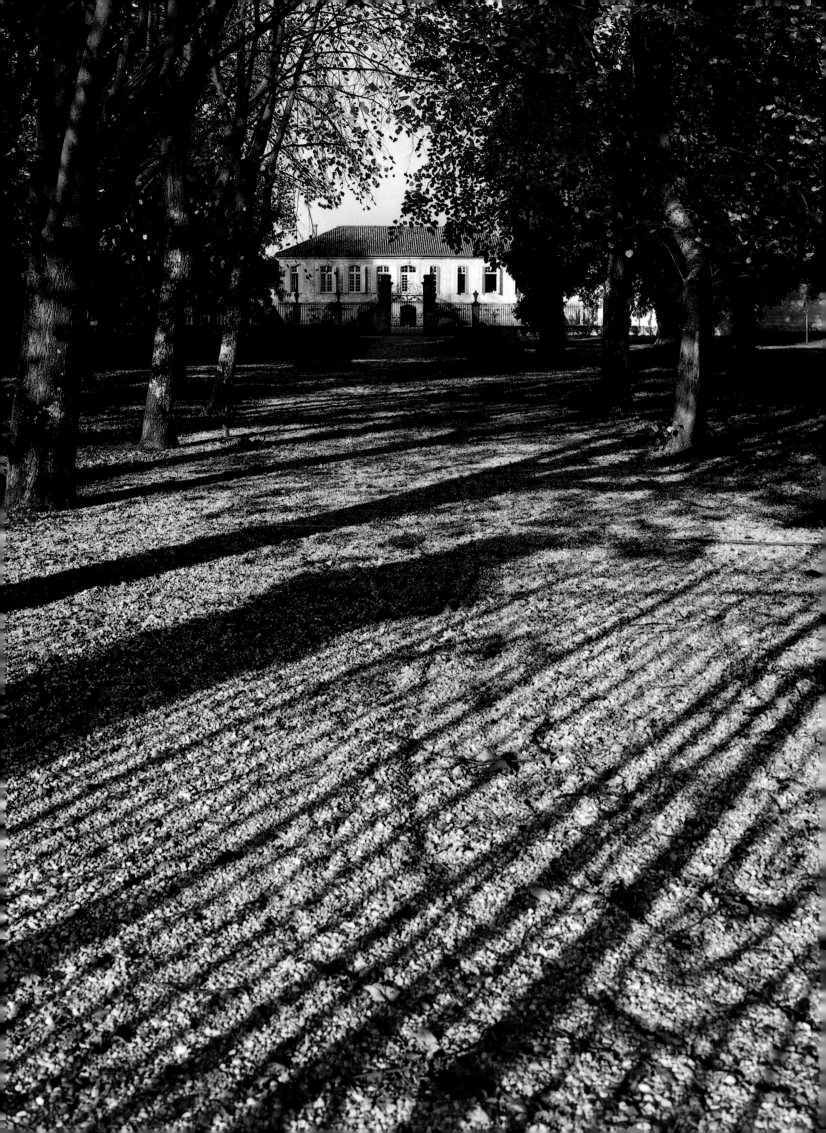

LA LAGUNE

*The great iron gates of Château La Lagune cast their shadow in the autumn sun, as they did in Médoc's halcyon days at the end of the Second Empire. Then, the arrival of the wine-picking season would herald the arrival of the owners of the great **crus classés**, like the Rothschilds, Johnstons and Duchâtels, whose carriages would pass each other on the wine trail.*

C hâteau La Lagune lies some 10 miles to the north of the city of Bordeaux on the famous D2 road, known as the *route des vins*, or wine road. Standing on the threshold of the Médoc, there is no doubt as to its *raison d'être:* the wrought-iron gates are studded with corkscrews. The château, a classic example of the Médoc charterhouse style, was designed in 1730 by the architect Victor Louis – famous for the splendour of Bordeaux's theatre.

At the turn of the century the wine enjoyed an excellent, well-deserved reputation. In fact, it was known as Château Grand-La-Lagune to distinguish it from other, lesser, *La Lagunes*. As the 20th century wore on, however, the quality of the vineyard and its wine began to decline. Output and quality plummeted to levels unacceptable for a *grand cru classé*. In 1923 the vineyard covered 40 hectares (less than 100 acres), and barely one-tenth of that by 1958, the year in which Georges Brunet bought the château.

He set about replanting the vineyard, restoring the château, designing a state-of-the-art *cuvier* (fermentation cellar), and putting in place a unique pipes system which carried the newly fermented wine from the *cuvier* to the cellars. Such enormous capital expenditure was required, however, that in 1962 he had to sell the château to the Champagne house of Ayala, which continued the good work by putting the Boyries, a husband and wife team, in charge of the estate. When Monsieur Boyrie died three years later, his wife took sole charge as estate manager and cellar master: her competence and acumen were central to the revival of La Lagune. On her death in the late 1980s, she was succeeded by her very able daughter Caroline Desvergnes. She is still estate and cellar manager, which means women have run La Lagune for over 30 years - no mean feat in the anti-feminist world of wine.

It is fair to say that Madame Boyrie and her daughter Caroline have created the La Lagune that is drunk today, a wine that has regained, even surpassed, its former prestige. With its dark colour, chewy texture and long finish, it is reminiscent of Margaux and known for the high percentage of new oak barrels in which the wine matures, adding structure and profound flavour.

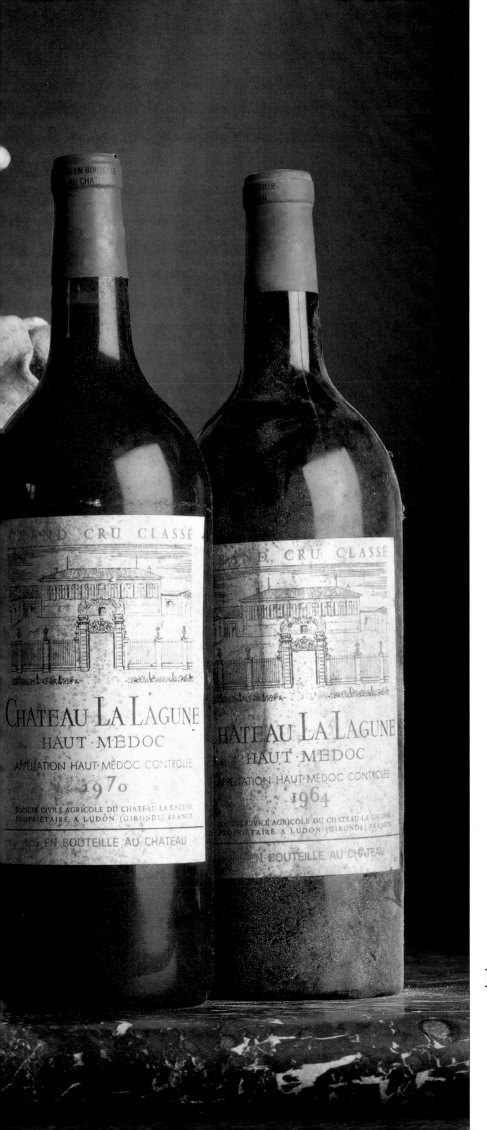

A classified third-growth wine, Château La Lagune is a consistently reliable performer. Owned by the Champagne house Ayala since 1962, it produces wines which are balanced, full, fruited and long-maturing. Their quality stems from the vineyard's fine alluvial soil – unusual in the Médoc – from which the estate takes its name: lagune means, of course, 'lagoon'.

CANTEMERLE

antemerle means 'the singing blackbird'. The origin of the name goes back to the Hundred Years' War. Legend has it that the château possessed a cannon known, for some reason, as the *merle* (blackbird). English troops, encamped at the château, embarked on an orgy of drunken looting, while the local people looked on. Then someone remembered the cannon, hauled it out of its hiding place, and fired. The detonation was so loud the English fled, terrified by the sound of the singing blackbird.

The château's archives record a vineyard at Cantemerle as early as 1570. At the end of the 19th century it was bought by Théophile Dubos. His son, Pierre, was to become a legend in his lifetime in the Bordeaux region for his *Livre du Cru*, or 'book of growth', in which he unfailingly recorded, morning, noon and night for 65 years, all that was germane to winegrowing: the direction of the wind, temperature, air pressure, the flowering of the vines, the ripening of the grapes, the size of the harvest, the quality and quantity of the grapes in the fermentation vats. His loving attention to detail and traditional methods of winemaking resulted in a supple, fruity, fast-maturing wine with a fragrant bouquet and early appeal.

Family disagreements and tax issues in the 1970s caused the estate and its wines to decline, and in 1981 the Cordier family (see *Château Talbot* and *Gruaud-Larose*) bought Cantemerle. Assisted by technical director and oenologist Georges Pauli, they overhauled both the winegrowing and winemaking.

The château was renovated, and new cellars and a state-of-the-art winetasting room built. The vineyards were extended and replanted with fewer Cabernet Franc grapes – which mature poorly in the light soil – and more Cabernet Sauvignon, Merlot and Petit Verdot. Strict selection was introduced into grape-picking and the vines were trimmed. Recent years have seen a new development – the *vendanges vertes*, or green grape-picking – removing still-green grapes to allow riper ones to reach full maturity. In 1990 the château was sold to a French insurance group.

From vine to wine, maturity is of the essence: although the elegantly rendered 1983 was the first wine produced in the new cellars, it is only as the replanted vines have begun to reach maturity that the rich, aromatic, fifth-growth Cantemerle, with its high percentage of Merlot grape, has begun to establish itself as a wine of true quality.

After a remarkable 1989 wine, this classified fifth-growth wine produced disappointing vintages due to frost and rain which affected the ripeness of harvests in 1991, 1992 and 1993. However, with the 1995 and, particularly, the 1996 wines, which were especially fruity and floral, tannic and elegantly balanced, the Cantemerle blackbird was singing again.

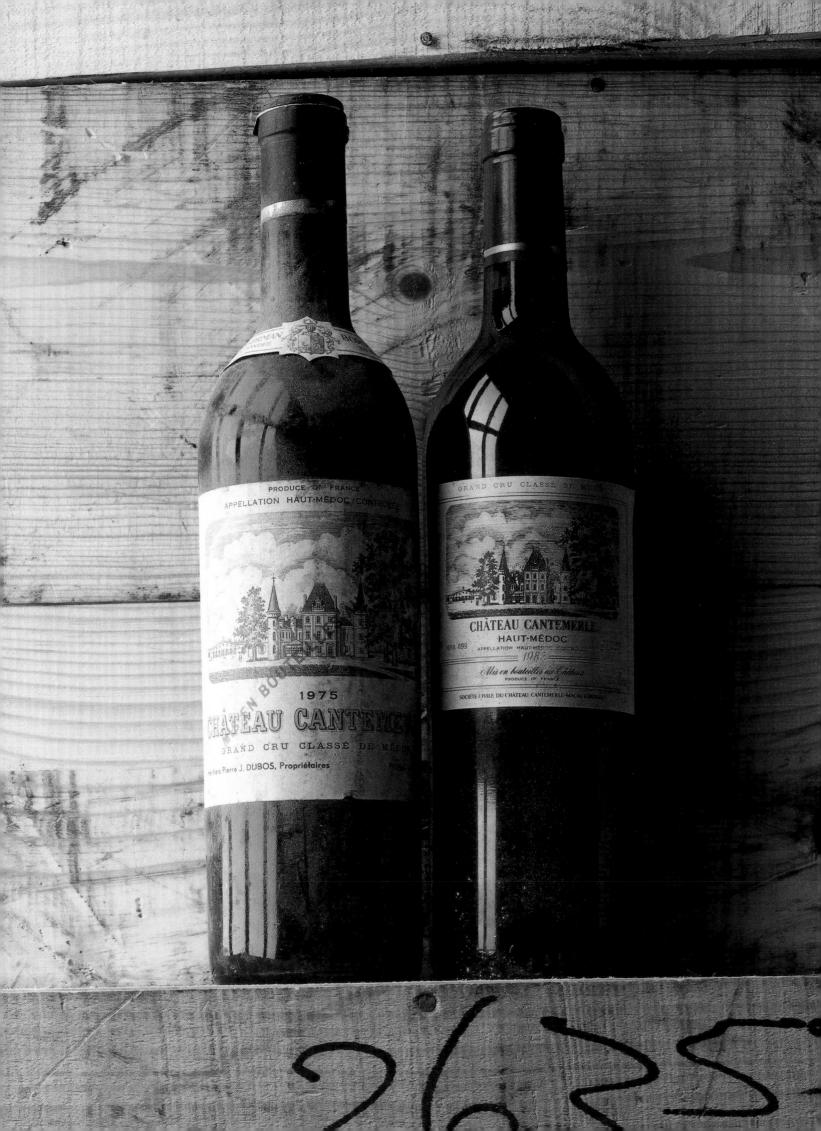

The château, initially built in the 16th century, then extended and rearranged in the 19th, now belongs to a group of French insurance companies which operate in the civil engineering and public works sector. They renovated both the château and outbuildings, but left the superb wooded park untouched.

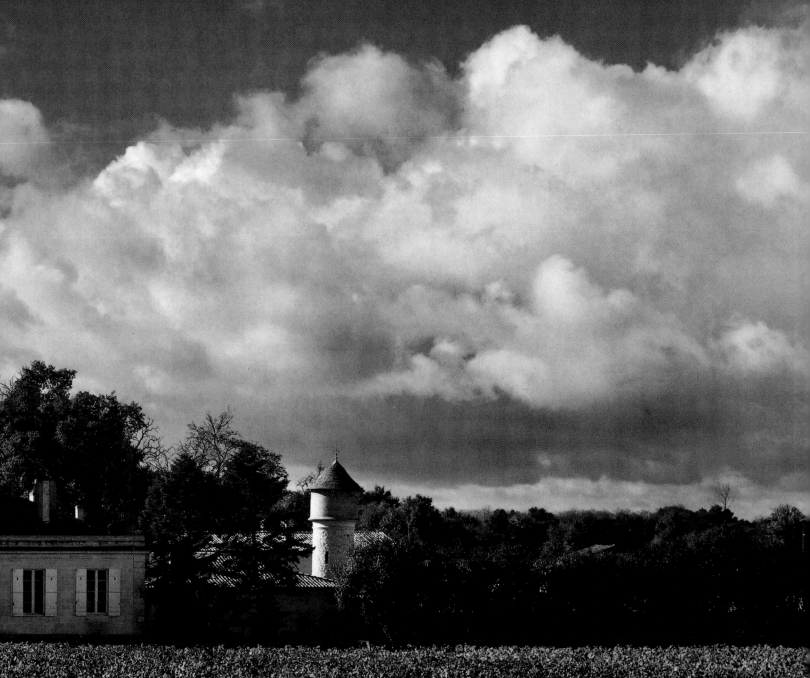

Appellation MARGAUX

GISCOURS

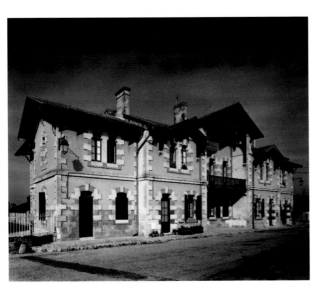

Above: the farmhouse is typical of those built in the 19th century. In the 1980s, it became the venue of sporty socialites when the dashing Pierre Tari made it the home of the polo club he founded.

Left: the 1986 vintage was one of the great clarets of the decade. It boasted a superb dark colour and plenty of fruit in the nose, fine concentration, and a muscular but supple texture. Its elegance reflected that of the master of the Giscours realm at the time. A different world from the commercial wine of the 1990s.

Margaux, the Médoc's most illustrious appellation, had 21 clarets classified as *grands crus* in 1855. They are often described as the most feminine in the Médoc, delicate and supple, with an elegant, heady aroma. Château Giscours shares these characteristics, while being richer and more muscular.

It epitomises the turbulent history of Bordeaux wines in the last 200 years, with a penchant for waning with the century. A 16th century bill of sale describes it as a vineyard, and Claude Féret, France's foremost authority on the wines of Bordeaux at the time, wrote that the wine appealed to Louis XIV. But with the demise of the Sun King, the sun set on the château of Giscours.

At the time of the French Revolution, the estate belonged to the Marquis de Saint-Simon, a family associated with a French classic, the *Mémoires*, an aristocrat's chronicle of court life. The estate was confiscated in the Revolution and became the 'property of the Nation'. The nation sold it in 1795 to an American, and it changed hands several more times before 1847.

The restoration of the monarchy in 1814 also saw a restoration of Giscours fortunes, and the estate blossomed under the Second Empire. In 1847, a Parisian banker, the Comte de Pescatore rebuilt the château as an abode fit for a queen: the Empress Eugénie. He also undertook extensive work on the vineyard, draining the gravelly soil, growing grape varieties geared to obtaining a certain quality of wine, and improving vinification with the introduction of destalking and fining. In 1855 Pescatore's efforts bore fruit: Château Giscours was classified a *troisième cru* (third growth).

As the 18th century drew to an end, the Revolution had cast its shadow over the estate. In the late 1860s, the flow of both wine and money had dried up as disaster struck in another form. *Phylloxera devastatrix*, a parasite, all but wiped out vineyards throughout the Bordeaux region. At one point, hens were allowed to roam free in the Giscours vineyard to destroy insects. But more effective measures were needed to counter the voracious phylloxera. Eventually, a solution was found to the blight: the French *vitis vinifera* vine plant was grafted onto American rootstock, which was immune to the bug. Another parasite, known as mildew, was a transatlantic import. The cure this time was a locally concocted anti-mildew measure, *bouillie bordelaise* (Bordeaux mash), made from lime and copper sulphate.

The Parisian banker, the Comte de Pescatore,
built the château in the prevailing style of the
19th century. At the back, the château opens onto
an enormous park in which lies a small lake.
The owner had it dug especially to improve the
natural drainage of the undulating, gravelly
terrain which predominates in the vast vineyard.

From outside, the château seems ordered and well-organised, but inside it is rather more chaotic.

The Giscours estate, however, had gone into decline. The tainted beauty of its vineyards slept for some 70 years. Then, in 1947 – much as Pescatore had a century earlier – Nicolas Tari a seasoned winegrower from Algeria, came to the rescue. He found a dilapidated château, crumbling outbuildings, and vines growing on only seven of the 80 hectares (200 acres). Over the next 20 years, he and his son, Pierre, were to restore the estate to its former glory.

Nicolas, and subsequently, Pierre rehabilitated and extended the vineyards on a scale never seen in Médoc. Its most spectacular feature was the artificial lake, dug to entice vine roots deeper into the subsoil and so improve the quality of wine. The lake also protects the grapes from frost, allowing them to reach maturity.

Pierre was a passionate, entrepreneurial modernist who espoused the new theories of vinification propounded by wine guru Emile Peynaud: closer control over fermentation, refined *assemblage* (i.e. blending of grape varieties), and *élevage* (conditioning) in new casks to give the wines more complexity. The equipment he installed helped Château Giscours to produce off-vintages of a quality far superior to other renowned Bordeaux chateaux. But the jinx which afflicted Giscours was soon to strike.

A combination of ill-judged management, ill-will on the part of banks and ill-feeling within the family compelled the Taris to sell in 1995 to a Dutch investor, Eric Albada Jelgersma. The wine during this decade – with the possible exception of 1994 – has been thin, and Jelgersma was accused of malpractice at his very first harvest. A characteristic of Château Giscours is its oakiness. It was alleged that Eric Albada had placed oak staves in two barrels of Haut Médoc wine, i.e. not Château Giscours. To his accusers, he was seeking to pass it off as the genuine article. He swore he was not and asked official wine inspectors to investigate. They reported fraudulent practice. He rebutted their findings flatly. The controversy has continued ever since, while the quality of Giscours continues to improve.

Such is Eric Albada's enthusiasm for Margaux wines that he has recently purchased the fifth-growth Château du Tertre from the Capbern-Gasqueton family.

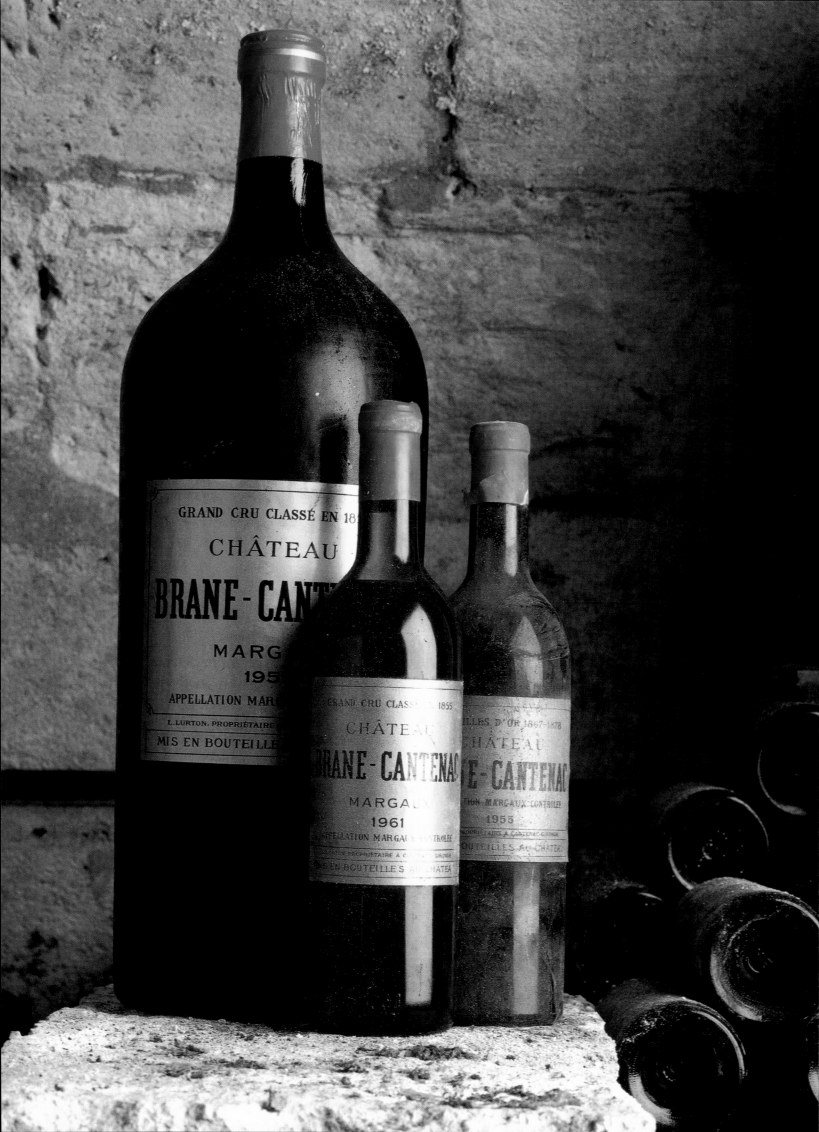

BRANE-CANTENAC

Above: a charming charterhouse in a charming landscape. Everything here mirrors the quietly efficient Lurton family, whose dedication to winegrowing is exemplary.

Left: a claret which has maintained its personality over the years. It can be highly refined or exceptionally tannic. The 1996 vintage was rich, supple and amply textured. In 1997, Brane-Cantenac bought new oak vats.

The Brane-Cantenac estate in the autumn is reminiscent of the pointilliste techniques used by the Neo-impressionist painters Signac and Seurat. In a vibrant tide of yellows, ochres, reds, browns and russets juxtaposed with still-vivid greens, blues and blacks, the vines swirl up towards the plateau of Cantenac on which the charterhouse itself stands like a white island against the blue sky.

At the centre of a panoramic tableau which spreads over some 150 hectares (370 acres) of rolling vineyards, Brane-Cantenac commands a sweeping view of six other Margaux châteaux. The owner of the estate, Lucien Lurton, has a patchwork of domains within the Margaux appellation and in the Bordeaux wine-growing regions of St Emilion, Graves and Sauternes. His brother André also runs large tracts of vineyard in the Graves and Entre-deux-Mers regions.

It has been suggested that the Lurton brothers seek to emulate Baron Hector de Brane. He was known as the 'Napoléon des vignes' for having acquired so many châteaux. In 1833, he sold Château Mouton (now Mouton-Rothschild) to buy a 40-hectare (100-acre) château, Gorse-Gui. Five years later he took the daring step – for the time – of naming the wine after himself. He wrote to a trade journal, *Le Producteur*, stating: 'Although the name of Gorse enjoys a fine reputation both in Bordeaux and abroad, the name of Brane is by no means inferior'. So Château Brane-Cantenac came into being.

Looking back, it is perhaps surprising that Baron Brane should have preferred Brane-Cantenac to Mouton. Yet archives record that over a century before the 1855 classification, the wine of the Cantenac plateau was commanding very considerable prices. It continued to enjoy its fine reputation throughout the next century, and the baron shared the general opinion that the vineyard had great potential. Sadly, the wine has not always lived up to expectations.

Lucien Lurton, however, relentlessly seeks perfection. He runs a very stringent selection policy, and for a long time used expert advice from renowned wine-taster Emile Peynaud. They actually abandoned entire harvests in 1960, 1963 and 1968. In 1961, 1975 and 1986, this dark, supple, amply structured claret rewarded them for preferring quality to quantity.

CANTENAC-BROWN

Although Cantenac-Brown has been described as the most British château in the Médoc, it was built by a Frenchman, Armand Lalande, in the 1860s. He bought it in 1843 from a banker who, more interested in money than wine, had allowed the vineyard to run to seed. A British wine agent, John Lewis Brown, bought the estate in 1826, when it was known merely as Cantenac. He added his name. Brown had three consuming passions: women, wine and painting horses. Women took him to bankruptcy, wine to his death. His paintings and château remain.

The château's upright, formal appearance was, until recently, reflected in the wine. Despite its deep garnet colour, it was unyielding, thin and rough, which impeded its maturity. Comparison with the rounded, supple wine produced by the adjacent Brane-Cantenac estate highlighted the difference that careful growing, fermentation and selection can make. John Brown initially called the château Brown-Cantenac, before reversing the word order because it sounded too like Brane-Cantenac. No such confusion is possible between the taste of the wines.

In 1989, the insurance company AXA bought and invested in the property, enlisting the expertise of Jean-Michel Cazes, owner of the admirable Château Lynch-Bages. And 1994 has a remarkable palate, while 1996 is supple, balanced and almost engaging.

PRIEURÉ-LICHINE

Prieuré-Lichine is the story of an American in Bordeaux. The Russian-born US *bon vivant* Alexis Lichine fell so deeply in love with France and its wines that he settled in a tumbledown, vine-covered priory in the heart of the Médoc. He is celebrated for his passionate knowledge of wines. He wrote widely on the subject and his *Encyclopaedia of Wines and Spirits*, a compendium of formidable authority, is greatly appreciated by connoisseurs.

In 1950, when he bought the 300-year old Benedictine priory, he spared neither time nor money in improving the quality of the wine. He contacted neighbouring châteaux within the Margaux appellation and offered them two metres of his land for one metre of theirs. Renowned châteaux like Brane-Cantenac, Palmer, Kirwan, Giscours and Issan accepted. As a result, Château Prieuré-Lichine's vineyards are scattered across Margaux, some miles away from each other, varying in size from the tiny plot west of Château Palmer to the large vineyard north of Château Margaux. The latter called on all Lichine's skill in drainage technology.

Wine writer, engineer and drinker, Lichine put down roots in his beloved Médoc. When he died he was buried among the vines. His son Sacha sold the property in 1999.

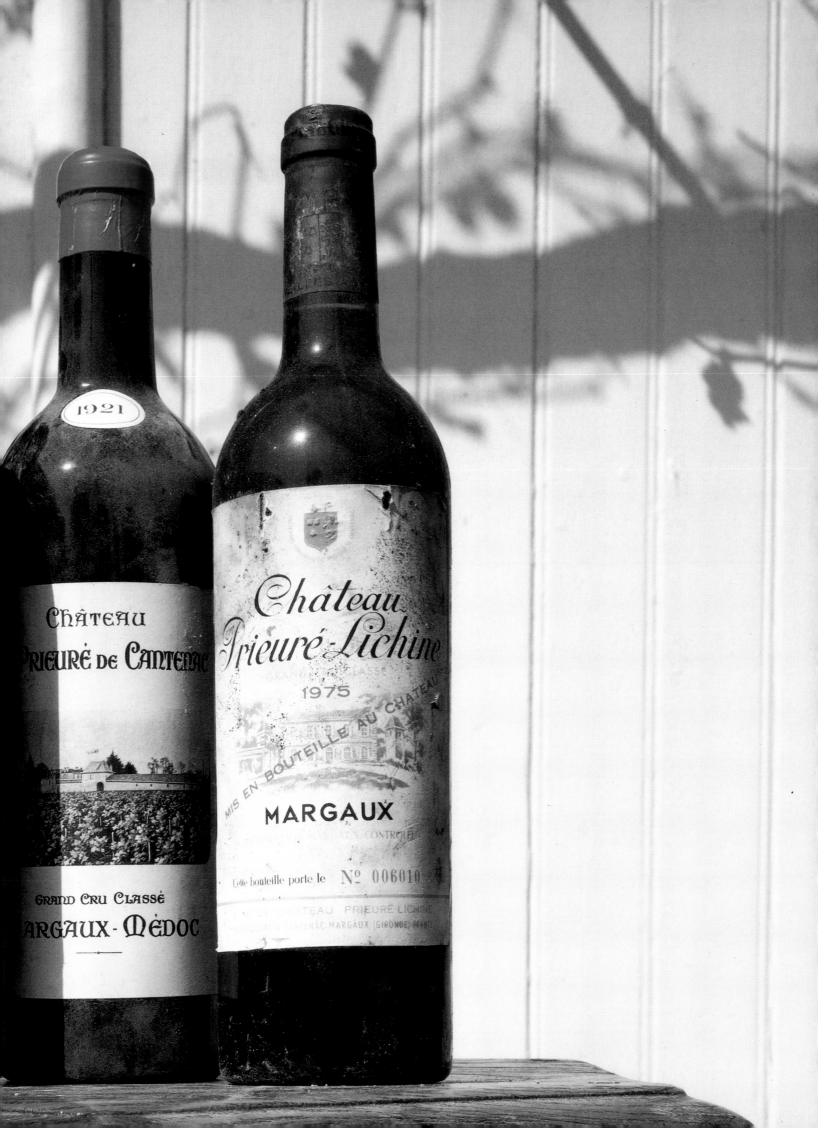

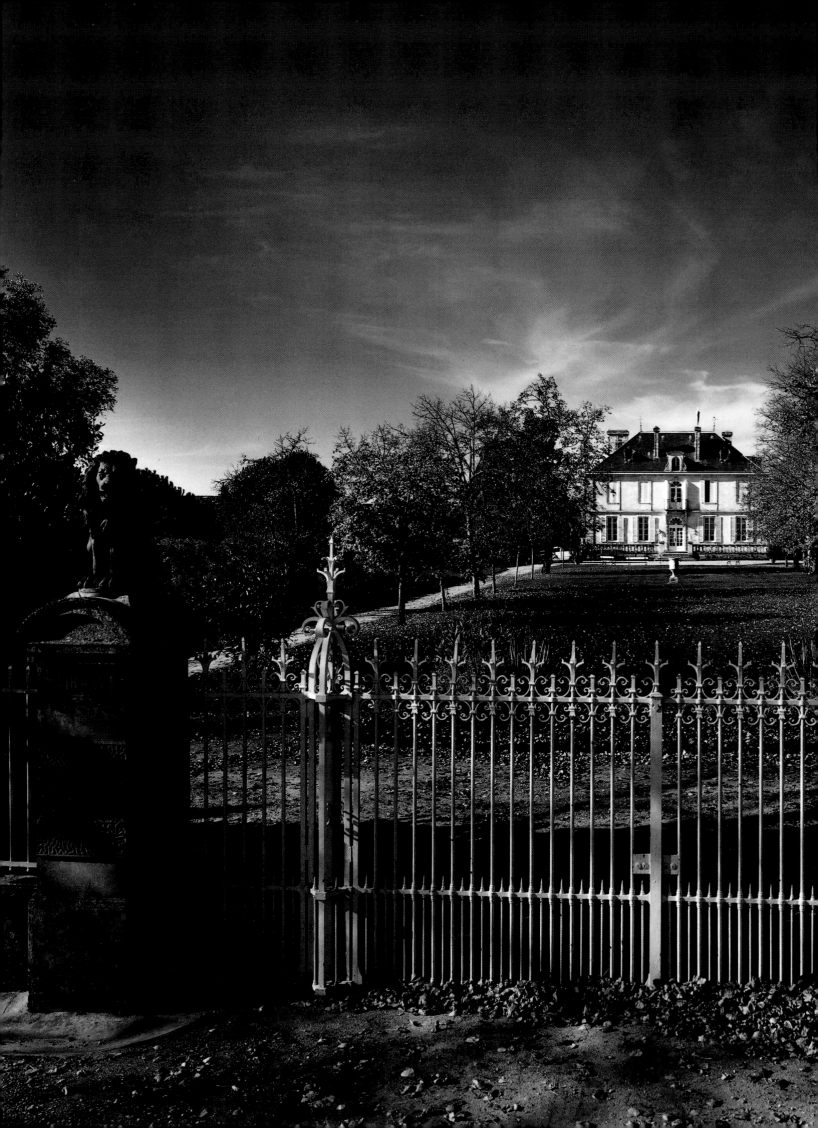

KIRWAN

The Kirwan vineyard can be traced back to the time of the Crusades. In 1147 it was the property of Raymond de Lassalle and remained in the family until the beginning of the 17th century. It then changed hands several times before an Irish emigré by the name of Kirwan bought it from its English owner, Sir John Collingwood, whose daughter he also won. That was in 1776. Thirteen years later he lost everything, including his head, when he was guillotined by the Revolution. The château has retained his name, spelled 'Quiroven' by Thomas Jefferson, who rated the wine worthy of a second growth in 1787 during his sojourn in Médoc.

Château Kirwan has belonged to Schröder et Schyler, one of the oldest Bordeaux wine houses and one of its most important, since the turn of the century. In 1973, the inside of the small 18th-century chateau was entirely renovated. Visitors can admire the superb tapestries and Charles X furniture.

A classified third-growth wine, Château Kirwan epitomises the femininity of Margaux wines. The 1993 vintage is a feast for the senses. It has a deep purple-red colour. Its bouquet bursts with violet, wild flower, blackberry and blackcurrant, with an after-taste of cooked cherry and liquorice turning to leather and hints of oak. It has both body and refinement.

Château PALMER

Only one man in Médoc can claim to have tasted the same château over three generations – Claude Chardon, head cellar master at Château Palmer. He has sampled the 1893 vintage, the work of his grandfather; and the wines nurtured by his father in 1928, the year he was born; and the 1961 vintage.

Château Palmer took its current name from yet another wine-loving Briton, General Major Charles Palmer, who, on his return from fighting Napoleon in Spain, fell in love with the Bordeaux wine-growing region. His love turned into a passion and for 30 years he added to the estate, which tripled in size. Like other of his wine-loving compatriots, he lived beyond his means and financial ruin drove him to sell.

Château Palmer has achieved a balance between change and continuity over the years: continuity in the 120 years of loving care lavished by the Chardon family on this third-growth wine; continuity in the 75 years of financial support from the brothers Pereire, who also built the château. Continuity has also come from the 60 years of profound attachment to their property by its owners, the Mähler-Besse and Sichel families.

The reward has been some outstanding clarets, which equal and often surpass first growths. In 1978 a tasting of some twenty 1966 vintages saw Palmer triumph over Lafite, Mouton, Latour and Margaux. Of all Margaux wines it has the highest proportion of Merlot – 40% – which adds complexity, fat and fruit.

So much for continuity. What of change? It has been gradual. The vines are still pruned and their leaves and buds removed by hand. However, new technical manager Philippe Delfaut closely monitors his maturing grapes. He has even installed machinery with electronic vision able to detect fruit-bearing branches and to count buds. Clipping, too, is now mechanical, while tractors have replaced horses. But vines are not planted to accommodate tractors and they are still as densely planted as they were two centuries ago. Château Palmer's concessions to modern technology apply only where there will be gains in efficiency.

Change within continuity is perhaps nowhere better illustrated than in the decision to adjust the proportion of Merlot to 40%, while maintaining Cabernet Sauvignon for grip and backbone.

A relatively high proportion of Merlot is what makes Palmer so distinctive. It is a wine which even the most demanding connoisseurs savour: its name is associated with a string of legendary years, such as 1945, 1961, 1966, 1982, 1983 and 1989. The 1990s appear unlikely to be so rich.

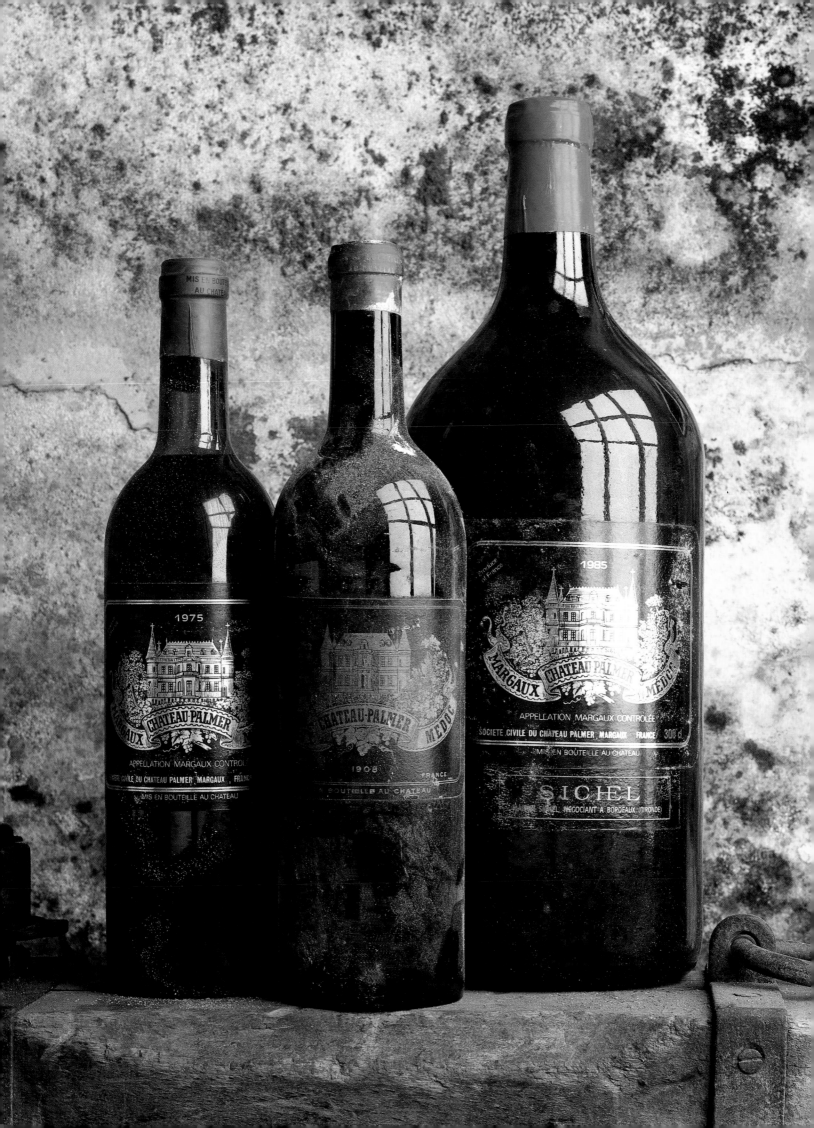

The Pereire brothers, bankers after whom a
Parisian boulevard is named, were great rivals
of the Rothschilds. They built this jewel of a
neo-Renaissance château between 1857 and
1860 appropriate to a third growth which had
inspired a consuming passion in General
Palmer, a friend of Wellington.

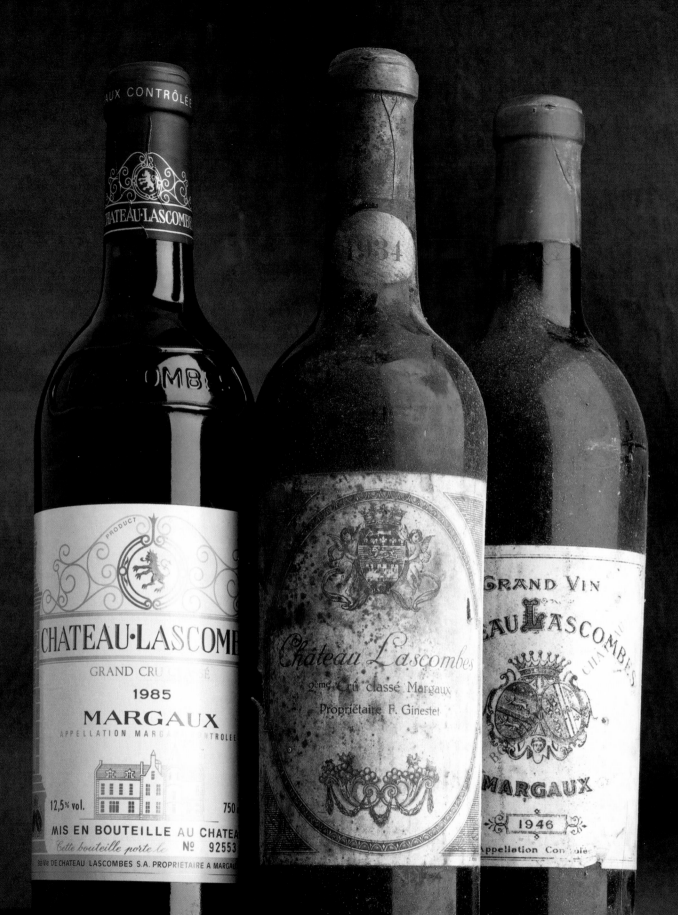

LASCOMBES

Lascombes has a fine bouquet of wild fruit aromas and a flower-like after-taste. Both energetic and supple, it is a wine which gets better and better.

When Alexis Lichine bought his priory at the beginning of the 1950s, he gained the enthusiastic support of a group of wealthy, wine-loving friends including David Rockefeller. They pooled their resources to help Alexis Lichine buy his second property in the Margaux *appellation*. It was Château Lascombes, a classified second-growth wine.

Early in the last century Château Lascombes was frequently compared to Château Margaux. One issue of the trade review *Le Producteur* enthused that 'its wines are reputed to be of such high quality that they can rival Château Margaux'. Admittedly an overstatement, it gives an idea of Lascombes' reputation. Yet, by 1890, the vineyard had been allowed to decline to only 13 hectares (32 acres).

A succession of owners then helped to extend it until, in 1952, Lichine's enthusiasm for and devotion to fine wine restored Château Lascombes to its rightful status as a great wine. He lavished attention on the château itself and on its cellars where, as at Château Prieure-Lichine, he had the barrel tops varnished, an unusual practice which gives an impression of cleanliness and order. Lichine also began holding regular contemporary art exhibitions at the château on the themes of vines and wines. He had a swimming pool built for his friends, which is now used by visitors.

The estate's current owner is the British brewer, Bass Charrington. The company has channelled enormous sums of money into Château Lascombes, determined, like Lichine, to make it one of the Médoc's truly great wines. The *chai* (cellar) was comprehensively renovated in 1973, setting new standards. The vat room, where the grapes are fermented, has been placed on the first floor, so that now the wine can be drawn off gradually before the next phase, malolactic fermentation. A word of explanation: almost all red and some white wines ferment twice. The second fermentation is not, however, alcoholic. Lactic bacteria transform malic acid in the wine into lactic acid and carbon dioxide. Malic acid is sharp and tangy, while lactic acid is, as its name suggests, milky and soft. It smooths the young red wine's stiff structure, so contributing finesse and a tendency to soften as it matures to the very feminine Château Lascombes.

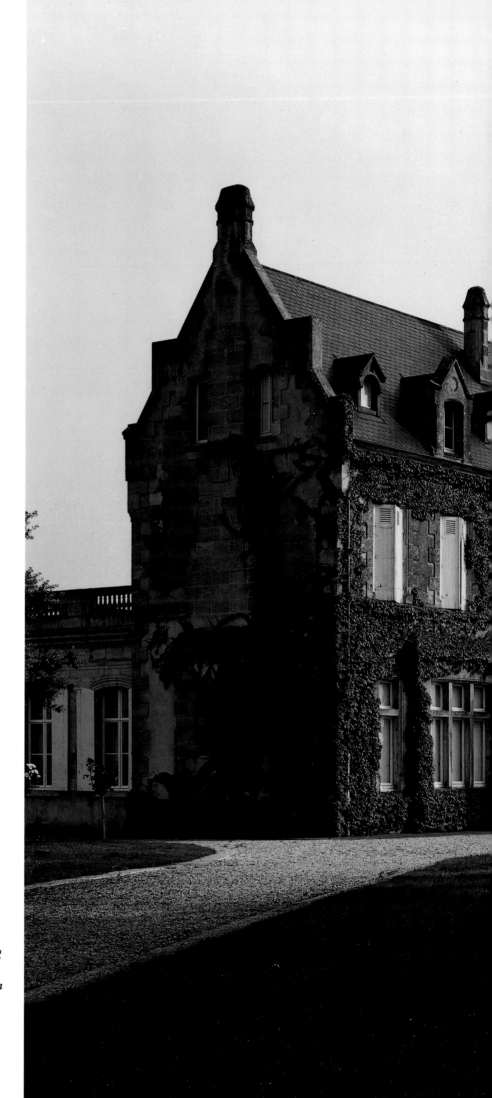

The château was built by the great 19th-century barrister, Chaix d'Est-Ange, who presided over the Bordeaux bar and successfully represented France against Egypt in the dispute over the Suez Canal. A century later, this austere building was transformed by the enthusiasm of Alexis Lichine and a group of his wine-loving American friends.

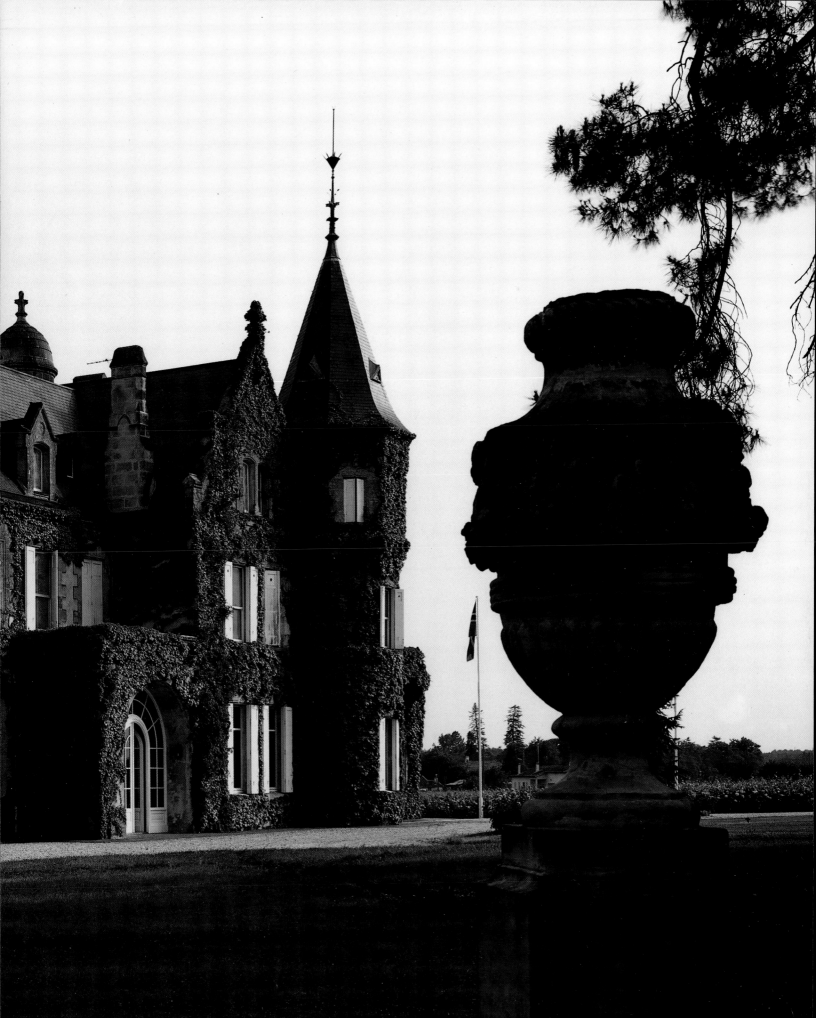

Château D'ISSAN

The main gate at Château d'Issan proudly displays the Latin motto *Regum mensis aris que deorum*, which means 'for the table of the king and the altar of the gods'. Issan was indeed the wine of kings and even of emperors. It was served at the wedding of Eleanor of Aquitaine and Henry Plantagenet – the future Henry II – in 1152 and was for some time the favourite wine of Emperor Franz-Joseph of Austria. It is said that until the fall of the Austro-Hungarian Empire, he would not drink any other wine, and his courtiers followed suit.

The Cruse family, which owns the property, has kept up the tradition of serving Issan to royalty. Members of royal families, as well as politicians, diplomats, showbusiness personalities, journalists, chefs, wine connoisseurs and winegrowers are among the guests invited to the many social occasions held at the château. These include the Bordeaux Musical May festival and meetings of the *Commanderie du Bontemps de Médoc et des Graves*, a society of wine-lovers from these Bordeaux regions. It brings together winegrowers and the rich and famous to promote wines. The members wear medieval capes and flowing robes at their meetings, which generally take the form of banquets or presentations.

Some believe that Issan has become a place to be seen rather than a wine to be savoured, following a lack of investment resulting from a wine scandal involving the Cruse family business in the 1970s. Speculation about overproduction of the 1970 and 1971 vintages led to a drop in quality followed by the 1973 slump in prices. The crisis proved a financial drain for the Cruse family, who also found themselves embroiled in a scandal over substandard wines being passed off as appellations.

The Cruses are now trying to restore Issan to its historic standing among great wines. They have implemented some much-needed changes to methods of vinification, which should help to restore the reputation of the château.

Château d'Issan's blends contain no Cabernet Franc, a grape which adds a fresh element to the Margaux clarets. Despite its high proportion of Cabernet Sauvignon, it is surprisingly supple and rounded, thanks to a short period of fermentation in vats and its 30% proportion of Merlot.

Above: the château, rebuilt in the 17th century in the purest Louis XIII style, was saved from ruin by the Cruse family.

Right: a classified third growth which is always elegant, but frequently suffers from a lack of robustness and concentration.

Overleaf: close to the river, the moats and canals of the 14th-century fortress of Issan can still be seen. The vineyard is surrounded by walls, but can be entered through this elegant gateway which rises majestically against the Médoc sky.

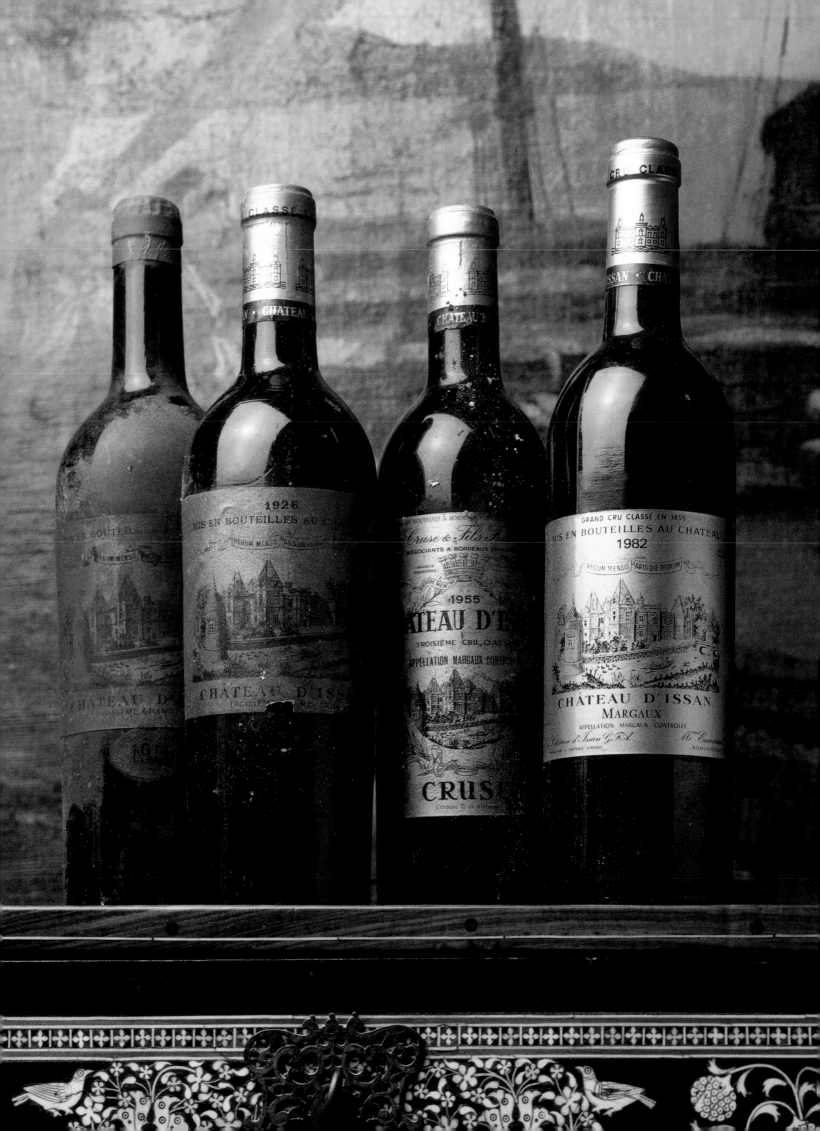

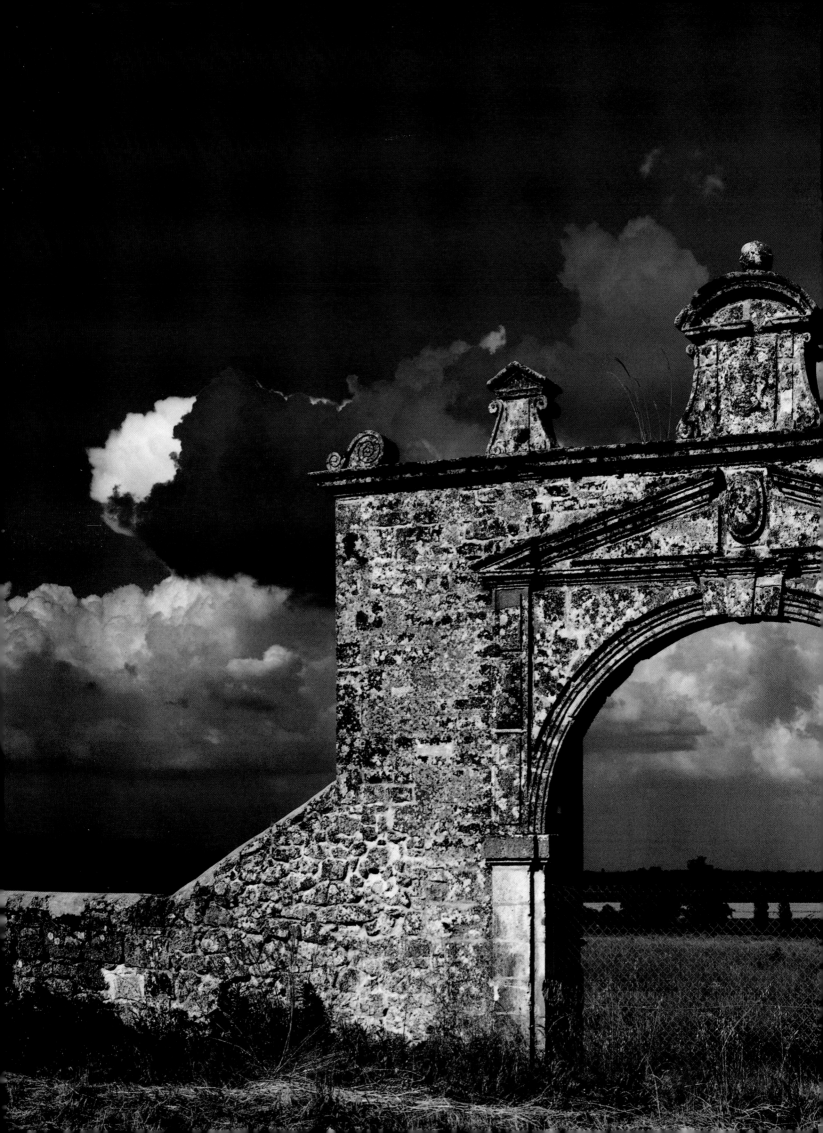

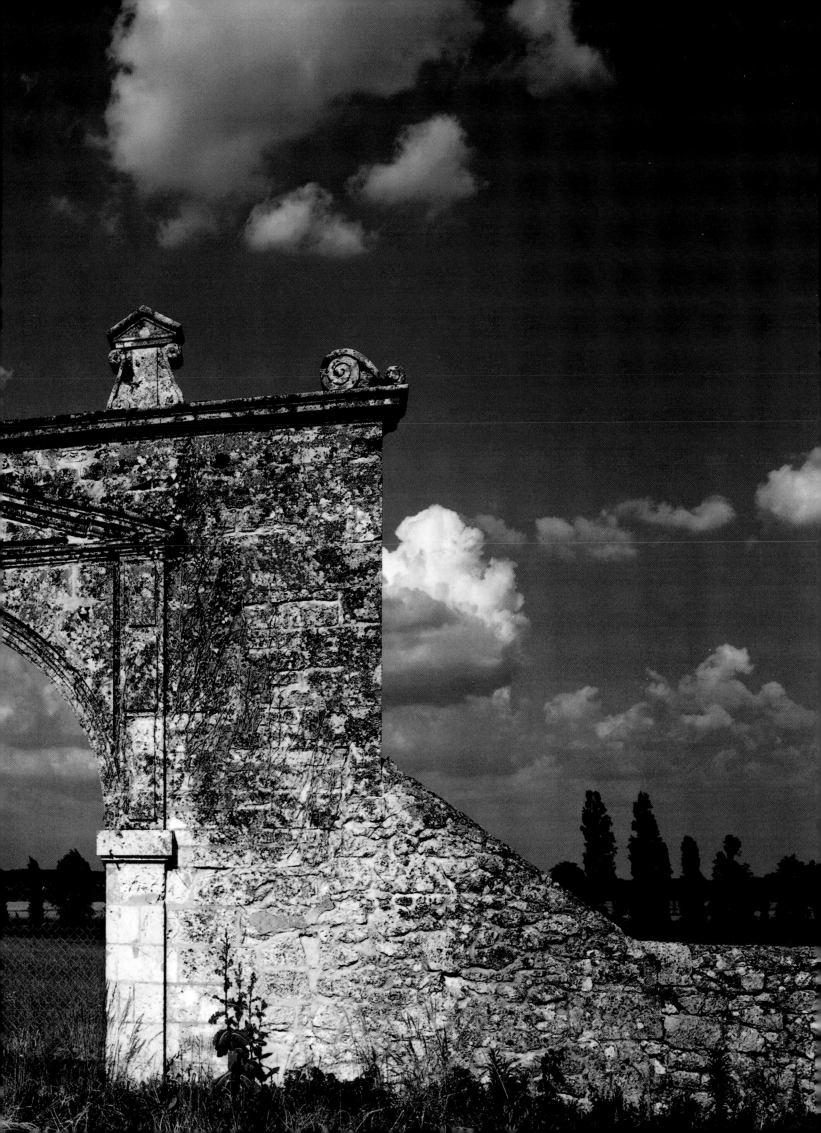

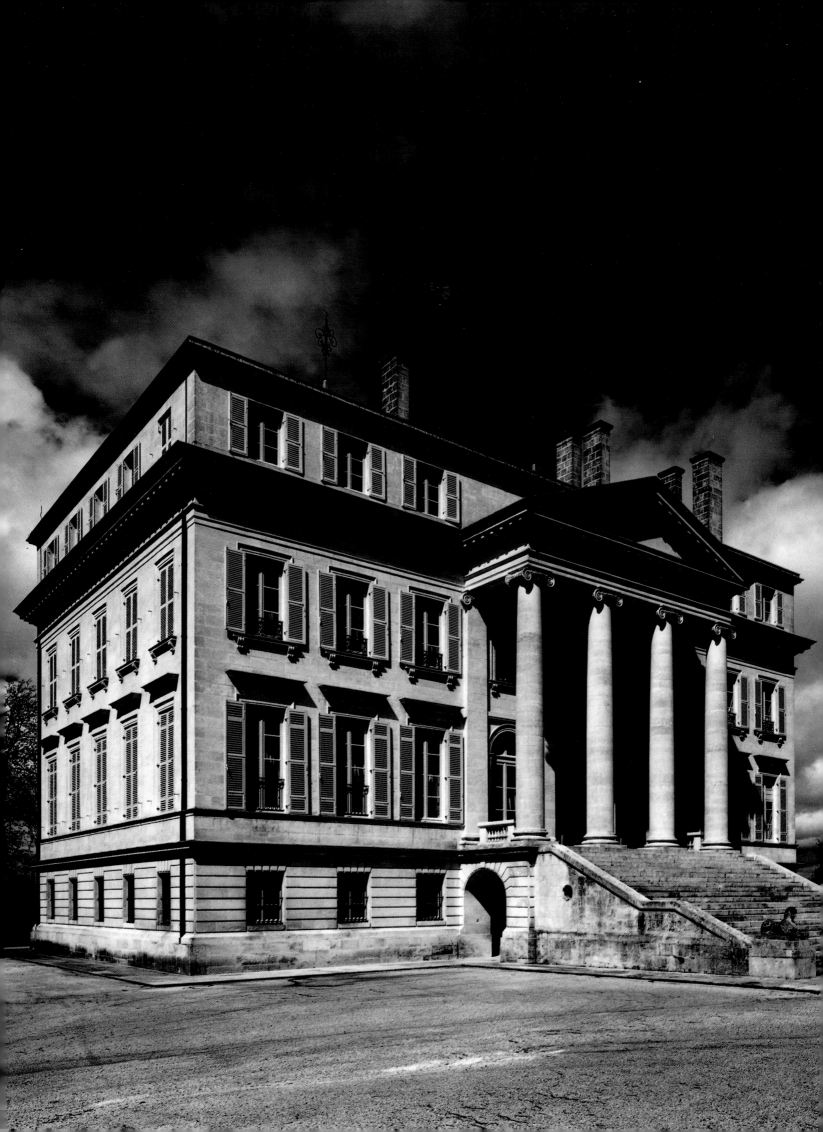

MARGAUX

Above: the Marquis Douat de la Colonilla commissioned the château in the early 19ᵗʰ century. In 1836, it was bought by the Spanish banker Aguado. Also a marquis, he was a renowned patron of the arts, particularly fond of the music of Rossini.

Left: it was on the site of an old fort that the Bordeaux architect Louis Combes began building the château in 1810. It was completed in 1816 – a grandiose neo-classical palace worthy of a wine which, more than merely prestigious, was truly triumphant. Château Margaux's triumph continues to this day.

The reputation of Château Margaux is reflected not only in its sheer grandeur but also in such telling details as the carefully polished brasswork of its oak vats. This reputation owes much to tradition. Established as a *premier cru* – first growth – by the famous classification of 1855, Château Margaux is unique in being the only Médoc wine to bear the name of its *appellation d'origine*. It is the product of methods which have been handed down for centuries. The vines are still tied with slim wicker lashes called *vimes*, the land is still worked by hand, while the hand-picked grapes are still carefully sorted in the vat room, or *cuvier*. The château's wine-makers have also maintained the tradition of using oak vats for fermentation.

The estate, too, is steeped in a tradition which can be traced back to the Middle Ages. It encompasses a number of widely differing vineyards which were brought together to form a single domain at the end of the 16ᵗʰ century. From the original founding family, the Lestonnacs, to Giovanni Agnelli today, the owners of Château Margaux have successfully managed to maintain both its good name and the distinctive qualities of its wines.

The 1960s and 1970s, however, saw a brief decline in the fortunes of the estate and the quality of the wine. When, in 1976, the Ginestet family, who owned the property at the time, sought to sell it, the French government moved swiftly to veto its sale to a foreign company. It was officially classified as a national heritage monument. Château Latour had already gone back to the English; the government would not let the country's foremost Bordeaux go the same way.

Eventually a 'French' solution was found. This came in the guise of the grocery chain, Félix Potin, which stepped in to buy the property. Not only could Félix Potin lay claim to a sound tradition stretching back over a century, its name had a good French ring to it. Less so the name of its owners – the Mentzelopoulous family. The Bordeaux winegrowing community was dismayed by the idea of the Château's new owner being Greek.

Over the next two decades, however, André Mentzelopoulous, helped by a talented team headed by Paul Pontallier, managed to restore the wine to its former splendour. Indeed, it is widely acknowledged that Château Margaux came to produce the finest Bordeaux wines of the 1980s. The critics were silenced. So much so, in fact, that when the Italian

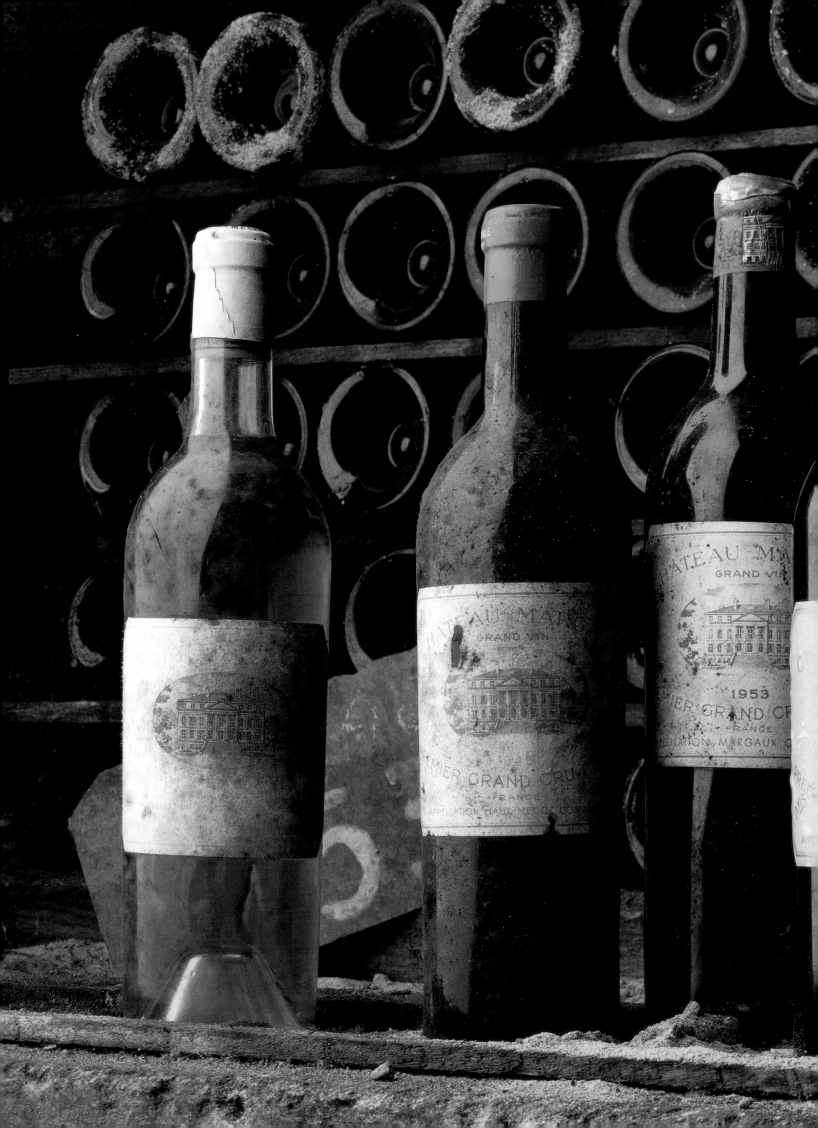

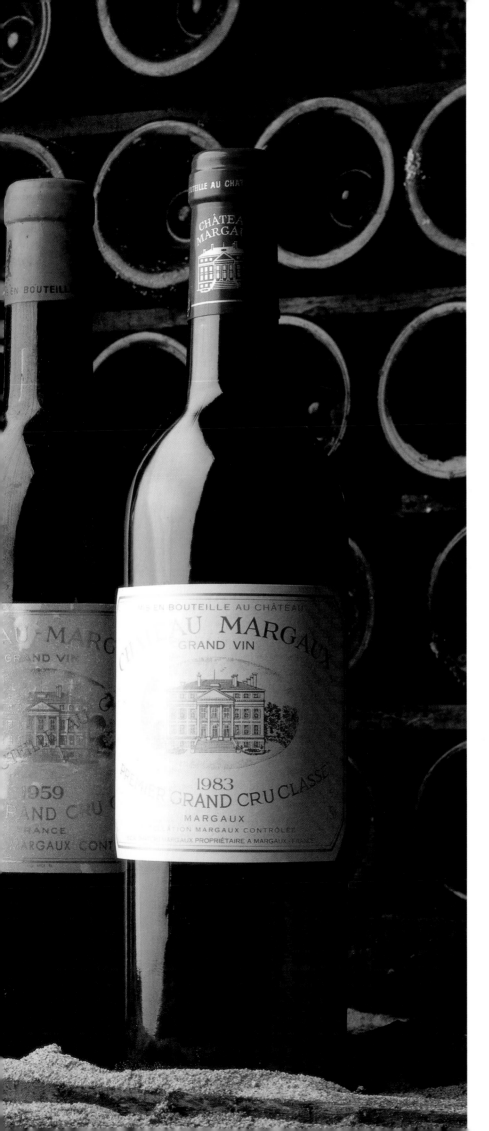

Unusually for the Médoc, Château Margaux also produces a very good white wine, Pavillon Blanc. But it is the red for which it is famous.

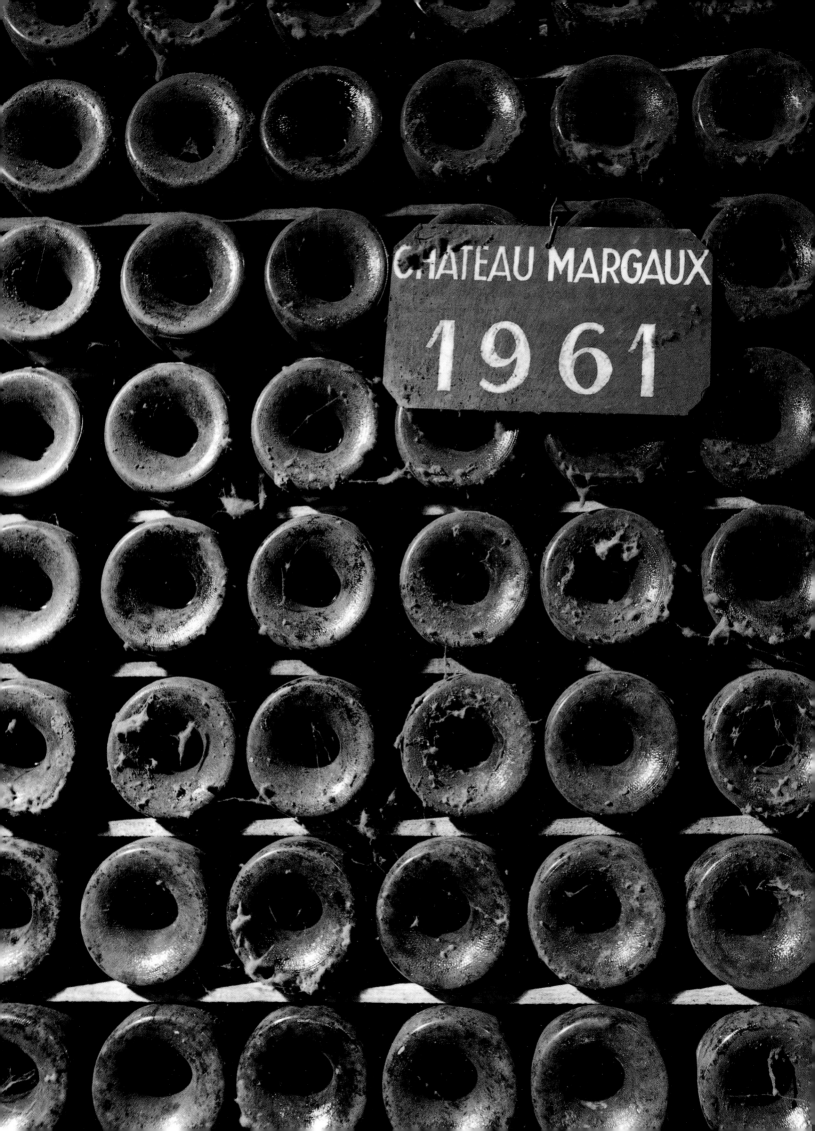

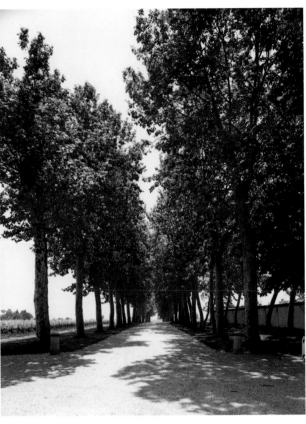

Above: the tree-lined avenue leading to the château.

Left: the 1961 vintage is the equal of that of 1945. This wine will still be drinking on its 100th anniversary.

Overleaf: the rows of barrels in which the wine ages.

car magnate, Giovanni Agnelli, acquired the domain following the death of André Mentzelopoulous, not a murmur of protest could be heard.

The château itself is a magnificent building of Palladian inspiration in a no less magnificent setting. At the start of the 19th century, the original Gothic château was razed to the ground, making way for one whose majesty reflected the reputation of the wine. It is approached along a broad avenue lined with plane trees at the end of which the neo-classical façade of the château rears into view like a giant gem, the Ionic columns of its mighty peristyle rising from the broad sweep of a monumental staircase.

The awe which the château's power and proportions inspire is of a more hushed nature in the almost religious silence of the cellars. It is here that the wine is matured in oak casks for two years. For the first year it is laid *bonde dessus* – bung upwards – in the great colonnaded, nave-like upper-cellar, or *chai*. One writer has described the thousand barrels arrayed in rows as 'prostrate like praying monks in sackcloth gowns'.

For its second year of maturing the wine is moved down to the underground *chai*. Here the cellar master and winemakers officiate, removing impurities from the wine with egg-whites, drawing it by candlelight, watching over it as it develops and changes.

The attention paid to the young wine produces the fully matured, bottle-aged claret, which Hugh Johnson calls 'the very taste and smell of elegance'. Take the legendary 1900 vintage – the perfect wine, described by Robert Parker as 'mindblowing'. He continued: 'fabulously rich and incredibly supple and full, it has a bouquet which could fill a room and a wonderfully clear-cut structure… it will keep perfectly 20 or 30 years into the millennium!' He then went on to award it a perfect score of 100 points. He called the 1928 vintage which he tasted in 1991 'immortal'.

Estate manager Paul Pontallier, so instrumental in Margaux's revival under Mentzelopoulos, believes the 1996 vintage has the makings of greatness. With its fullness and finesse, that rare marriage of youth and elegance and the concentrated, complex Cabernet Sauvignon nose, it is comparable to the luxuriant vintages of 1983, 1985 and 1990.

The 1996 will take Margaux well into the third millennium's first century. And since bottles of the 1784 and 1848 are still extant, Château Margaux is set to be a living legend which spans four centuries. Not quite 'immortal', but on the way.

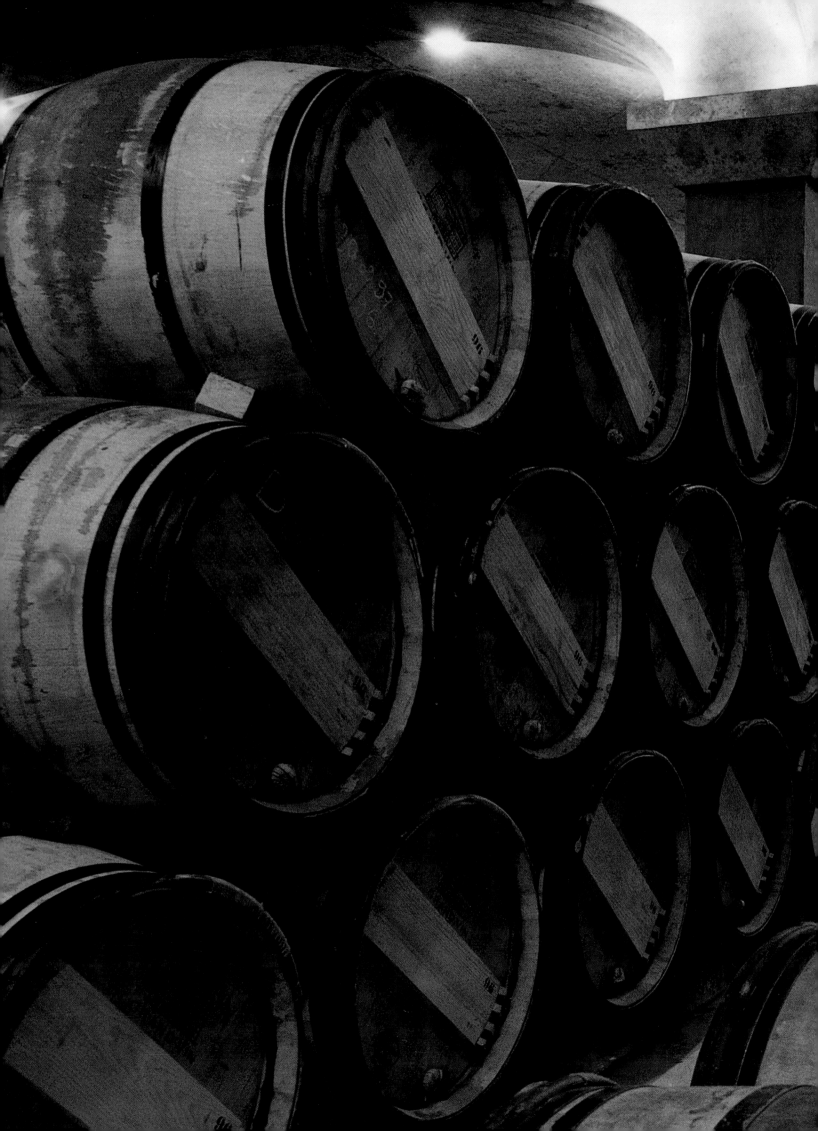

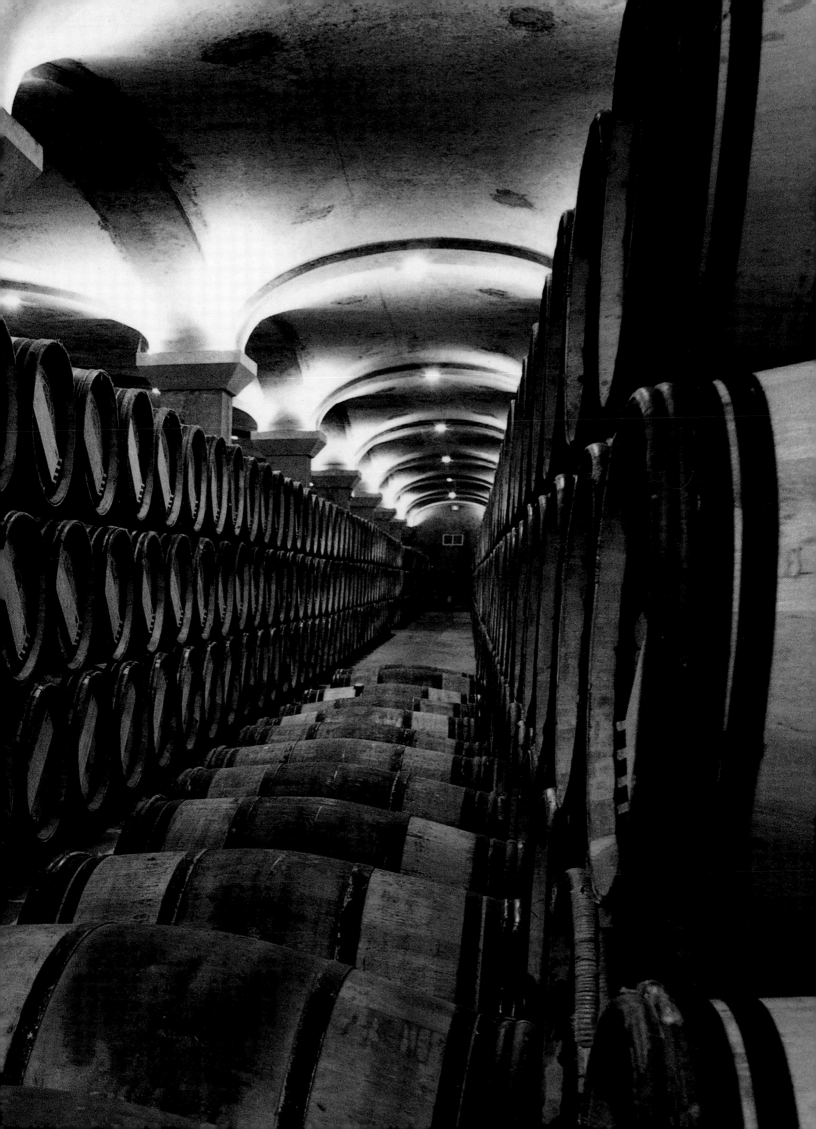

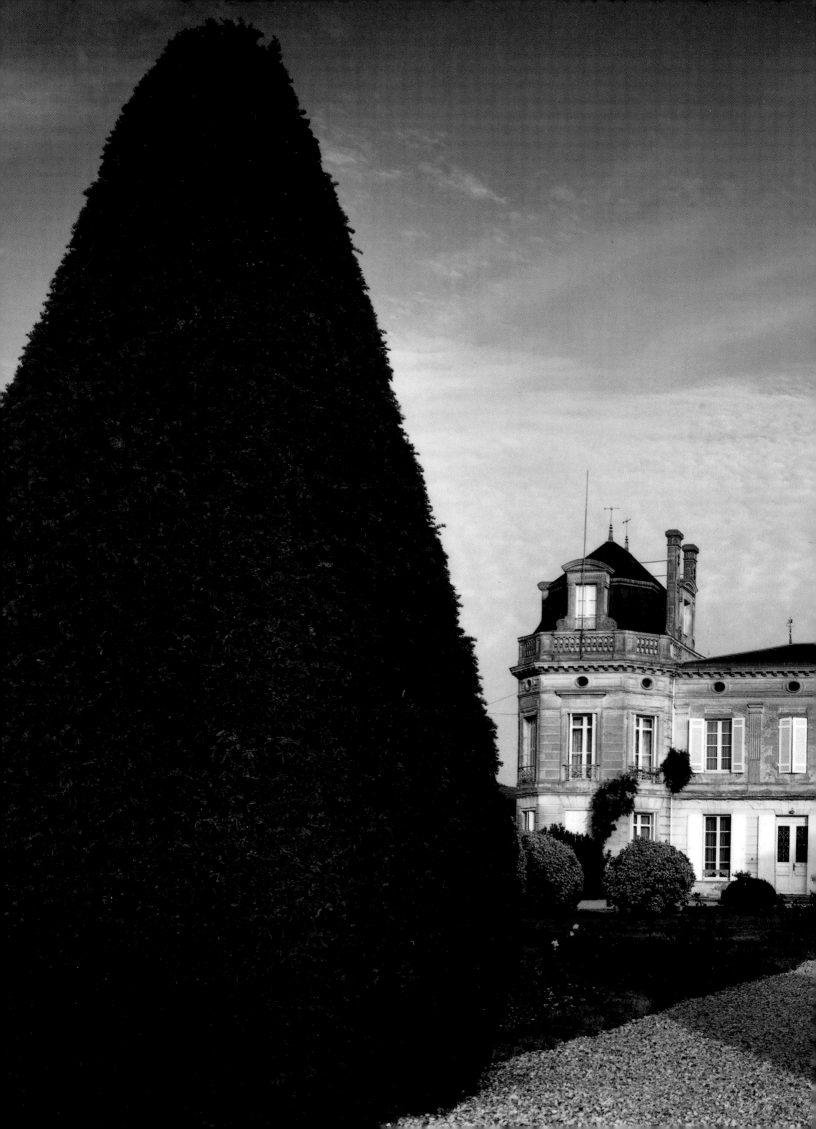

Appellation
MOULIS

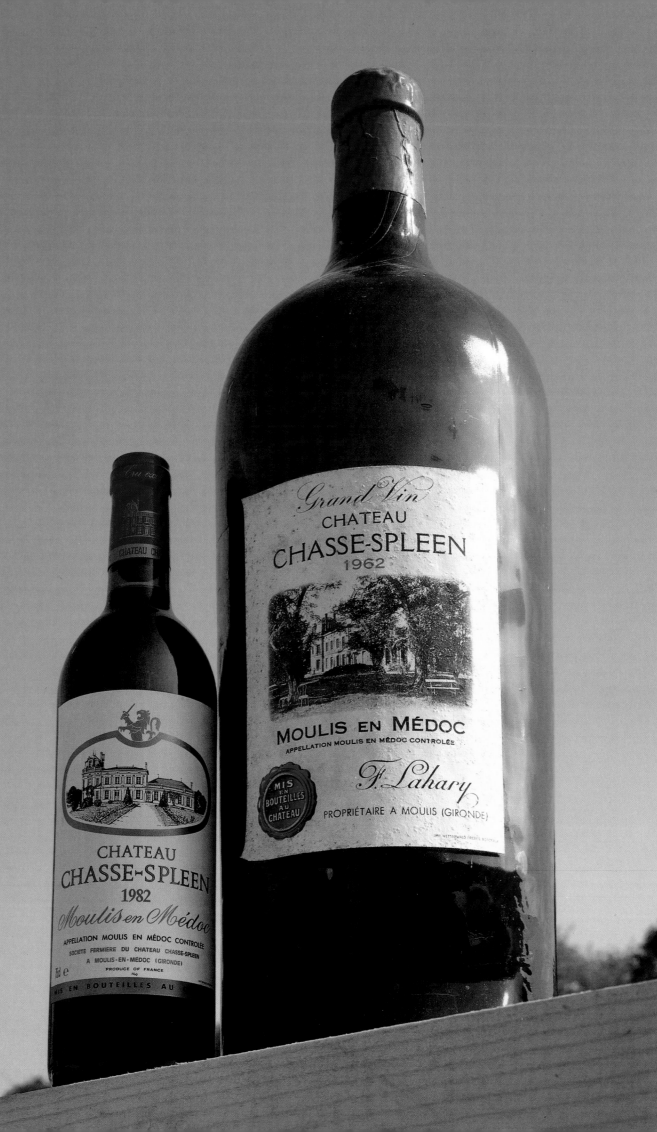

CHASSE-SPLEEN

This so-called 'grand cru bourgeois exceptionnel' (see Château Poujeaux) is the equal of some classified second growths. It has all the aromatic complexity of the southern reaches of the Médoc and all the richness of the north. It is, in other words, a splendid wine in its own right.

Chasse-Spleen means, literally, 'spleen-chaser' or, to put it another way, it chases the blues away. Even in poor or mediocre years, Chasse-Spleen consistently offers an uplifting experience: its colour is deep ruby, it has a ripe plummy texture and rich round flavours. The sheer quality of the wine is a further argument for updating the 1855 classification. For the time being, Chasse-Spleen occupies the upper echelon of the lower tier of claret classification.

The 80 hectare (200-acre) vineyard has deep, gravelly soils and boasts an average vine age of 35 years. The main grape varieties planted are Cabernet Sauvignon and Merlot, which stand at 70% and 20% respectively. The predominance of Cabernet explains the wine's five to eighteen-year maturing time, while the healthy percentage of Merlot is behind its roundness. The driving force behind Chasse-Spleen's rise over the past 30 years was Bernadette Villars. When Jacques Merlaut (the new owner of Château Gruaud-Larose) bought Chasse-Spleen from the Lahary family in 1976, he made his daughter, Bernadette Villars, estate administrator. Under her guidance, Chasse-Spleen joined the top ranks of the great Médoc clarets in the second half of the 1980s.

In the domain's winery, which, like the wine, is worthy of a *grand cru*, she displayed an unswerving commitment to traditional winemaking. She made Chasse-Spleen one of the very few Médoc châteaux which does not filter the wine either after malolactic fermentation or before bottling. Her one concession to modern technology was machine-harvesting part of the crop. Another of her qualities was meticulous attention to detail at every stage between fermentation and bottling.

That she applied stringently high standards, particularly to blending, is shown by her decision to introduce a second wine. A second wine is usually a guarantee of the quality of the first wine, which uses only the very best grapes. Those almost – though not quite – up to standard go into the second wine.

After Bernadette's death about ten years ago, her daughter, Claire, took over the estate. She has much to live up to, but not only at Chasse-Spleen. She also administers other properties her grandfather Jacques Merlaut had acquired: two *cru bourgeois* châteaux, Citran and La Gurgue; a third-growth Margaux, Château Ferrière; a fifth-growth Pauillac, Château Haut-Bages-Libéral, and, finally, the jewel in the crown, Gruaud-Larose.

POUJEAUX

Together with Chasse-Spleen and Maucaillou, Château Poujeaux is one of the big three Moulis appellation wines. It is deep ruby in colour, tannic, astringent and slow-maturing – all surprising given its 40% proportion of Merlot. The explanation lies in its 5% proportion of Petit Verdot, a late-ripening, high-sugar grape with a peppery, tannic grip. Although Chasse-Spleen has recently stolen the limelight, Poujeaux is a fine wine which fully deserves fifth-growth ranking.

This promotion remains elusive. The 127 non-classified growth wines are loosely called *bourgeois*, the key word in the most recent classification, drawn up in 1978, which ranked them in three categories: *Grand Cru Bourgeois Exceptionnel*, *Grand Cru Bourgeois*, and *Cru Bourgeois*. Some châteaux – Maucaillou is one – reject the classification, considering it nothing more than a marketing ploy. Their stance makes sense, since *bourgeois* categories had been outlawed by European legislation two years before Bordeaux wine officials recast them.

The *bourgeois* have formed a society to press their case for classified-growth status using the Mouton-Rothschild precedent and tastings to publicise the quality of their wines. One tasting tournament, organised by Belgian journalist Jo Gryn, pits *bourgeois* against a team of sommeliers, restaurant owners, distributors, journalists and winelovers. Poujeaux has won several times.

Appellation
SAINT-JULIEN

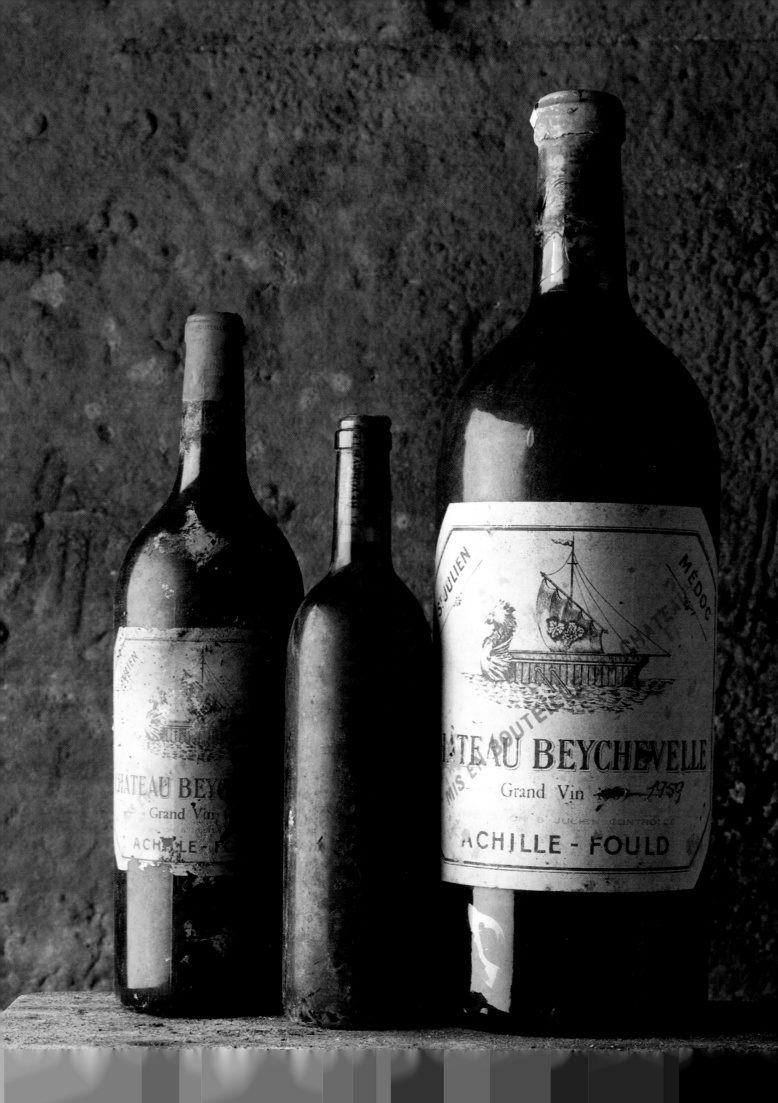

BEYCHEVELLE

The year 1587 saw the Duke of Eperon become Admiral of France and married. His bride's dowry included a vineyard and its château. As an admiral, he acquired the privileges and respect due to his rank. When ships sailing down the Gironde passed in view of the chateau they paid tribute to the admiral by lowering their sails to half-mast. The term for half-mast in Old Gascon was '*beyche velle*' – hence Beychevelle. Labels on the bottles (see left) feature a ship at half-mast.

According to Alexis Lichine in his *Encyclopaedia of Wines and Spirits*, both the wine's reputation and its prices are well in excess of its fourth-growth classification. He does not, however, say whether the same is true of its quality.

Visitors following the Médoc wine trail come upon an enormous 30-foot high wine bottle which rears into the sky at the edge of the Beychevelle estate, signalling the beginning of the St. Julien appellation. Château Beychevelle is one of the eleven St. Julien wines ranked *crus classés* in the 1855 classification. The wines of the St. Julien appellation area share similiarities with those of Margaux and Pauillac, its two adjacent appellations. St. Julien clarets are, however, distinctive in their own right. Like Margaux, they are refined and feminine, though darker in colour with a slightly more robust texture. They have, however, less body than Pauillacs and age more quickly in the bottle. Château Beychevelle itself is sometimes said to be a model of balance, a wine of pedigree and style, which needs to age in the bottle a year or two longer than other St. Julien vintages. The result is a light, supple, elegant wine. In the 1960s and 1970s there were worries about Beychevelle's lack of consistency and it was decided to firm it up. Accordingly, the period of *cuvaison* (fermentation in vats) was lengthened from 12-15 to 20-25 days, a greater proportion of Cabernet Sauvignon was used for a more muscular structure and new oak barrels were introduced. The result was a series of great wines in the 1980s – particularly the 1986 vintage – with a firmer, denser structure, which retained the distinctive Beychevelle quality of an easily accessible style and charm. Another distinctive quality was that Beychevelle had its own farm, in which some 100 head of cattle grazed, thus providing entirely organic fertiliser for the vineyards.

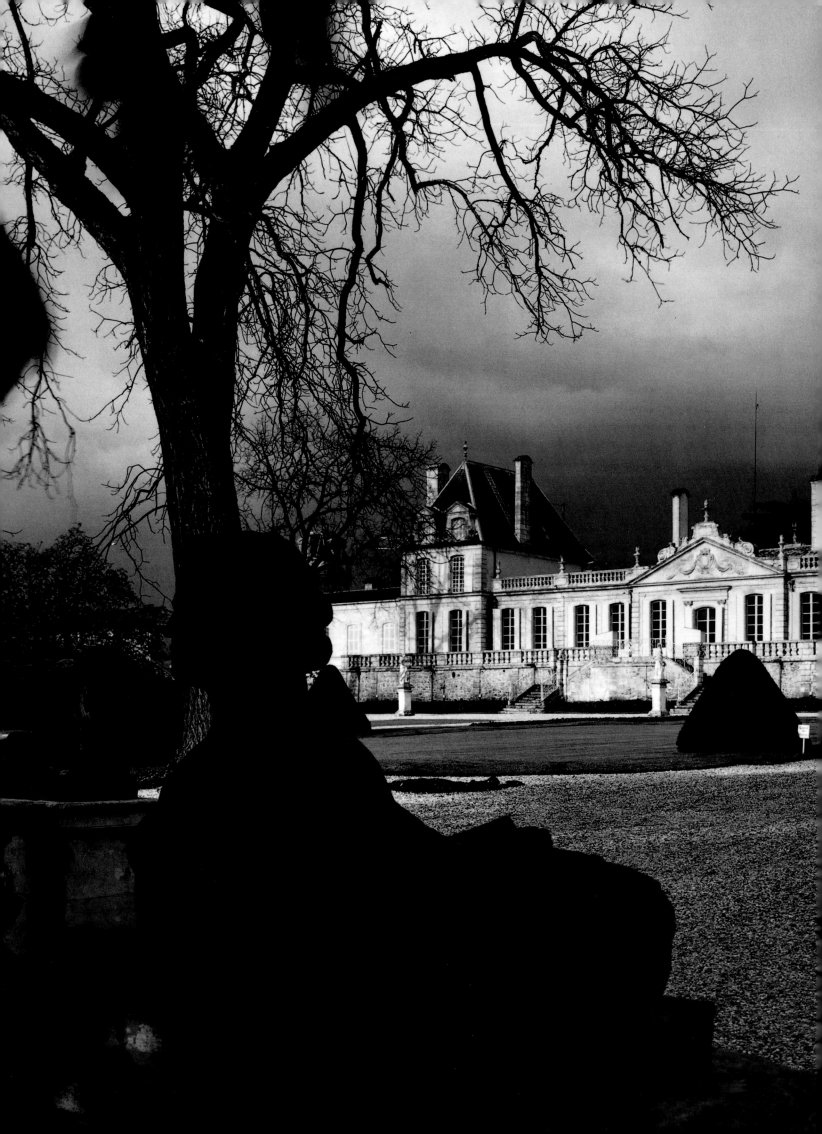

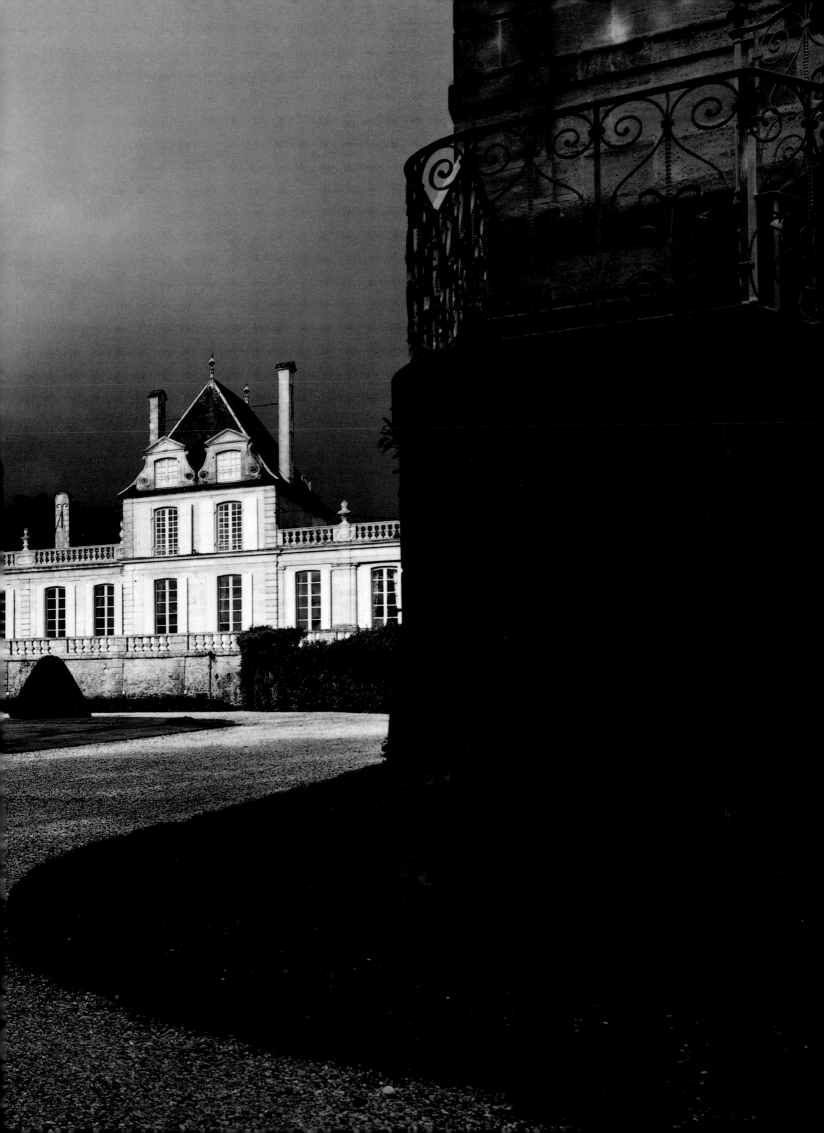

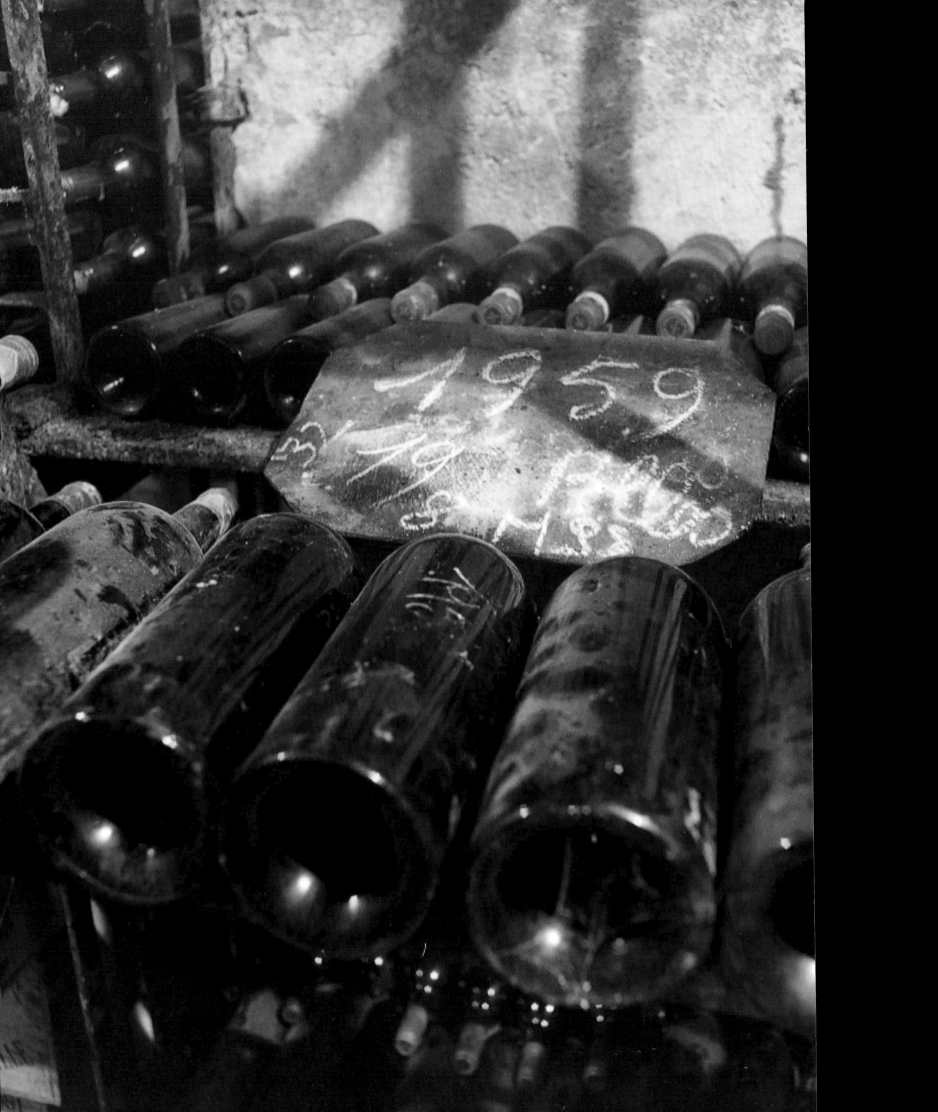

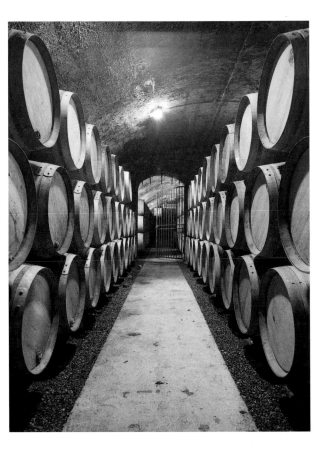

Above: row upon row of casks stacked in the vaults of the cellar. Inside them the wine, blended and fined with egg-white, waits silently to be revealed to the eager world of wine-lovers.

Left: thirty years after the superb 1959 wine, the 1986 vintage stands out among two decades of inconsistent wines.

The château itself is widely held to be the finest and most imposing in the Médoc. It was entirely rebuilt in 1757 on the foundations of a medieval fortress by the Marquis de Brassier. He replaced the battlements with balustrades, turning the edifice into an elegant château in the style of Louis XV. It is long and low and boasts a vast west wing. Its towering belvedere commands a view of its geometrically ordered French gardens, whose manicured lawns slope gently for over half a mile down to the River Gironde. In fact, the perspective from it is reminiscent of the château at Versailles, albeit on a much smaller scale.

For over 100 years until 1984, the owners of Château Beychevelle were the Fould family. Achille Fould – a Minister in the French government at the time – liked to tell the story of how it came into the family. His father-in-law, Armand, spent time in the United States, where he fell in love with and married a young American. He later took her on a tour of France and when they came to the château of Beychevelle, his wife said, 'That's where I'd like to live'. He bought it immediately.

The splendour and prestige of the chateau have, in more recent times, whetted other appetites. In 1984 a major French insurance company, GMF, bought the property, seeing it as an ideal blue-chip investment, where yield was low but safe. Sadly, its concerns do not seem to have gone much further than basking in the prestige gained from owning the château and its estate. The glory of yesteryear still masks what began as a disturbingly poor decade for Beychevelle's wine: 1991 was thin, 1993 astringent, 1994 stiff, but top form returned with 1995 and was confirmed with the round, finely-flavoured 1996. How much longer could the imposing elegance of the château serve as a facade for the neglected vineyards, which had not had any serious upkeep, let alone investment? GMF has now sold 40% of its stake in Beychevelle and has at last taken on a new steward. Just in time, one hopes, to prevent the etymology of Beychevelle assuming a new, sadder meaning.

BRANAIRE-DUCRU

Château Branaire-Ducru stands opposite Château Beychevelle, on the other side of the famous D2, *route des vins* or 'wine road'. The château is a model of the architectural style of the *Directoire* period, named after the five-man administration which governed France from 1795 until Napoleon's *coup d'état* in 1799. Built in 1794, its pure, taut lines reflect the ruthlessness of that period's politics. The 1990s minimalism of the purpose-built winery matches the château in its sobriety. Fermentation and ageing cellars were built in 1991, one under the other in order to use the natural effect of gravity for running the newly fermented wine from the vats on ground level to the ageing casks below. Although traditionalists may deplore the overtly functional design of the cellars, the presence of odourless mould on their walls is proof that air is conducive to ageing, as long-maturing wines thrive in a damp atmosphere. Bottled two years after harvesting, Château Branaire-Ducru is very dark in colour with a bouquet that is as intense as it is complex. Hard when young, it was a wine that acquired texture with age, although recent years have produced precociously maturing, easily accessible young wines catering to current trends.

DUCRU-BEAUCAILLOU

Left: an anecdote has it that 1959 was the first vintage to be described as the vintage of the century. The expression caught on and every decade now has its crop of vintages of the century jostling for pride of place.

Overleaf: the early 19ᵗʰ-century charterhouse was augmented by the addition of two heavy-weight, square towers very much in keeping with the 'financial renaissance' spirit of the Second Empire. The Borie family, who live in the château, enjoy a superb view over a clutch of palm trees to the estuary where the Médoc ends and the sea begins.

It was the Ducru family who named Ducru-Beaucaillou after the vineyard's soil, rich in a stony gravel that contributes to the greatness of many a Médoc wine, particularly Château Latour. Beaucaillou means 'beautiful pebble' and has made Ducru-Beaucaillou, classified a second-growth château in 1855, superior to most other wines in its category. Both supple and fleshy, it is what a good St. Julien claret should be. It has a dark, velvet colour and a bouquet that is at once refined and flattering. Good vintages should be allowed to age in the bottle for at least 10 years. At a 1978 tasting of 1961 vintages (see *Château Palmer*, page 36) attended by four of the most prominent Masters of Wine, Ducru-Beaucaillou was judged to be the fourth finest claret, superior to châteaux such as Lafite and Margaux.

The wine's depth of character is reflected in the breadth and opulence of the château and winery. The immense cellars are located under the sweeping stone staircase and house countless bottles. In the deepest cellar the personal bottles of Jean-Eugène Borie, the late owner of Ducru-Beaucaillou who lived on the premises and died in 1999, are like an oenological reference library of the past 120 years.

In 1866 – during the golden age of wine investment – the powerful Bordeaux wine merchant, Nathan Johnston, bought Ducru-Beaucaillou from the Ducru family for one million francs, a colossal sum at the time. The Johnstons added the two square, Victorian towers at either end of the château and applied themselves to improving the wine, producing a steady stream of ever greater bottles. They also were the first to experiment in the use of *bouillie bordelaise* (a mash made from lime and copper sulphate) to destroy downy mildew. Downy mildew was a parasitic growth carried by vine plants imported from the USA. Spread by the wind, the mildew blighted Bordeaux vineyards in the 1880s.

Neglect on the part of a succession of owners saw the quality of the wine decline so steeply in the 1930s and early 1940s that the Bordeaux wine world voiced the view that it was no longer worthy of a second growth. Enter Jean-Eugène Borie. With traditional growing and vinification methods, he elevated the wine to a level it had never before attained – rich, harmoniously balanced and elegantly tannic, it is truly the product of fully mature vines nourished by soil rich in 'beautiful pebbles'.

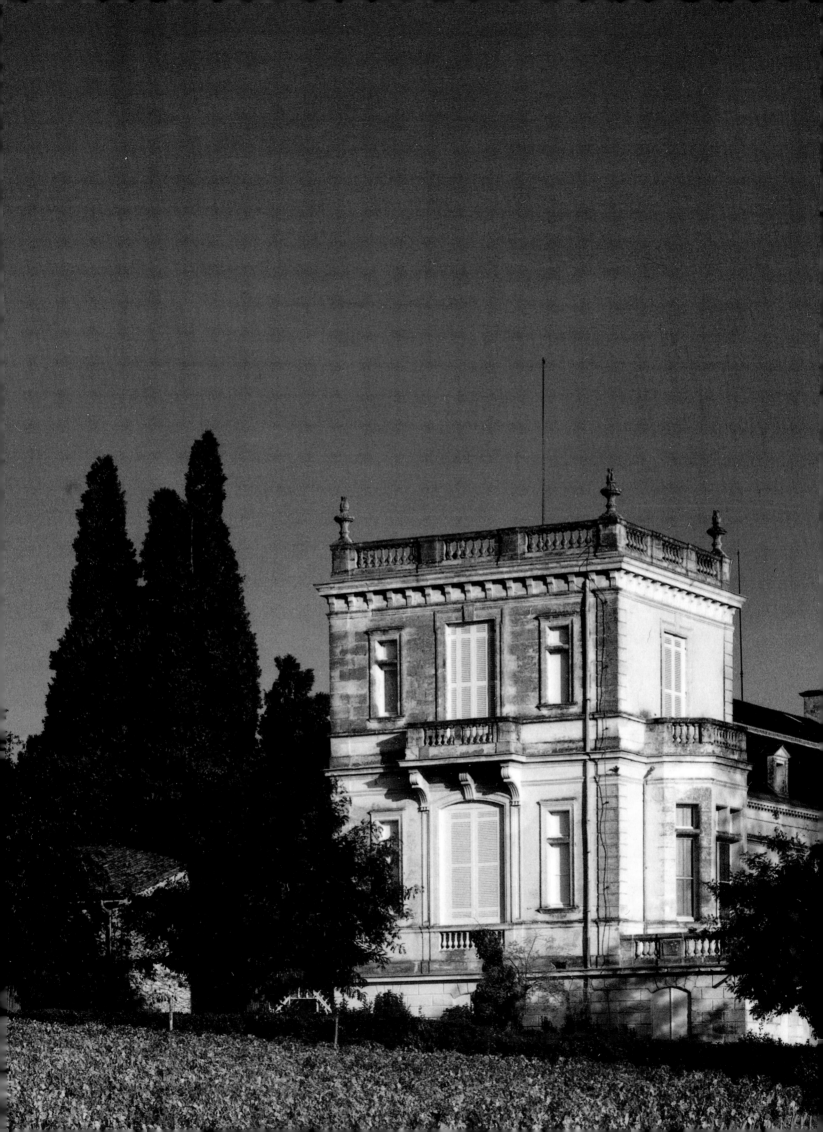

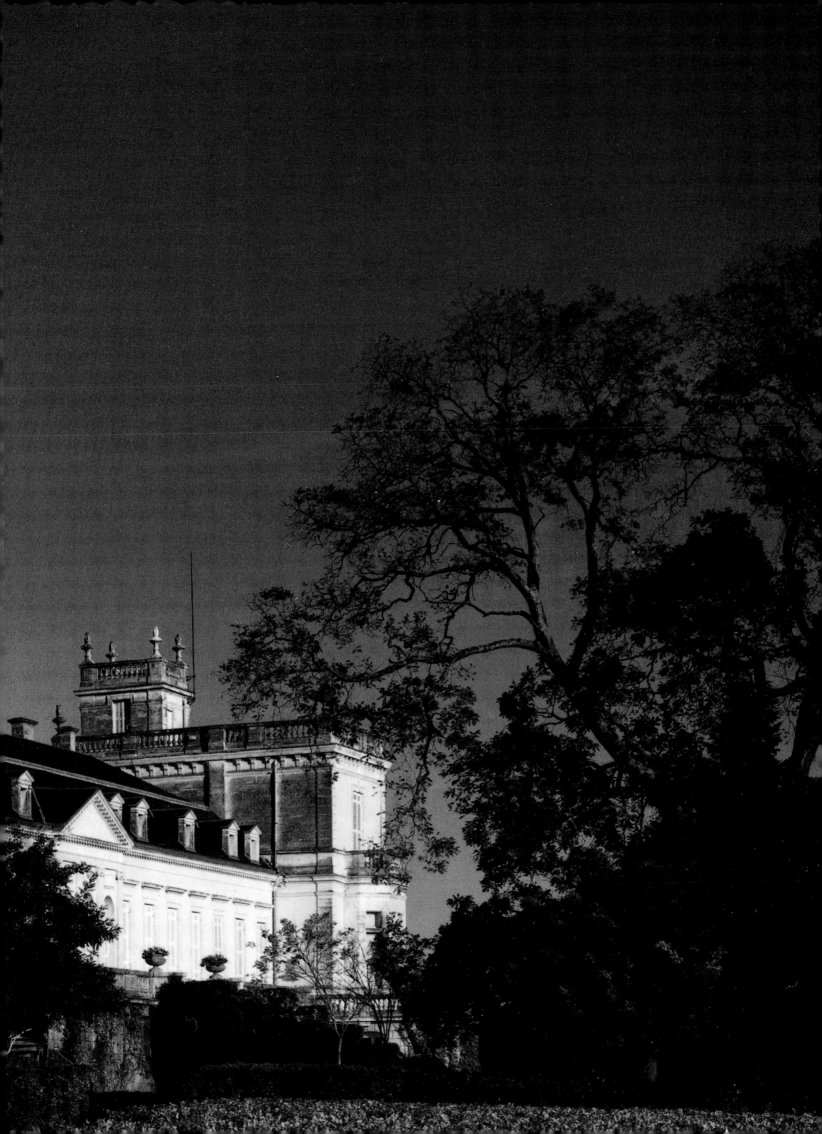

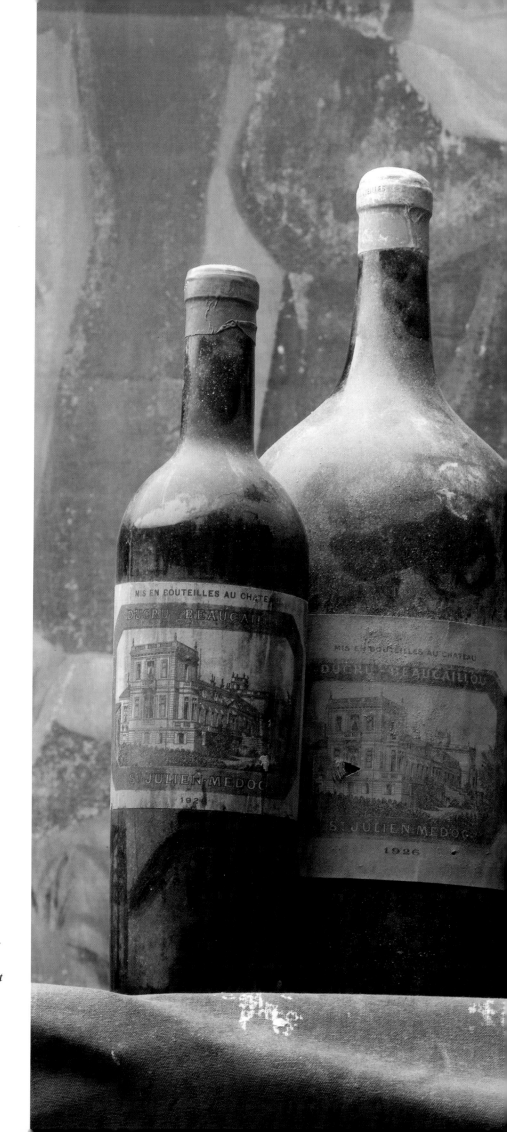

Sometimes called the 'Lafite–Rothschild of the St. Julien', Ducru–Beaucaillou boasts both ample texture and elegance, characteristics that are consistent in vintages like the 1961, 1970, 1982, 1985, 1994, 1995 and 1996.

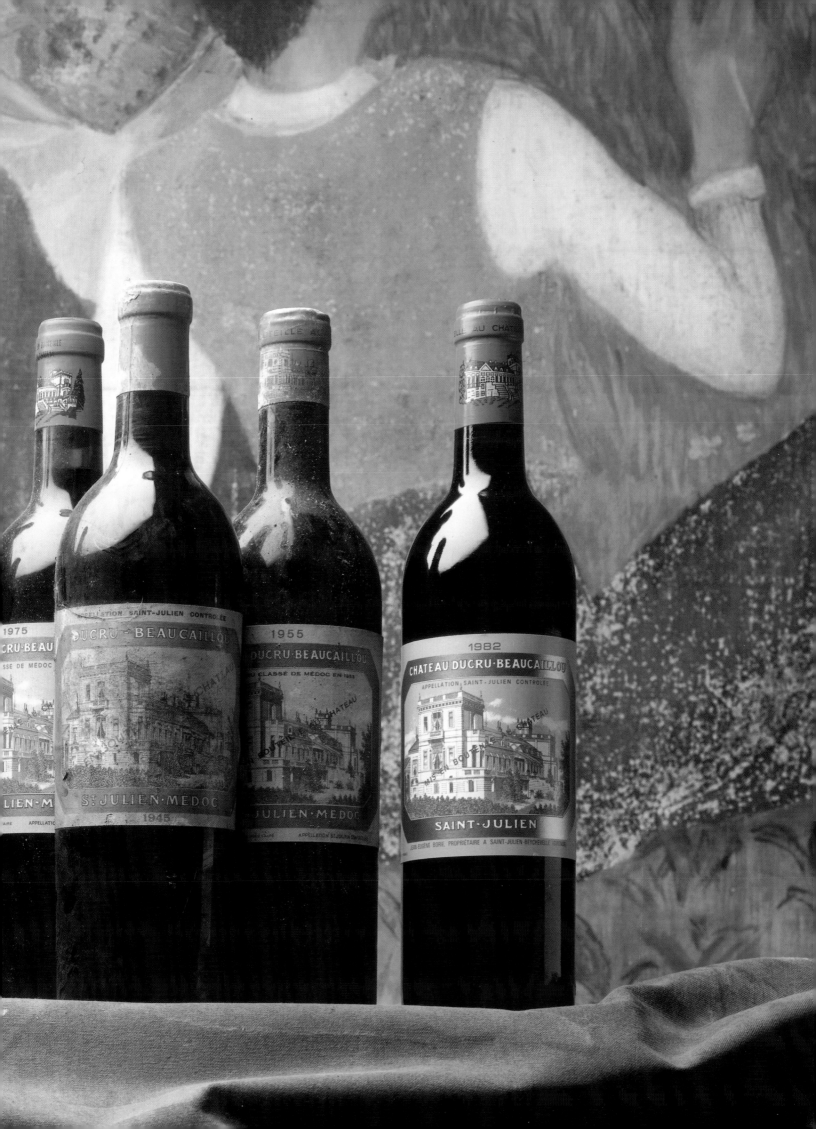

SAINT-PIERRE

Historical archives state that the St. Pierre domain goes back to the 17th century, when it was called Serançan. Some 100 years later, it became the property of Baron Saint-Pierre, who gave it the name it still has today. In 1832 the estate was divided between the baron's son-in-law, Colonel Bontemps, and his daughter, with each half being run as a separate entity. By the end of the century, each half was producing its own wine under a different name. It was not until 1922 that the Belgian Van den Bussche family succeeded in buying the two vineyards and reuniting them. More recently, Henri Martin, nicknamed the *âme du Médoc* (the soul of Médoc), bought the property in 1981. He had already helped to restore Château Latour to its former greatness and had created an excellent new vineyard called Château Gloria. The grandson of a cellar master and son of a cooper, he was also the mayor of the town of Saint-Julien for 40 years, as well as the founder and grand master of the *Commanderie du Bontemps de Médoc et des Graves* (see *Château d'Issan*). He continued patiently to reconstitute the scattered parcels of the domain and to revive a wine which was classified as a fourth-growth in 1855. His daughter has continued the good work, devoting herself to improving vinification at Château Saint-Pierre, a big, powerful wine with a full, jammy aroma.

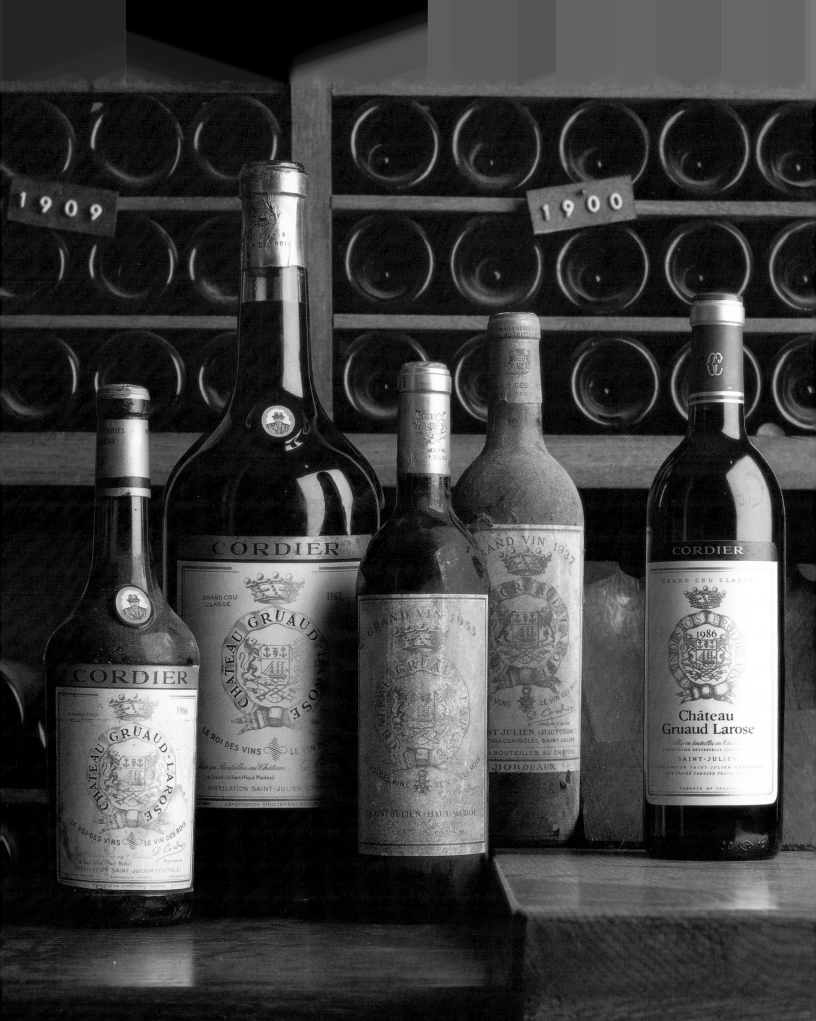

GRUAUD-LAROSE

Left: in 1990 a wealthy Texan organised a historic tasting at Fort Worth of 170 Gruaud-Larose vintages spanning the 170 years between 1819 and 1989. Most of the oldest wines – e.g. 1819, 1834 and 1870 – had retained the aromatic, lively nose, the refinement and length so characteristic of this classified second growth.

Château Gruaud-Larose's tower commands a view over the rolling vineyards of the Saint-Julien appellation. Monsieur Gruaud, who owned the château in the 18th century, used to stand at the top of the tower, not to admire the view, but to keep his beady eye on his employees, whom he considered idlers and tipplers. He appears to have favoured lofty stations, hoisting various flags to denote the quality of his wine each year. The German flag meant a supple wine, the British flag a full-bodied wine and the Dutch flag a combination of the two.

Monsieur Larose – who made up the other half of the château's name – was responsible for the wine's renown in the 19th century. He sought to create a fashion for it among the aristocracy, devising a motto which was still printed on the label as recently as the early 1980s. It was '*Le roi des vins, le vin des rois*' (the king of wines, the wine of kings). There was gentle disagreement about the aptness of the motto. Some argued that a king of wines should have body and opulence, that Gruaud-Larose was delicate and elegant, with too refined a bouquet. Others compared it to the music of Vivaldi.

Since Désiré Cordier acquired the estate in 1936, the wine's prestige has increased still further, due more recently in part to Cordier's association with the brilliant oenologist Georges Pauli. His use of canopy management to obtain late harvests and belief in minimal intervention in winemaking have taken Gruaud-Larose to first-growth standard.

The French conglomerate Alcatel Alsthom bought Château Gruaud-Larose in 1993, largely as a hobby for its chief executive, Pierre Suard. That said, it both renovated and innovated, building a wastewater treatment plant. Between five and ten litres of water are required to render one litre of wine. It was felt that it was high time measures were taken to safeguard groundwater sources and, by the same token, vine roots. Jacques Merlaut is the new owner of the estate, but Georges Pauli, also mayor of Saint-Julien, pursued his drive to persuade *grand cru* growers in the appellation to use recycled water. In 1998 they agreed.

The collection of Gruaud-Larose vintages contains a selection of rare bottles, some of which date back 150 years.

Overleaf: Jacques Merlaut got quite a bargain in 1997 when he bought Gruaud-Larose from Alcatel Alsthom, whose new CEO was anxious to dispose of what was essentially his predecessor's hobby. The château was restored, the park had been renovated, and there are now new barrel-ageing cellars housing 2,400 barrels of wine from 600,000 vines.

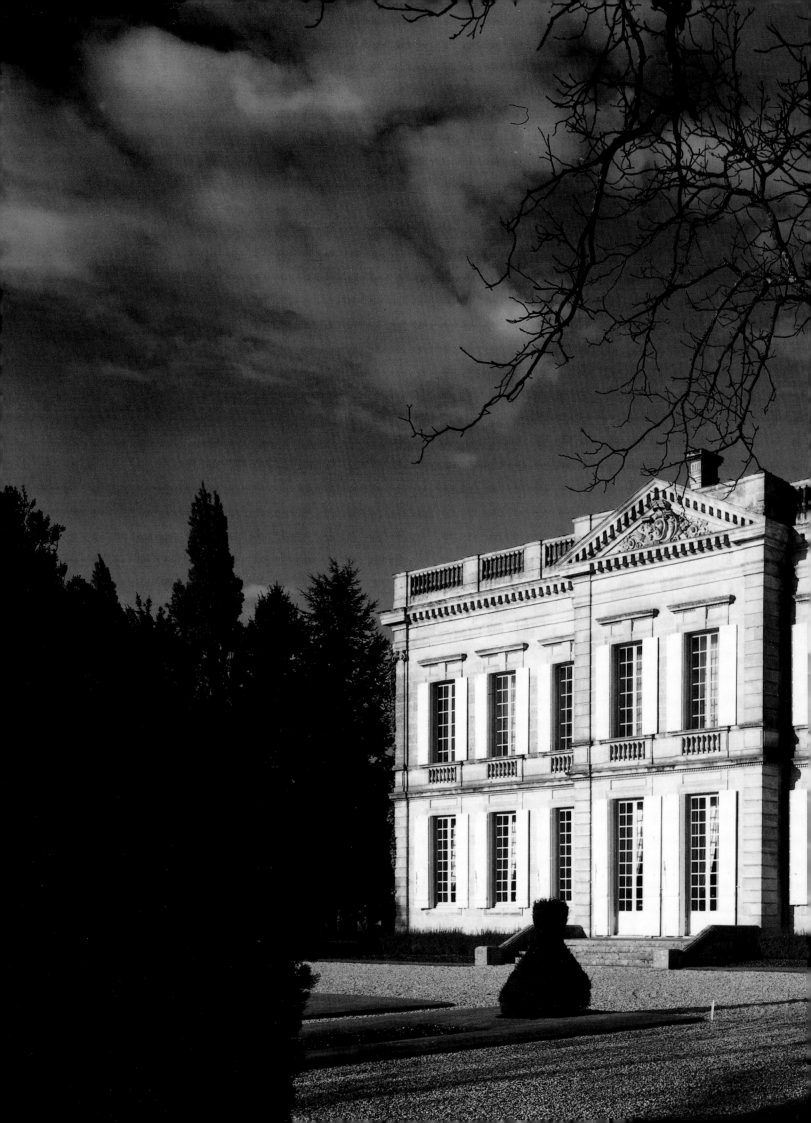

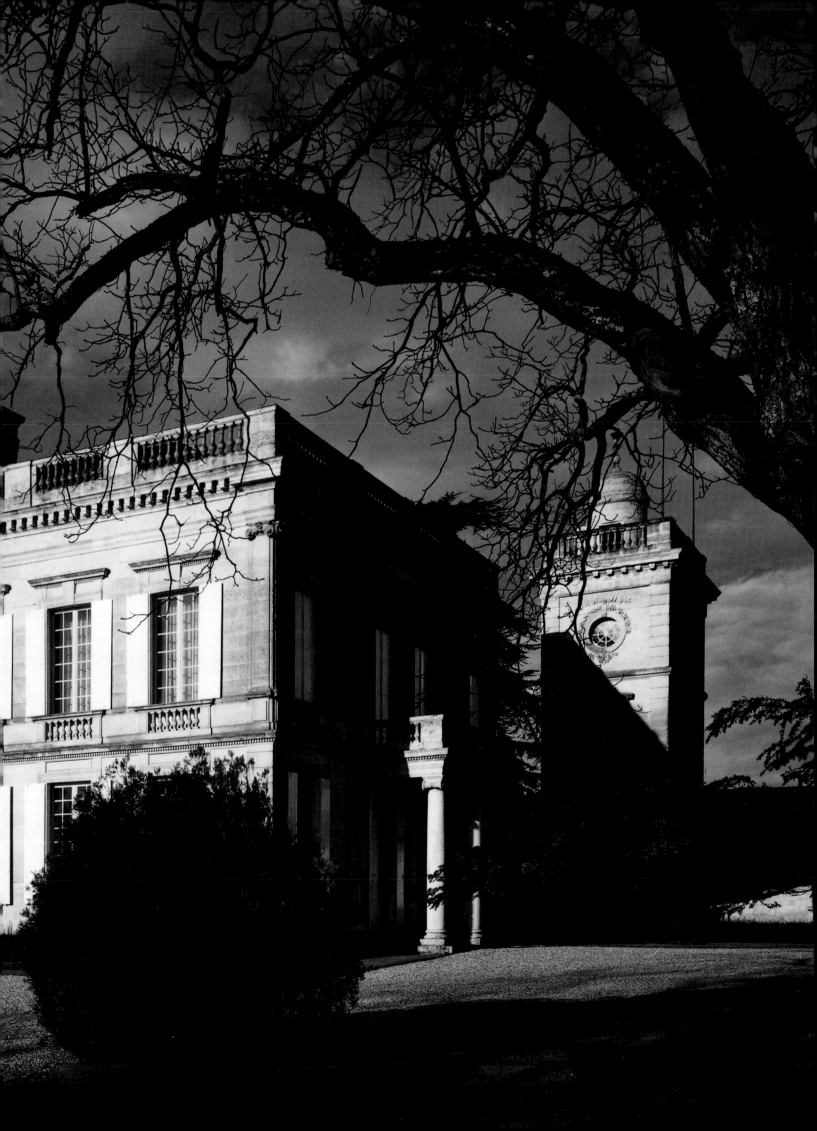

LAGRANGE

Château Lagrange has not always been held in the esteem it has earned since its acquisition and improvement by a Japanese company. Yet the fine concentration of the 1986, 1989, 1990, 1995 and 1996 vintages is a match for the best Saint-Julien châteaux.

Over the plateau of St. Julien one quiet, chilly morning in December 1983 there rose a red sun: it was the Japanese flag, fluttering from the tower at Château Lagrange. The largest wines and spirits company in Japan, Suntory, had decided to move into the Médoc. This caused some concern to the conservative Bordeaux wine world, while the French establishment worried about even more of the national heritage being sold off. Who had allowed the property to fall into foreign hands? The Cendoyas – a Spanish Basque family who had owned Château Lagrange for almost 60 years.

Quarrels over ownership of the property had compounded deepseated financial difficulties. The Cendoyas had invested little for decades and upkeep of the estate was beyond their means. The wine of course had suffered, becoming thin, dull and charmless. The Cendoyas jumped at the generous offer Suntory made.

Prophets of doom spoke of the French winegrowing heritage being swamped by big business from abroad. Eighteen years on, Suntory is still the only Japanese owner of a Médoc *cru classé*, and one of the only two foreign proprietors – the other being British brewer Bass Charrington (see *Château Lascombes*).

The wine, meanwhile, has improved beyond measure. Suntory was wise enough to seek the expert guidance of the great Emile Peynaud and advice from Michel Delon, who nurtured his Château Léoville-Las Cases to first-growth quality. It also took on an eminent oenologist, Michel Ducasse, to run the estate, and put marketing in the hands of Bordeaux wine merchants. The 1983 vintage was the first for which the new team took charge of selection and barrel-ageing; it earned plaudits like 'concentrated', 'delicately oaked' and 'promising'.

Suntory overhauled the vineyard's drainage and installed some 50 double-walled vats with heat exchangers and a 120-yard long barrel-ageing cellar with automated temperature control, the first of its kind in the Médoc. With the 1985 vintage, rendered in the new cellars, came words like 'deep colour', 'dense', 'fat', 'chewy', 'blackcurrant', 'supple' and 'balanced'. Château Lagrange had recovered its lustre.

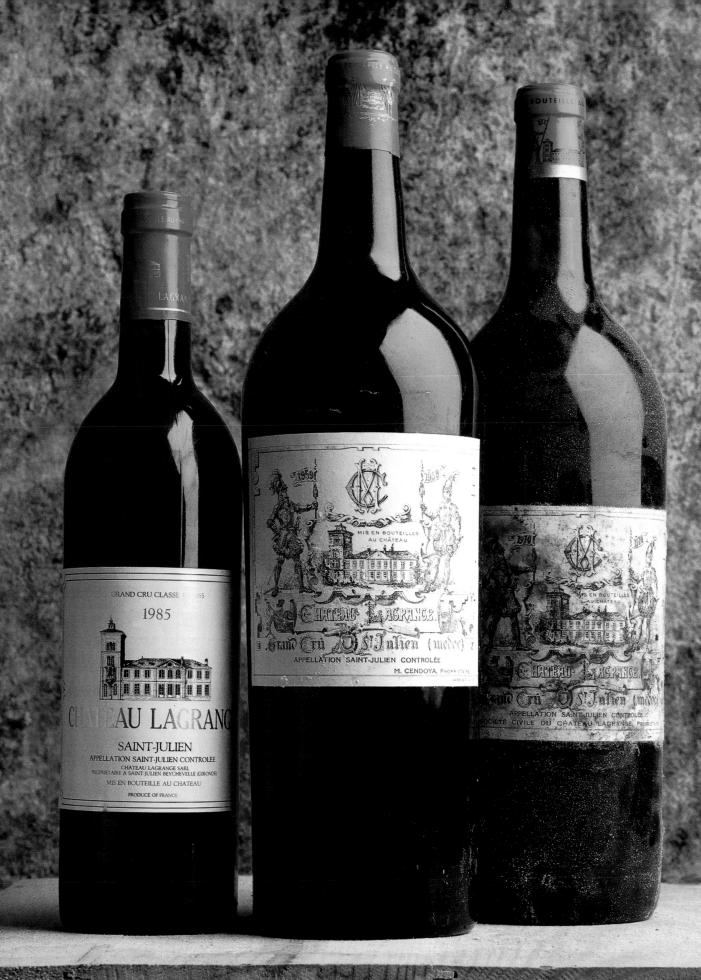

Like their wines, the châteaux of the Médoc are often the result of a mix of ingredients. But do they blend? Lagrange's château is a cross between Louis XVI and neo-Palladian Tuscan. Suntory invested heavily in the restoration of the château.

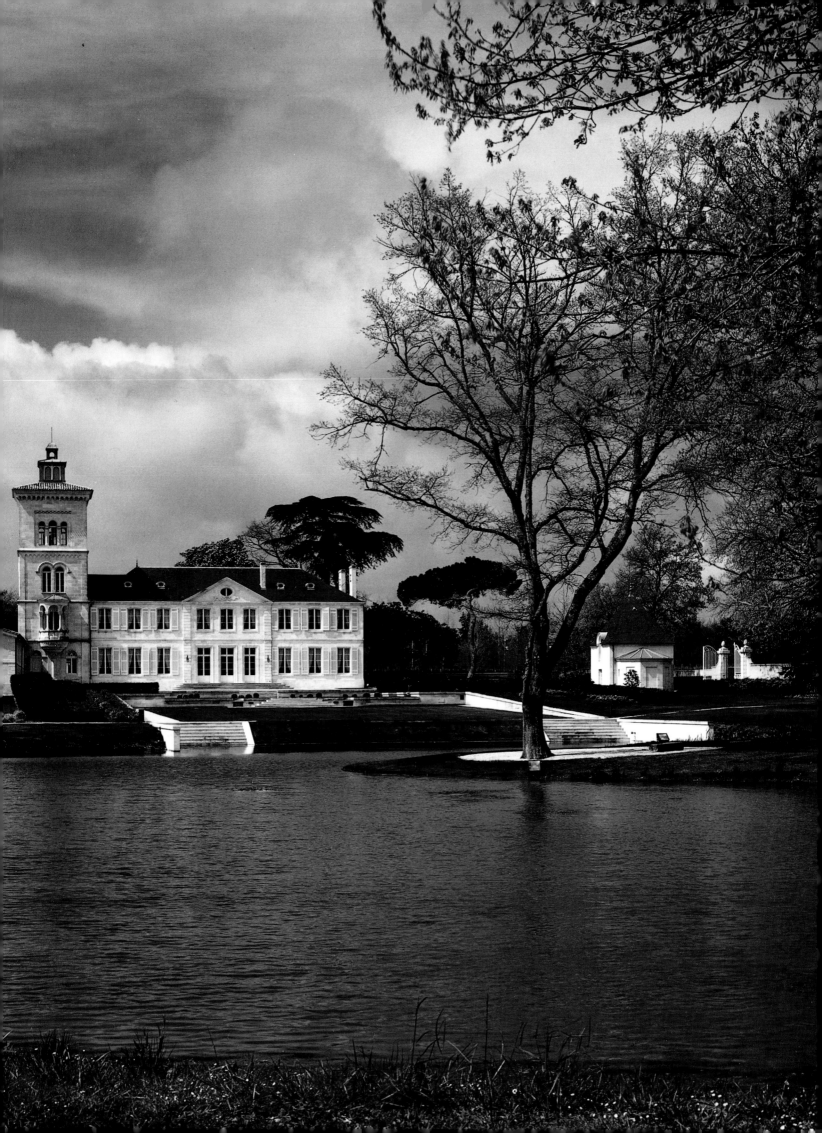

TALBOT

Château Talbot was named after John Talbot, Earl of Shrewsbury. He had his headquarters at the château prior to losing the Battle of Castillon in 1453 and giving France victory in the Hundred Years' War. Legend has it that, sensing defeat, he buried some priceless jewels in the château's cellars.

But Château Talbot has another treasure – its vineyard, owned and carefully husbanded by the Cordier family and their technical director, Georges Pauli (see *Cantemerle* and *Gruaud-Larose*). They add organic and mineral fertiliser to enrich the gravelly soil and practice canopy management, while Nancy and Lorraine – who succeeded their father Jean in 1993 – have laid a new drainage system. The result is vines with an average age of 35 years, high yield (despite low proportions of Merlot) and later harvests than at other St. Julien châteaux.

The spotlessly clean winery is built for abundant harvests. Its 25 vats each have a capacity of 16,000 litres (4,228 gallons), while the new wine is aged in giant 4,000-litre (1,057-gallon) barrels called *foudres*. Each vat is tagged with the grape variety, vine age, vineyard parcel and alcoholic strength of its must. The Cordiers, Georges Pauli and the cellar manager carefully taste all the musts and press wines to build the right *assemblage* (blend).

The ideal end product is marked by supreme balance, elegant bouquet, refined fruitiness and an unusually supple tannic feel. Some connoisseurs detect 'a hint of farmyard' and 'stable-like scents'! High praise, indeed, in the wine world, which means Château Talbot deserves much better than its fourth-growth ranking.

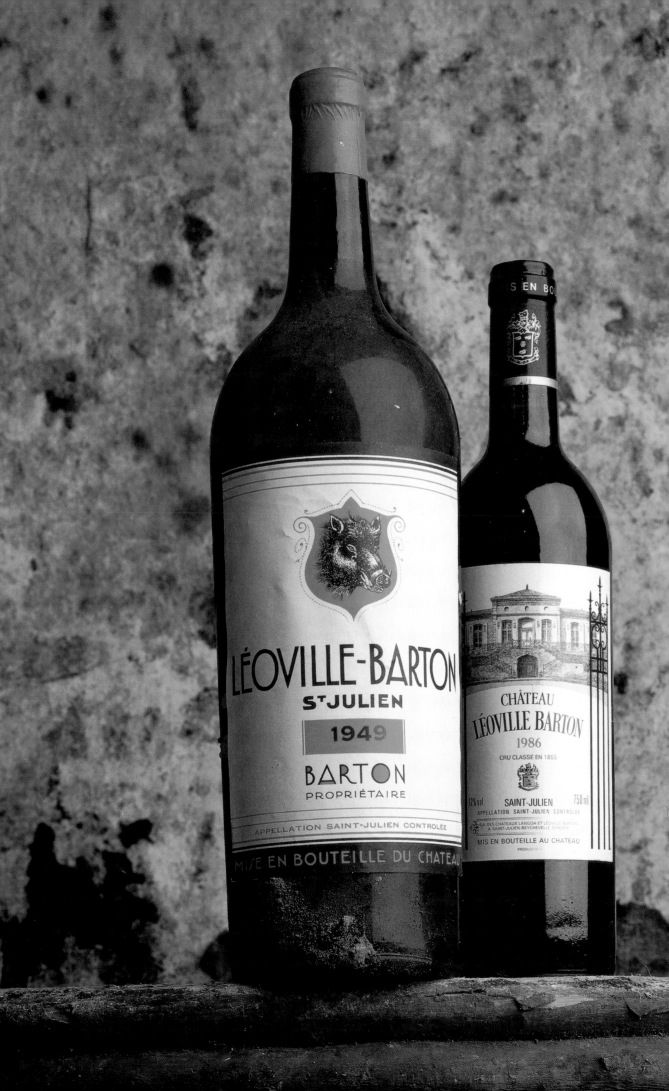

LÉOVILLE-BARTON

Léoville-Barton is a grandiose wine which sells for reasonable prices, a practice which is not merely honest, but dignified, too. The 1997 vintage will be similar to the 1995, with a strong structure and a stewed fruit mouthfeel, characteristics shared by the remarkable 1985.

There is no château at Château Léoville-Barton. There is neither winery nor cellar. There is a vineyard. Before the French Revolution, the vineyard was a part of a vast domain called Léoville, much of which belonged to the De Gasq family. In the aftermath of the Revolution, the estate was confiscated. Jean de Lascases, a De Gasq, bought back three-quarters of the Léoville domain, while Hugh Barton, who belonged to an Irish family that had settled in Bordeaux in the 18th century, bought the remaining quarter in 1826. It consisted exclusively of vineyards. Five years earlier, however, he had bought the nearby Château Langoa, complete with winery and château. It is at Langoa that both Château Langoa and Château Léoville-Barton are aged and bottled to this day. They are kept well apart, of course, as each grows in different soil and has its own distinctive character. Léoville, a second growth, is generally acknowledged to be superior to third-growth Langoa, although a tasting of all the 1967 Saint-Julien vintages saw Langoa ranked second-best and Léoville-Barton only sixth.

The current owners of Léoville-Barton are Anthony Barton and his daughter Liliane. They perpetuate the family tradition of a firm, pithy belief in the traditional approach to winemaking and scorn for trends. when Anthony says, 'Where grapes come from is more important than what's in them', he is criticising extraction methods which wring from grape skins their tannin, colour and flavour. When he says 'walls don't make wine', he is alluding to over-sophisticated, oversized wineries. His uncle, Ronald Barton, who ran the estate prior to him, shared similar ideas. He described oenologists as 'doctors for sick wines' and deplored the infatuation with supple wines which has led to the widespread planting of the high-yield Merlot grape.

The Bartons place their faith in allowing a wine to age naturally until it reaches full maturity. Their wines are fermented in oak casks, then allowed to develop for two years in new barrels. They are fined with egg-white and there is never any sediment to filter. Once the wine has been bottled, it is left to evolve at its own pace – a slow one, as Léoville-Barton has a very high proportion of Cabernet in the vinyards. Ronald Barton used to recall that his grandfather died in 1927 saying the 1870 vintage was still unfit to drink: after nearly 60 years, it was still not mature enough for him.

On refusing a mind-boggling offer to buy the property, Anthony Barton quipped, 'You'd have to be mad to turn down an offer like that. Unfortunately, I am mad'.

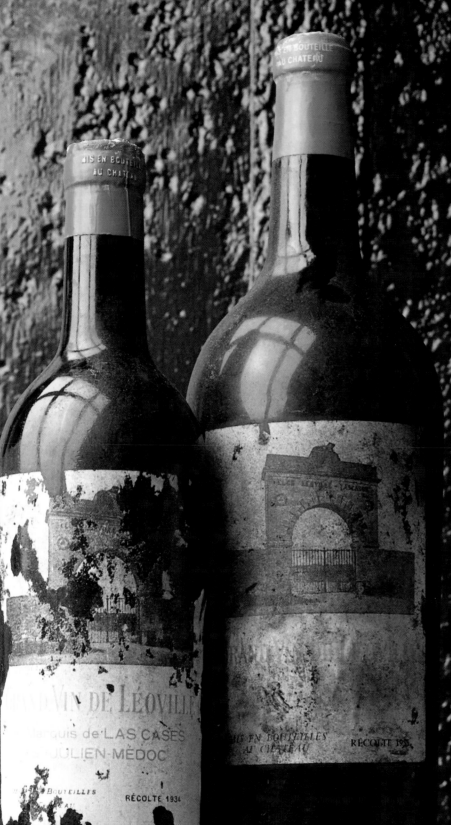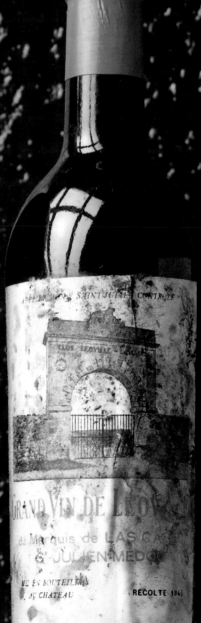

LÉOVILLE-LAS CASES

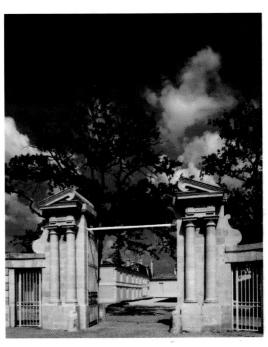

Left and above: Léoville-Las Cases is known as 'the Great Léoville', a plaudit it deserves for its full body, its richness and the headiness of its fruit aromas. Exceptional wine is no exception at Las Cases, it is the rule laid down by the administrator, Michel Delon. This is a claret which remains unique even though it shares its winery with Léoville-Poyferré.

Overleaf: the Las Cases vineyards lie on the very edge of the St. Julien appellation. They cover an area of over 100 hectares (250 acres) between the D2 'wine road' and the Gironde. Its proximity to the water enabled it to withstand the frosts of 1991 and the even harsher ones in 1956. Europe's largest estuary (72 kilometres long and between three and 12 wide or 45 miles long by two to seven and a half miles wide) regulates temperature ideally.

Three estates now make up the former domain of Léoville (see *Château Léoville-Barton*). They are Léoville-Las Cases, Léoville-Barton and Léoville-Poyferré. Of these the largest is Léoville-Las Cases, which stretches from the edge of the town of St. Julien to the fringe of Château Latour. Driving north from St. Julien towards the Pauillac *appellation*, visitors know they have reached Léoville-Las Cases when they see its monumental gate, a landmark in the Médoc region. The gate is the entrance to the larger vineyard, the *Enclos* (enclosure), so called because it is entirely surrounded by a wall.

The *cuvier* was built as an extension of a wing of the château and houses traditional oak vats, the capacity of each roughly equal to the quantity of grapes picked in one day. Stainless steel vats have now been installed to supplement rather than replace the old oak ones. The *chai*, where the new wine is aged in barrels for up to 20 months, is on the other side of the road. The ageing-barrels are renewed only every three years, as experience has shown that Léoville-Las Cases clarets which develop in new barrels have an over-emphatic oak taste.

Though nature cannot be improved upon in a good year, some practices can help to add a little to wines affected by poor weather. Chaptalisation – named after its inventor Jean-Antoine Chaptal (1756-1832) – is one such technique. It consists of adding sugar (beet sugar or grape syrup) to the must (fermenting juice) in order to increase its alcohol content and bring the wine's acid levels into balance. Put simply, chaptalisation makes a wine less thin. Léoville-Las Cases does use the technique, although sparingly, and not in great years like 1975, 1982, 1989 and 1990. It does practise stringent selection on a regular basis, and went as far as to discard half of 1991's harvest and declassify 60% of the crop in 1995.

Such an approach results in wines like the near-perfect 1970 – rich, intensely coloured, robust and long – and the perfect 1982 which was… well, perfect, earning the accolade of a 100 point rating from Robert Parker. It is easy to see why Léoville-Las Cases is considered an honorary first growth and is dubbed *vice-premier cru*. Although unlikely to gain official *premier cru* status, it already achieves *premier cru* prices.

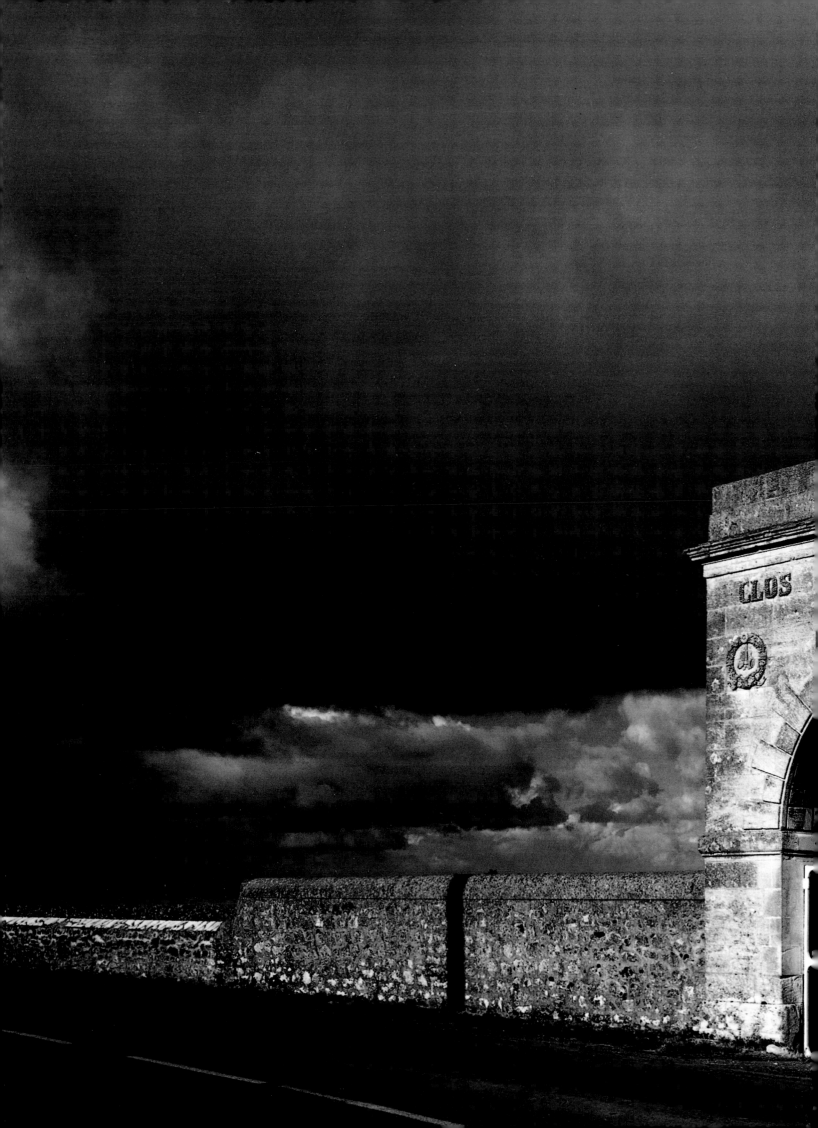

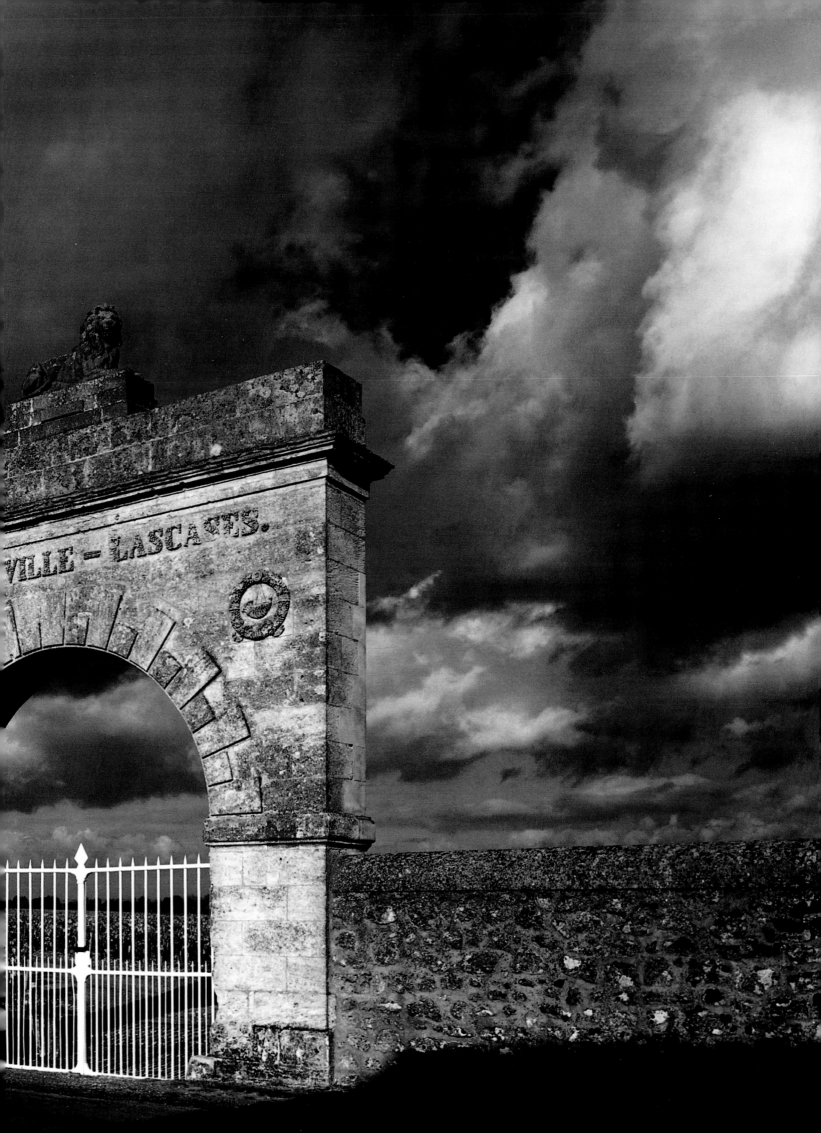

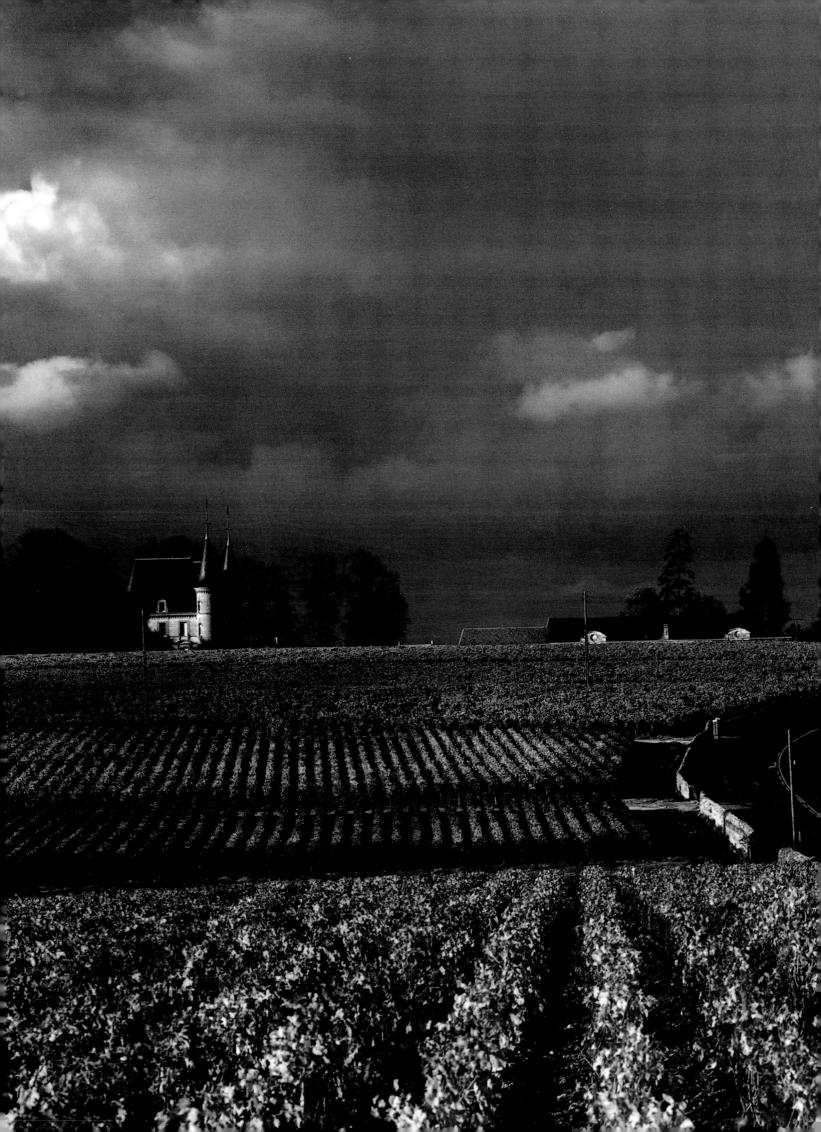

Appellation PAUILLAC

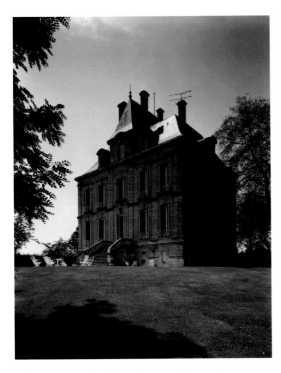

Above: a stately, though somewhat petit-bourgeois, home which has no particular charm. It is here that the current owner – François Pinault, who also owns the Parisian department store Printemps, and mail-order firm, La Redoute – stays on his visits to the property.

Left: the fortune of Château Latour rests more in the hands of the estate's manager, growers and winemakers than in those of its owner. The long-maturing Latour is a wine worth waiting for, one which never disappoints. The coffee- and chocolate-scented aromas of the 1991 vintage make it hard to believe that there were frosts that year.

Château Latour is one of the three Pauillac wines in the select band of five *premier cru* wines. Young Latour is heavy and hard, but matures to become vigorous, rich, firm and tannic – a process which never takes less than 15 years. Of all four Médoc first growths it is the most muscular. Were your wildest dream to come true and you found yourself at a gourmet meal serving all four, you should drink them in this order: Margaux, Lafite, Mouton-Rothschild and, finally, Latour.

The tower (*la tour*) which gives the property its name was part of a medieval fort built to ward off marauding pirates. Restored under Louis XIII, it remains as it was in his day. Montaigne, the great French 16th-century essayist – and Bordeaux winegrower – writes about the renowned Château Latour in his *Essais*. At the end of the 17th century, Latour became a jewel in the crown of the 'Wine Prince' Ségur, who also owned Lafite and the Saint-Estèphe château, Calon-Ségur.

Although steeped in tradition, Latour is not traditionalist. As early as 1842, the Wine Prince's descendants took the unprecedented step of creating a company, the *Société Civile Agricole*, to prevent any break-up of the property. When British corporation Allied Breweries bought the property after 300 years of Ségur ownership, it renovated outbuildings, cellars, winery and vineyard, building the first stainless-steel fermentation vats in the Médoc. They are impeccably clean and their thin walls can be sprayed with cold water to cool the must and slow fermentation. Allied Breweries channelled most of its investment, however, into improving and building employees' accommodation – an enlightened approach in conservative Médoc.

Among the time-honoured practices which retain their place is the replacement of vines by a method known as *jardinage* (gardening). Each vine plant is allowed to age until it no longer produces fruit before it is replaced by a new vine. Most winegrowers replant swathes of vines when they reach a set age – 50 to 70 years. By replanting individually, Latour boasts the oldest vineyard in Médoc.

The Latour tradition is impeccable winemaking, a tradition perpetuated by its new owner, François Pinault. To quote the 1998 *Hachette Wine Guide*: 'The French team is as outstanding as the British one was'.

The tower pictured right is not the tower after which Latour is named. The one which appears on bottle labels dates back to the fourteenth century. It was a fortified tower with battlements which, during the Hundred Years' War, was occupied by the French and the English. This one was built in the 18th century to watch over the vines.

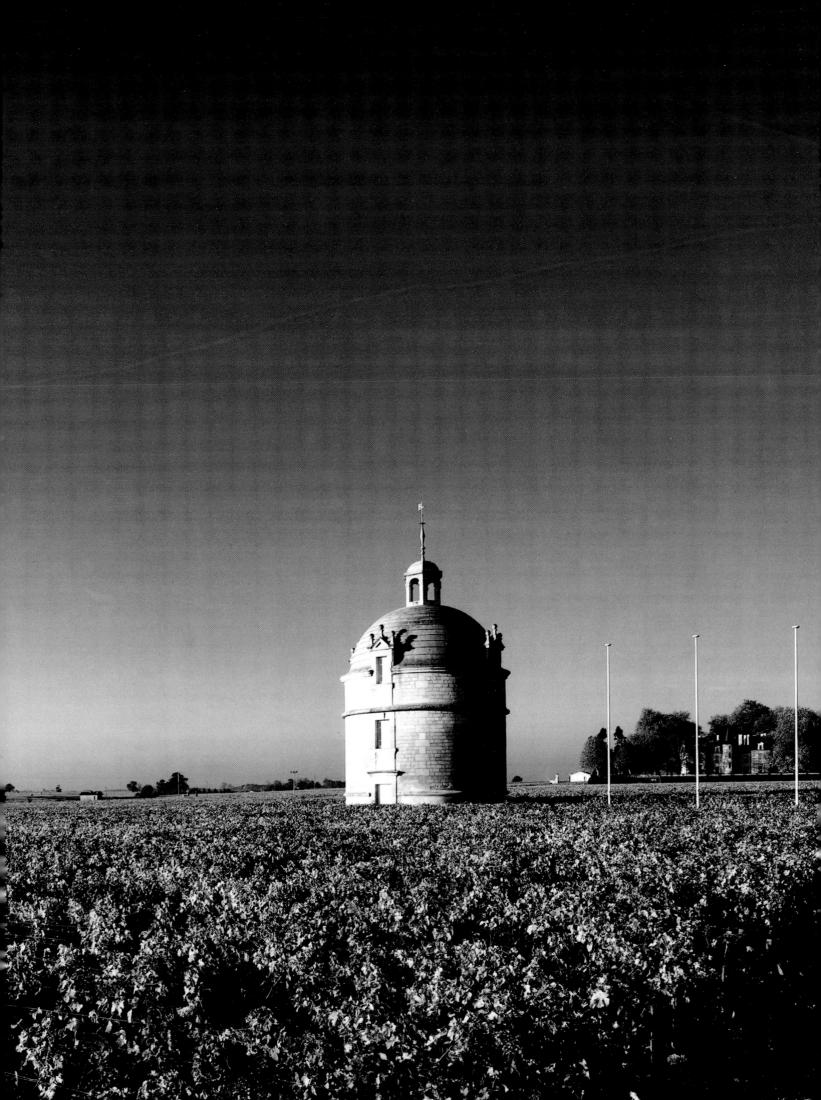

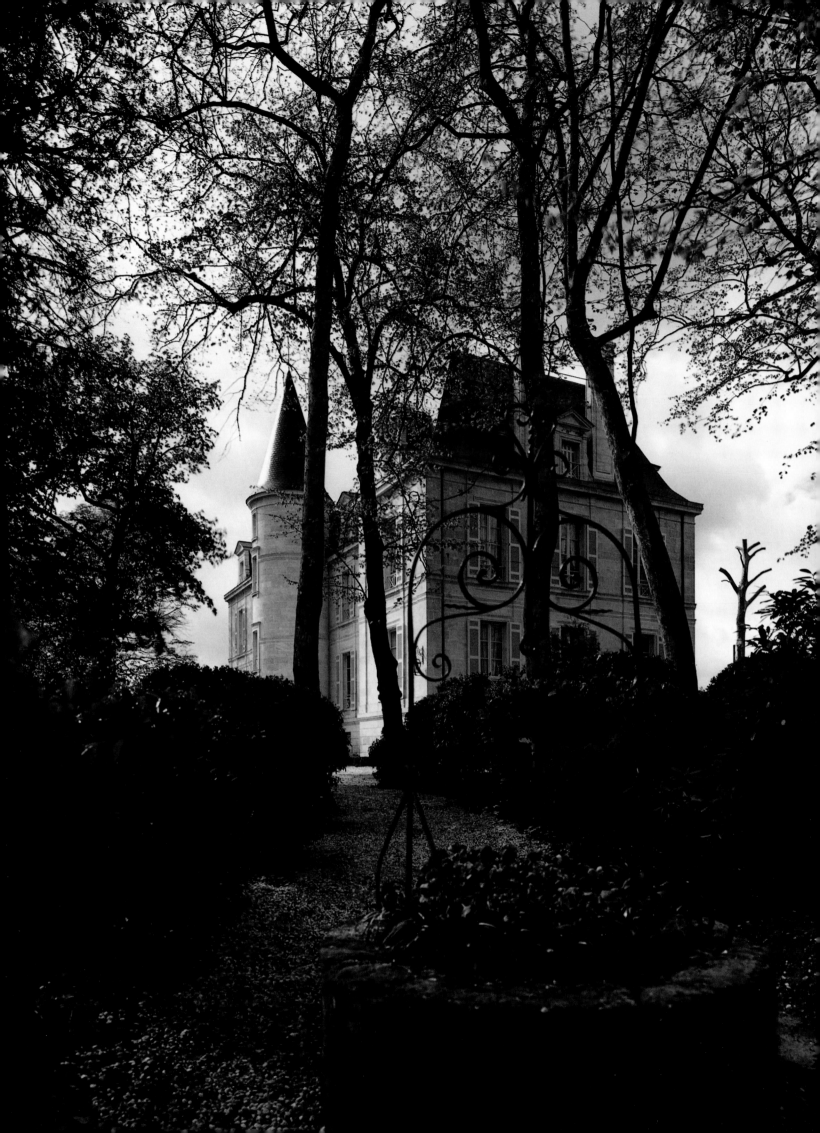

Château
BARON-LONGUEVILLE
—COMTESSE-DE-LALANDE

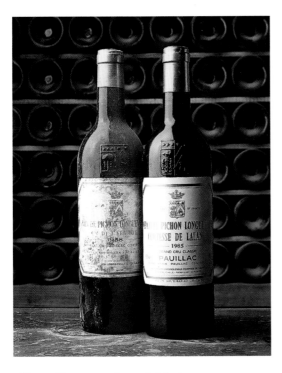

Above: 'I want to leave behind me an unforgettable wine', the Comtesse de Lalande (1794–1882) is alleged to have said. She indeed fulfilled her wish with this second-growth cru classé.

Left: a Médoc château in which someone really lives. A rare occurrence, as rare as the woman's touch which, over the centuries, has been behind the wine. A wine which is round, ripe and supple, but never flattering.

There are two Châteaux Pichon-Longueville – Baron de Longueville and Comtesse-de-Lalande. Pichon-Comtesse (also known as Longueville-Comtesse-de-Lalande) was, as the name suggests, named after a countess – Countess Virginie de Lalande. In the 19th century, Baron Joseph de Pichon-Longueville bequeathed two-thirds of the estate – formerly the enormous Saint-Lambert domain – to his son and the remaining third to his three daughters. His sense of equity doubtless mirrored ideas prevalent at the time, but even now few women play a prominent role in winegrowing in the Médoc. Two of the three sisters died childless, so Virginie de Lalande came into their shares of the property. It is said that she devoted herself to wine with a passion, crafting a soft supple wine reminiscent of the neighbouring St. Julien *appellation*.

Her sister Sophie shared her passionate nature, falling deeply, but unhappily, in love with a romantic painter and ending her days in a convent in Munich. Legend has it that Virginie's better fortune in love explains why the Longueville-Lalande château and park form an enclave within the domain of Château Latour. She is said to have been the lover of one of Latour's owners, who built a château for her in his vineyard. Longueville-Comtesse-de-Lalande's owner lives in the château today, one of the few Médoc winegrowers still to do so. She is May Eliane de Lencquesing, the younger daughter of the estate's previous administrator, and the driving force behind the spectacular revival of Pichon-Comtesse in the past 20 years.

She took over the estate in 1978, giving it a new *cuvier* in 1980. It was followed eight years later by a new barrel-ageing cellar and tasting room. By the early 1980s, she was producing some superb wines that were supple, fruity and smooth enough to be drunk young. As passionate about wine as Virginie once was, May Eliane de Lencquesing has not only turned Pichon-Comtesse into a – some say *the* – premier second-growth, she has become its ambassador. She goes as far afield as Singapore and New Delhi to vaunt the fleshy richness and Merlot-inspired suppleness of her wine.

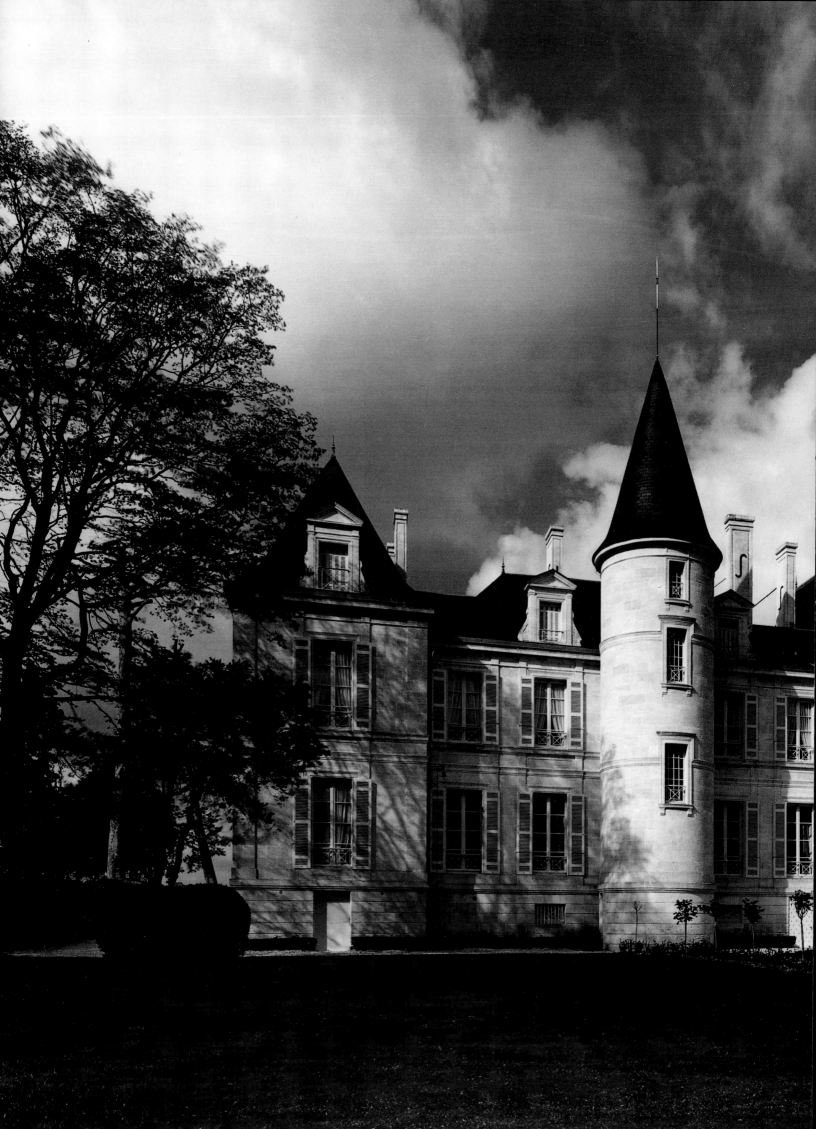

The château stands, shrouded by the trees, in its park. The lines of its roof are sober, those of its rigorously aligned windows discreet. The view from the terrace sweeps over Château Latour and the River Gironde, sources of inspiration and irrigation.

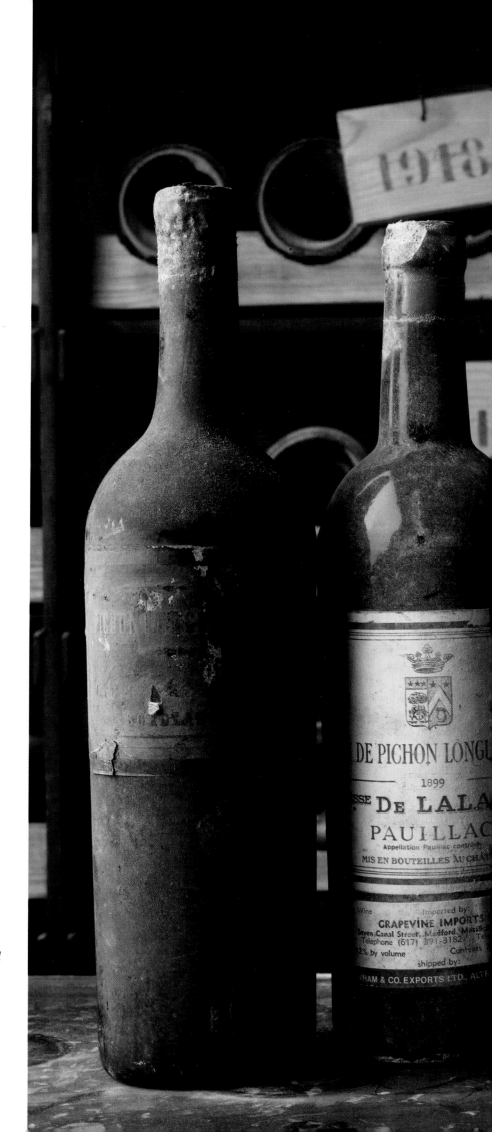

Pichon-Lalande has an unusually high
proportion of Merlot for a wine from the
Pauillac appellation – 35% compared to
Cabernet Sauvignon's 45%. It brings colour and
suppleness, which balance impeccably with the
concentrated flavour and complex bouquet of a
long-maturing wine.

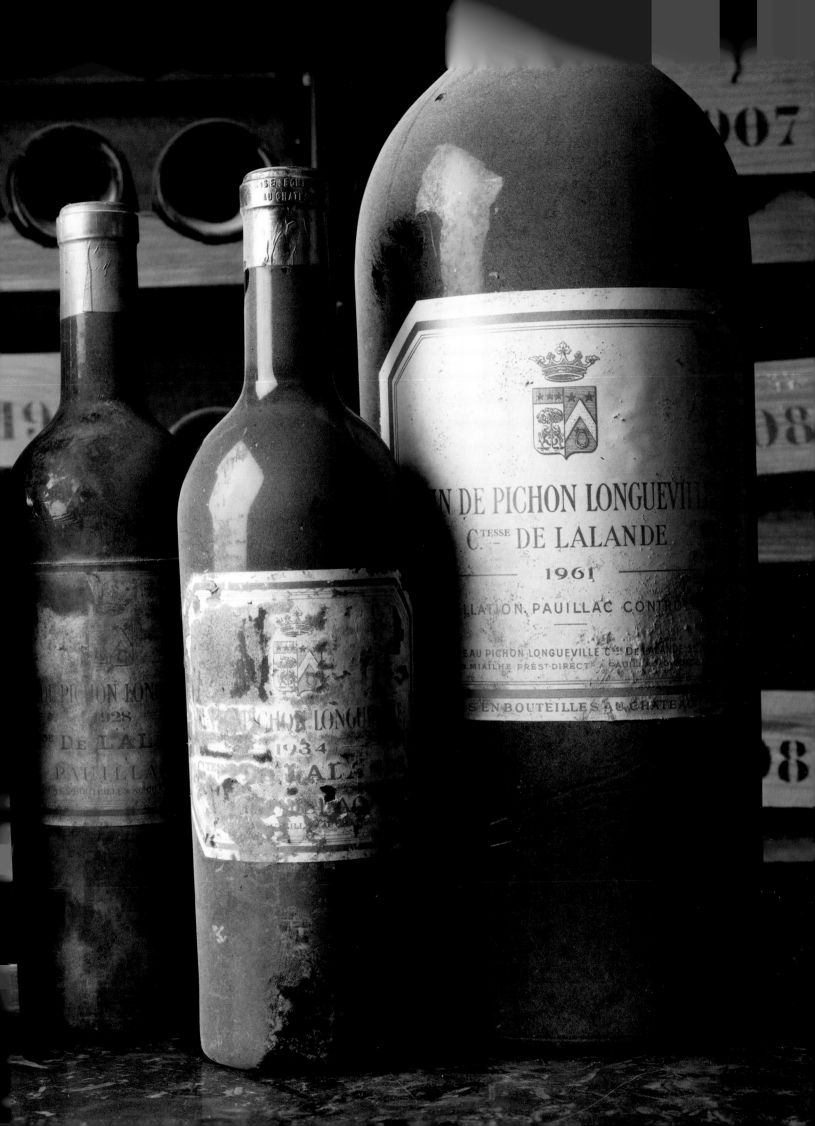

PICHON-LONGUEVILLE–BARON-DE-LONGUEVILLE

The château at Pichon-Longueville (Baron) is a prime example of 19th-century Médoc architecture. With its Renaissance towers and pointed roofs, it is evocative of a fairy-tale castle. Its picturesque charm has not been lost on the estate's owners, the French insurance conglomerate AXA, which bought the domain in the late 1980s. Whereas the previous owners, the Bouteillers, who ran Pichon-Longueville (Baron) for over 50 years, neither lived in the château nor took advantage of its obvious attraction for tourists, AXA has set out to encourage visitors, furthering the estate's appeal as an architectural curiosity with the construction of great and gaudy – some say garish – winemaking facilities. The man behind the new *cuvier* and ageing cellar is Jean-Michel Cazes (see *Lynch-Bages*). He takes visible exception to the criticism: 'The winery is Disneylandish, admittedly', he says, 'but it can cope with 50,000 visitors a year without intefering with the people at work on making a great classified growth'.

But AXA made an astute move in appointing Jean-Michel Cazes to oversee the vineyards and winemaking. A remarkable estate manager, he built the new *cuvier* and *chai* in response to the need for more efficient, cleaner facilities and for greater storage space. The dearth of space was such that even before the Bouteillers began château-bottling their wine, every square inch was used. Thereafter, makeshift solutions had to be found, which perhaps explains why Robert Parker reports having seen bottles stacked, sacrilegiously, in the midday sun at Pichon-Longueville (Baron).

Other improvements in efficiency made by Jean-Michel Cazes include stricter picking and blending selection, a second wine, a higher percentage of new oak barrels and the introduction of filtration. His changes have led to a marked improvement in the wine, with the 1989 vintage being outstanding. Cabernet Sauvignon – there is only 5% Cabernet Franc – accounts for 70% of a wine which, while being robust, intensely concentrated and extractive, is softened by its 25% of Merlot.

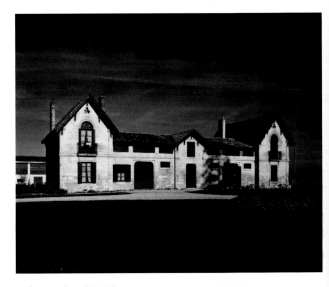

Above: the old 19th-century winery at Pichon-Longueville (Baron) resembled a small provincial factory. It has now given way to the architectural extravagance of the new cuvier and chai. The wine may have improved, but nostalgia is not what it used to be.

Right: wine writer David Peppercorn has described Pichon-Longueville (Baron) as quintessentially Pauillac in comparison to the more feminine wines of Pichon-Comtesse. It is both a rich, finely crafted raw material and the natural expression of the soil which nurtured it.

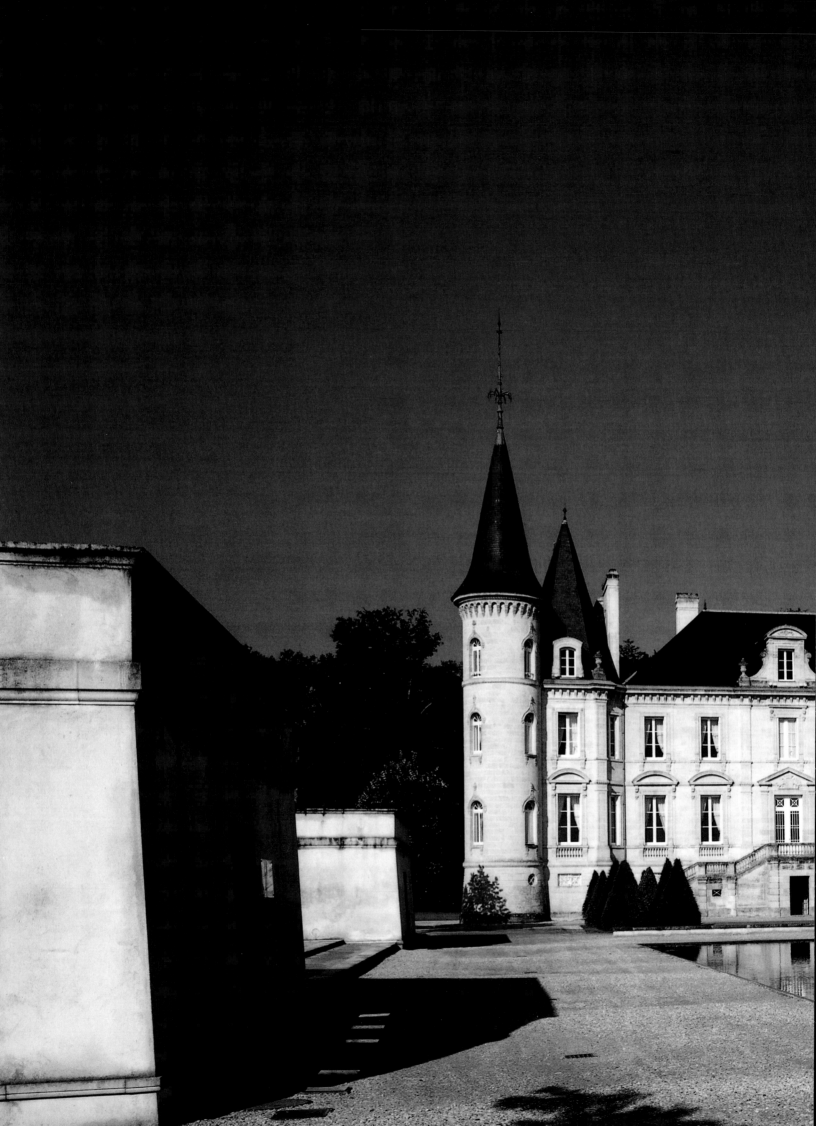

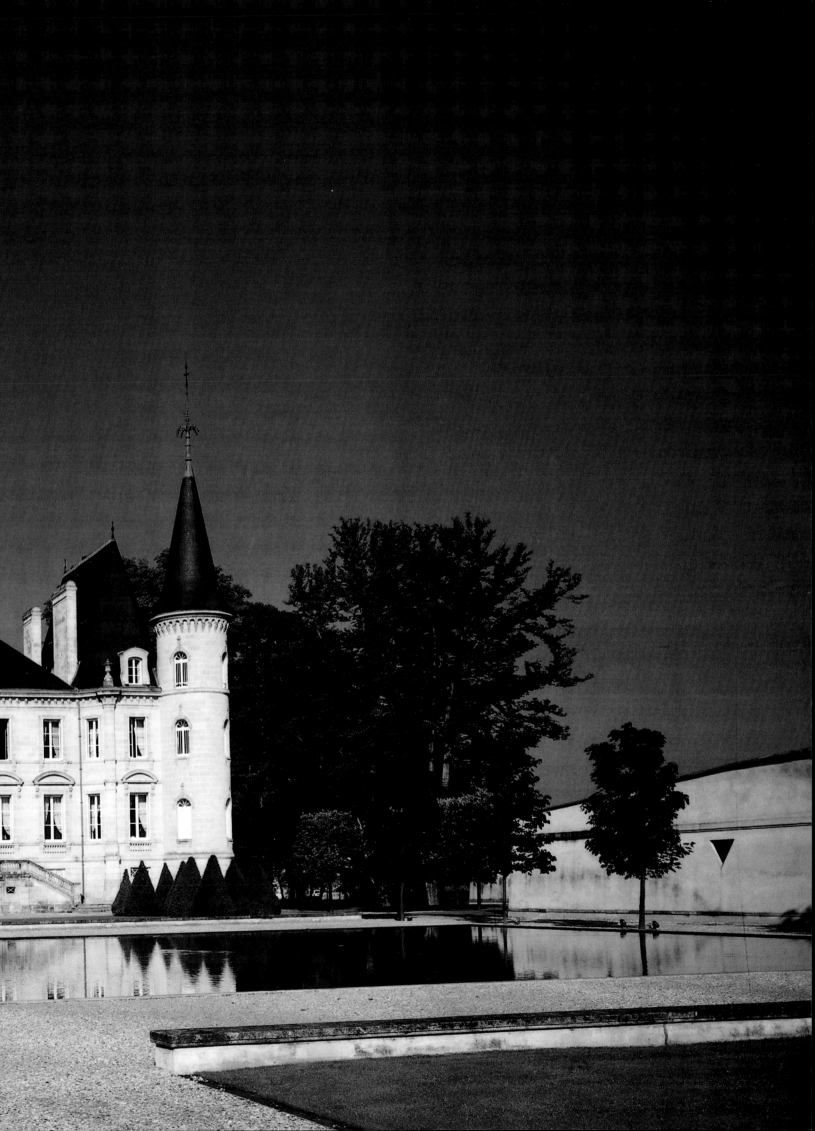

Preceding pages: considered a little too dainty for a baron, the addition of the two sober, solid catafalque-like buildings on either side has made it weightier and more imposing.

Right: built long ago as a vantage point from which to watch vineyard workers, this tower marks the demarcation between Pichon-Baron and Pichon-Comtesse. To the east lie the 75 hectares (185 acres) of Comtesse vines with their high proportion (35%) of Merlot; to the west is the Cabernet Sauvignon-dominated vineyard of the Baron.

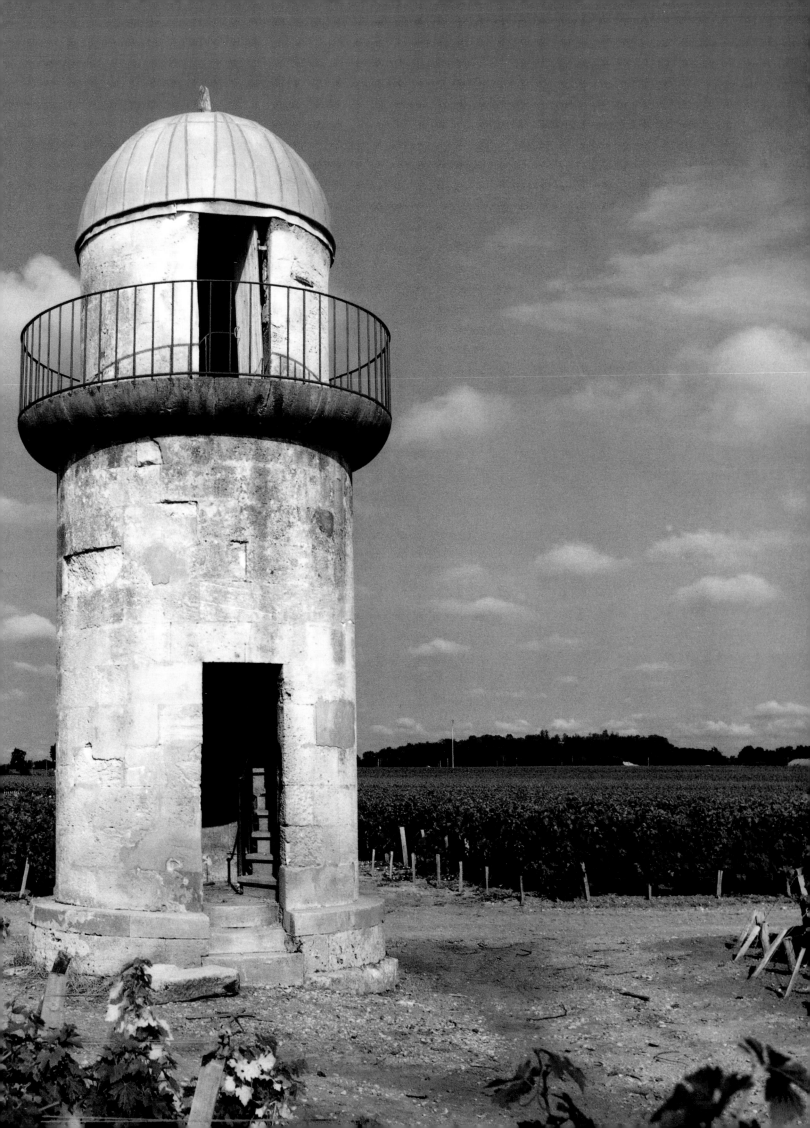

BATAILLEY

Above: the Laspic Tower, a part of Château Haut-Batailley, stands in the middle of the Batailley estate of which it was once part. It is neither part of an old fort nor a lookout tower, but a monument to the Holy Virgin built by a devout believer to protect the vineyard from phylloxera.

Left: stiff, austere wines made for ageing. The young wine has no early appeal, which runs counter to current tastes. But Batailley has often won the battle of ageing with wines like the 1978 and 1982. It will win more with 1995 and 1996 in years to come.

Where rows of vines now stand, ranks of soldiers once fought. The opposing forces were the English army of occupation and the French, who were fighting yet another bloody battle in the Hundred Years' War. Victory went to the French forces, who then overran the fort at Château Latour and razed it to the ground. The name of the château derives from the French word for 'battle'.

It was some 200 or 250 years later that Batailley's first vines were reported. In the early years of the Second Restoration, Bordeaux wine merchant Guestier, who also owned Beychevelle, bought the property. At the time of the short-lived boom in wine speculation in 1929, Marcel Borie bought Batailley. His daughter Denise Castéja inherited the property, and it remains in the family to this day.

The Castéjas live all year round in the magnificent château which, though built in 1750, has undergone such extensive modification that it was truly completed only in 1960. Its rooms exhibit the furniture, Chinese porcelain and Dutch masters' paintings that members of the family have collected. The château's park houses another kind of collection – one of trees which the estate's various owners have brought back over the years from journeys to Asia and Central and North America. One of the cellars has been converted into a reception room tiled with blue delftware depicting scenes from daily life in the 17th century.

Grape varieties are typically Pauillac, with a high proportion of Cabernet Sauvignon. A constant concern at Batailley is to avert the excessive stiffness associated with Cabernet Sauvignon, which has led to some connoisseurs judging Batailley to be robust and tannic, but lacking in poise. Nevertheless, a fully-matured Batailley has a powerful bouquet, fruity palate and is long in the mouth. And while some believe it is worth no better than its fifth-growth ranking, others say it was unjustly deprived of a higher place because it lies too far from the River Gironde.

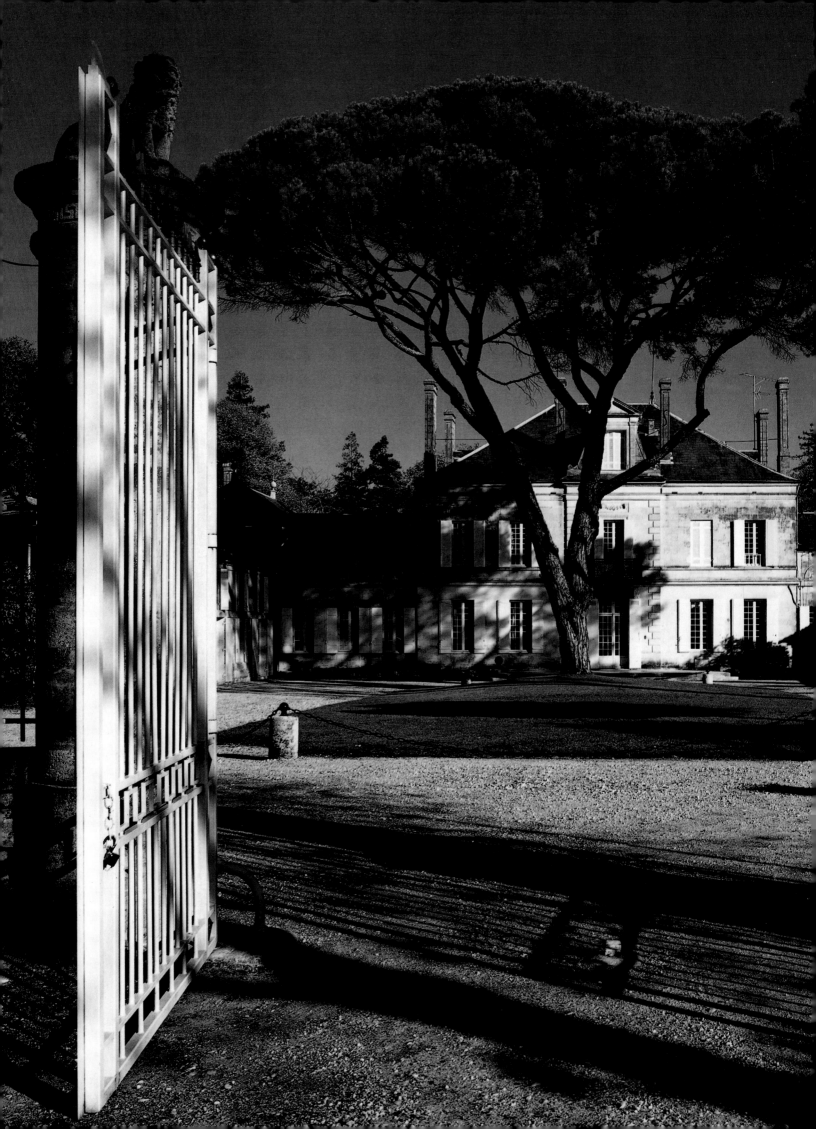

In the 150-year-old park designed by Napoleon III's landscape gardener, Barrillet-Deschamps, the elegant residence of the Castéja family erases all memory of the bloody battle which gave the property its name 500 years ago.

GRAND-PUY-LACOSTE

Grand-Puy-Lacoste is a fifth-growth *grand cru*, whose vineyard lies on the Bages Plateau, one of the highest points in the Pauillac appellation; hence its name: *puy*, or 'rise', in old French. It is one of the few properties in the whole of the Médoc which has been neither divided nor broken up in any way since the classification of 1855.

Only two varieties of grape are grown – Cabernet Sauvignon and Merlot. In 1997, the Merlot grapes at Grand-Puy-Lacoste flowered early, reaching full bloom earlier than ever before this century. Growers like flowering to be as swift and early as possible – once the Ice Saints days on May 11 to 13, have passed – so that the grapes can ripen fully in the allotted 105 to 110 days before picking begins.

Owner Xavier Borie renovated the dilapidated old cellars in 1982, replacing the unsanitary oak vats with steel ones. Ageing of the newly fermented wine – what the French call *élevage*, or 'bringing wine up' – takes place in new or nearly-new barrels for between 18 and 24 months. Monsieur Borie has also introduced later harvesting, which has resulted in powerful, full-bodied wine with blackcurrant fruitiness. Wine-lovers in the 19th century ranked it more highly than did the 1855 classification. It is an opinion many share to this day.

LYNCH-BAGES

Château

Left: this classified fifth-growth wine is sold for the same prices as second-growth châteaux of which it is the equal. The well balanced, complex and refined 1996 with its good tannic texture will mature to reveal both density and suppleness.

Overleaf: the Cazes family use the Lynch-Bages property as a testing ground for the winegrowing and winemaking experiments which oenologist extraordinaire, Jean-Michel Cazes, implements at the other properties he manages. He is assisted by another virtuoso, cellar master Daniel Llose, who makes the wine.

The Cazes family have owned Château Lynch-Bages for some 60 years – not yet as long as the 74 years that it belonged to the Lynch family, who gave the wine the first barrel in its name. The Lynches, an Irish family who fled religious persecution in the late 17th century, settled in Bordeaux, making their mark on both winegrowing and politics in the region. In 1750, Thomas Lynch married into ownership of the Bages estate, which thus became Lynch-Bages. The family owned other properties, one of which, Château Dauzac (a Margaux *grand cru*), belonged to Jean-Baptiste, president of the Bordeaux Parliament before the French Revolution and mayor of the city in its aftermath.

Sometimes belittled as the 'poor man's Mouton-Rothschild', Lynch-Bages has, in the accomplished hands of brother and sister, Jean-Michel and Sylvie, become an outstanding wine in its own right. The 1997 Paris-Singapore wine awards placed it ahead of all the great *premiers crus*, while another Cazes wine, Les Ormes de Pez, was voted the best 1994 vintage *cru bourgeois* (a term forged to designate the next class of wine 'down' from the *grands crus*).

To what does Château Lynch-Bages owe its quality? The estate's vines are relatively old and yield is kept deliberately low, unusual when Jean-Michel Cazes is at the helm. He is renowned for high-yield vineyards and an unabashed use of modern processing techniques to produce commercially and aesthetically pleasing wines. Yet here on his own property, vinification is classic, with the exception of the extraction method used: the cap (the thick crust of skins and pips which floats to the top of the fermentation vat) is not held under the surface of the wine, but immersed briefly and repeatedly. The result is a wine which is firmly tannic but not overly extractive. The *cuvaison* period is quite short, so, although the Cabernet grape dominates, the wine is fruited and can be drunk after five to six years. In fact, a young Château Lynch-Bages can be rather flattering and fade in its maturity. Generally, however, this full-bodied, rounded claret with a rich palate is a perfect illustration of how sorely the 1855 classification needs revising.

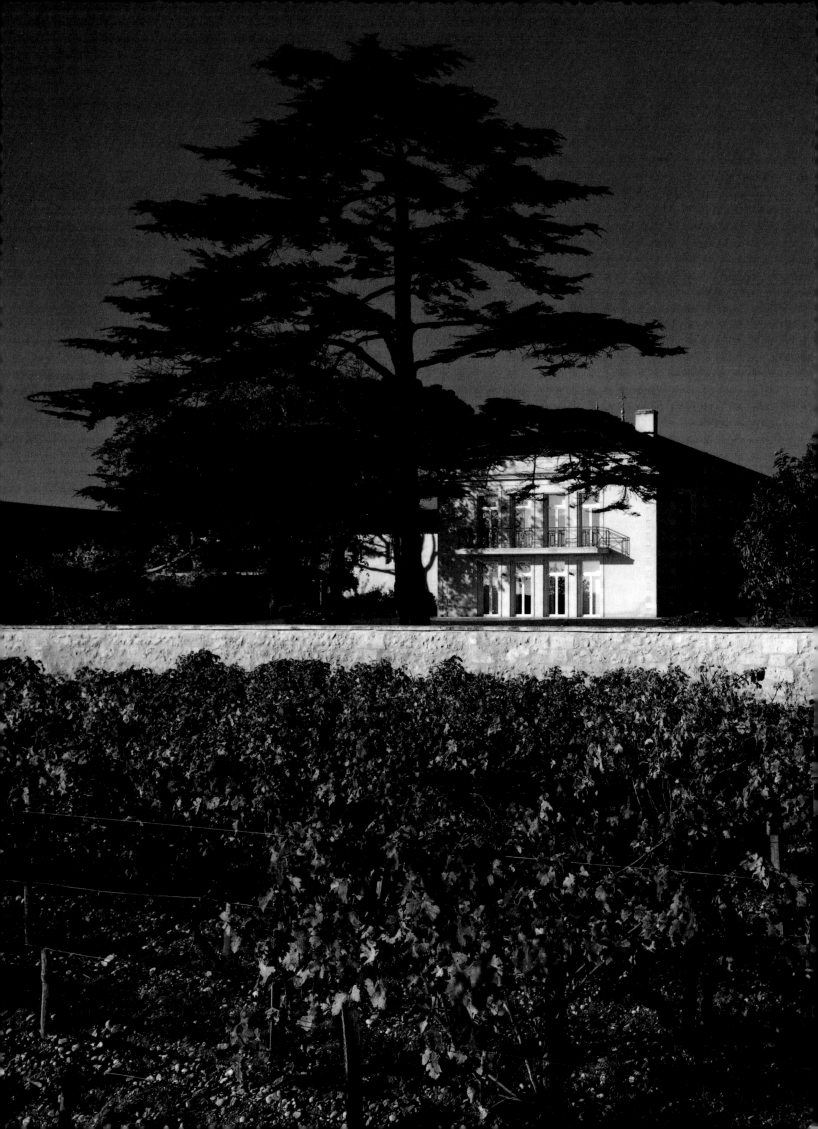

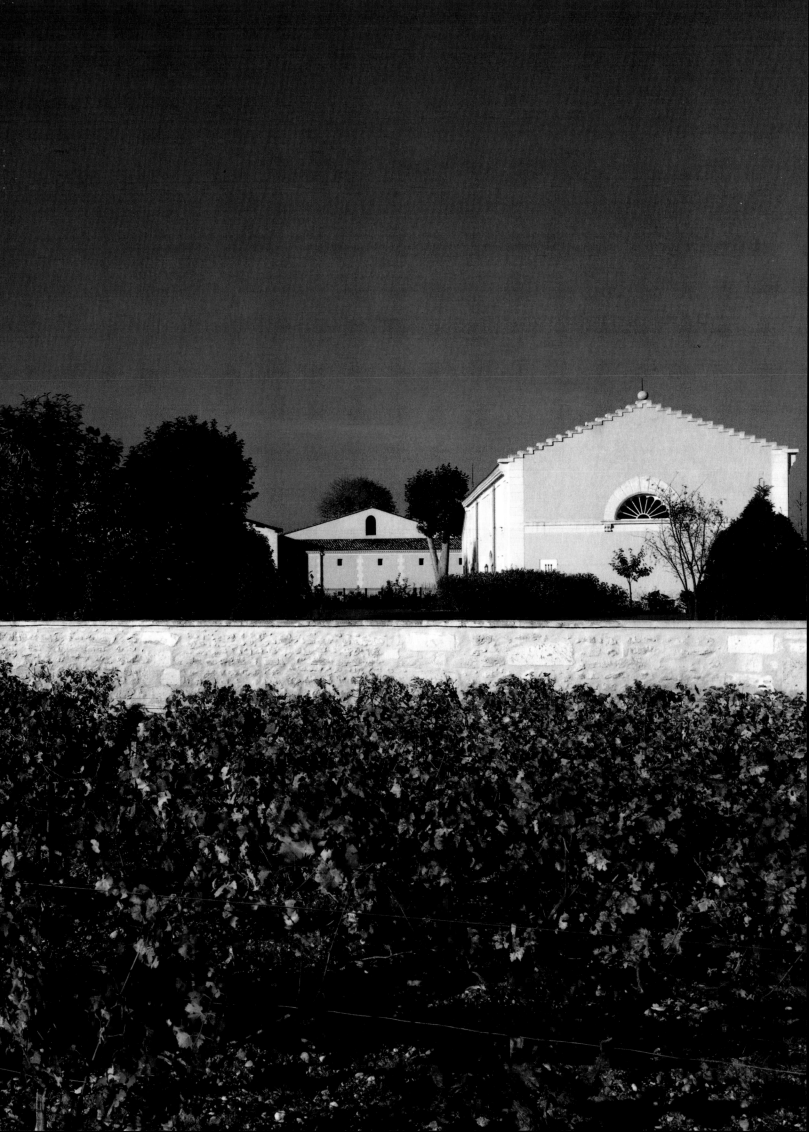

PONTET-CANET

hâteau Pontet-Canet is famed for its cellars. The *chai* in which the wine of the year is developed is cathedral-like, while the deeper cellar can contain up to 1,200 casks – a capacity equalled only by Mouton-Rothschild, Beychevelle and Lafite. Between the *chai* and the underground cellar is the employees' wine store: the sheer number of barrels is a reminder that wine is part-and-parcel of daily life. In other words, a wine-drinker is not a heavy drinker.

For over a century (1864-1975) Pontet-Canet was the pride of the glittering Cruse family, also owners of a third-growth Margaux, Château d'Issan. It was also long associated with the golden age of railway dining cars as the fine wine at the top of the list. Although some of Bordeaux's more unforgiving critics scoffed at this 'Railway Pauillac', it was recognised as the best of the fifth-growth wines and the equal of some second growths. Some connoisseurs, like wine writer Maurice Healy, felt it sometimes reached the dizzy heights of first-growth wines, while others maintained that if Mouton-Rothschild could petition for reclassification, then so should Pontet-Canet.

There was another body of opinion, however, which argued that its reputation, tied up with the prestige of the Cruses, was overblown. After all, the Cruses did not bottle their wine on the estate. That was done either in their riverside cellar in Bordeaux or by London wine merchants. Admittedly, some bottles were superb, but there was too much variation. Wines were sometimes oxidised or stale, while tastings revealed a lush bouquet but poor finish.

The slump in the price of claret and the Cruses' implication in the sombre Bordeaux wine affair was a blessing in disguise for Pontet-Canet. The Cognac merchant Guy Tesseron bought it in 1975. He renovated the property and replanted the vineyard. In the last four to five years the new Pontet-Canet has come of age with powerful, supple vintages like those of 1995 and 1996 with their fine, spicy noses.

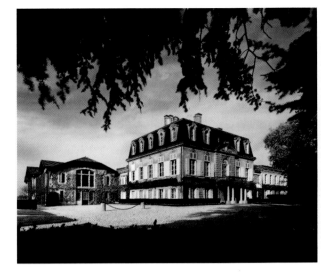

Above: set in a romantic park, this rather retiring château has a wine which expresses itself more forcefully by the year.

Right: 'the Marseillaise broke out and all the spectators, dappled with verdigris and bathed in brass, stood up, their faces ruddy and drunk on the history of France and Pontet-Canet'.
From Dîner de Têtes *(The Dinner of Heads) by popular poet and screenwriter Jacques Prévert*

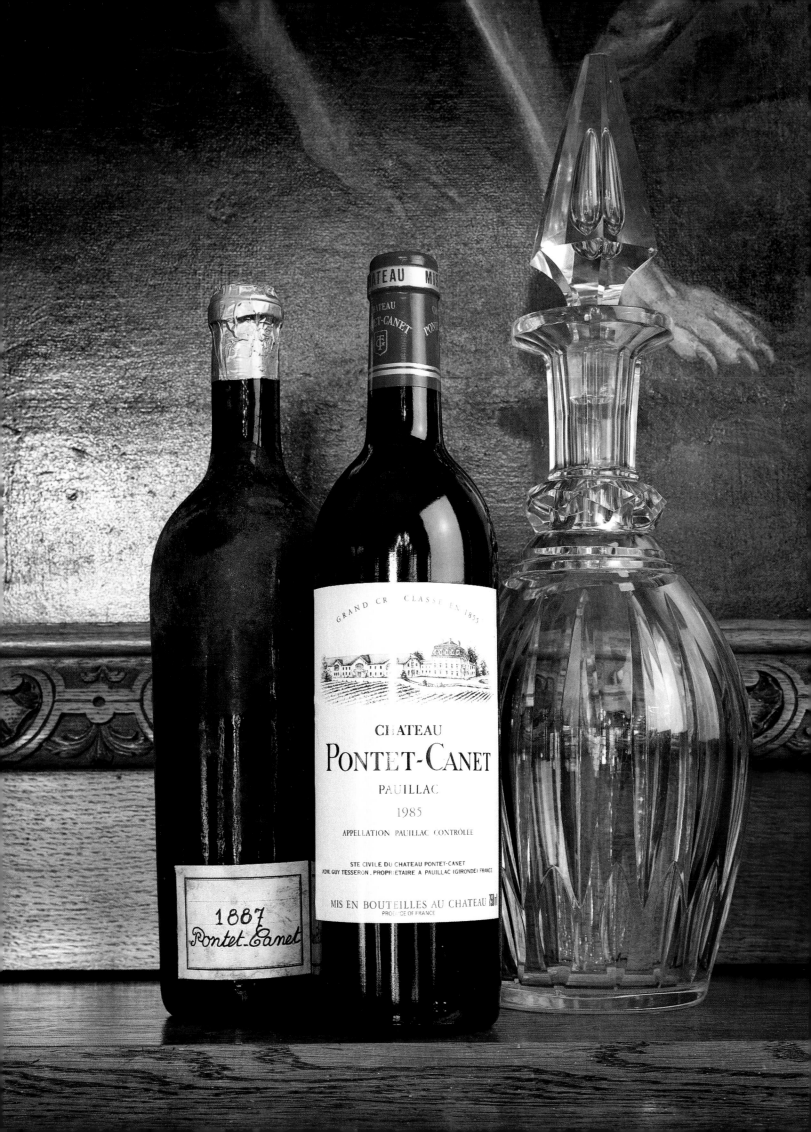

The 19th-century style of these charming outbuildings is quaintly pleasing. Now, however, on the threshold of the 21st century, they are fully functional once again.

Double-page overleaf: the chai, or underground cellar where the wine develops, still bears traces of a proud past whose achievements stretch back 200 years. Today, the chai is the scene of extensive renovation which will take Pontet-Canet two centuries into the future.

MOUTON-ROTHSCHILD

The French for sheep is *mouton*; 'Mouton' as in Mouton-Rothschild, however, is a corruption of the Old French word *mothon,* which means 'hillock' or 'knoll'. A characteristic feature of the undulating landscape of the Médoc generally and the Pauillac appellation, in particular, are their many *mothon*s. Why then, one may ask, is a sheep the emblem of the property? The sheep is in fact Aries, the ram, which was Philippe de Rothschild's zodiac sign.

Château Mouton-Rothschild is the labour of love of one man – Philippe de Rothschild. It was he was who made the property the most fascinating in Médoc, so much so that it welcomes tens of thousands of visitors every year. He was also behind some of the century's greatest wines, such as the 1945 vintage which moved Michael Broadbent, perhaps the world's foremost claret connoisseur, to exclaim: 'This is not claret. This is Mouton, a Churchill of a wine'.

The widespread interest in the wine stems initially from Philippe de Rothschild's long battle to have Mouton admitted to the pantheon of classified first-growth wines established in 1855. To mark the Exposition Universelle of 1856, Emperor Napoleon III asked the Bordeaux *Syndicat des courtiers de commerce* – the wine brokers' trade body – to draw up a list of the greatest clarets. This they did, so establishing 'a classification based on many years' experience [which was] the culmination of developments observed for more than a century'. The classification ranked only four wines as *premier crus*, or first growth: three Médoc clarets, Lafite, Margaux and Latour, and one from the Graves region, Château Haut-Brion. Mouton, then known as Brane-Mouton, was granted the special status of 'first of the second growths'. Why not first growth? It was, after all, acknowledged to be a superb wine, the equal of the first growths. The reason the *Syndicat des courtiers* gave was the 'pitiful state' of the property at the time. Yet the Rothschilds had acquired it only two years previously and so had not had the time to concentrate on the vinification as well as the vines. The most important criterion behind the classification was in fact price, and although Mouton was sold at a higher price than any of the second growths, it was slightly cheaper than the *premiers crus*.

Above: the work of Charles Siclis, the property's building is a model of balance and elegance, as befits a perfect claret.

Right: the term 'designer label' takes on a whole new meaning. Francis Bacon, Salvador Dali, Henry Moore and Robert Motherwell are among those who have illustrated the Mouton label. The three bottles pictured bear the signatures of Chagall (left), Miró (centre) and Picasso (right). Another Rothschild innovation was that Mouton labels read Mise en bouteille au château, *so making estate owners responsible for the wine.*

The *Syndicat des courtiers*' decision prompted the Rothschilds to adopt this motto for Château Mouton: '*Premier ne suis, second ne daigne, Mouton suis*', which could be translated as 'First I cannot be, second I will not be, Mouton I am'.

The family was still smarting from what it felt to be an injustice when, in 1920, Philippe de Rothschild took over the property. Although Mouton-Rothschild had by now established itself as clearly superior to the other second-growth clarets, he was determined that its sheer quality should earn it its rightful place in the first-growth classification.

His first step, in 1924, was to have the wine bottled on the estate – a way of guaranteeing its authenticity, as some *négociants*, or wine traders, left to their own devices had few qualms about spinning out wines. He was the first winegrower in Médoc to take this measure, authenticated by the words '*Mise en bouteille au château*' on the label. The following year, Lafite-Rothschild followed suit, and it is now standard practice throughout the region.

The quality of the wine became more consistent, as Philippe de Rothschild devoted himself to further improving it. He changed the proportions of grape varieties grown in the vineyard, increasing the amount of Cabernet Sauvignon to 80%, leaving Merlot at 8% and Petit Verdot at 2%. He also lengthened the *cuvaison* period, during which the grapes are left to ferment. Most Médoc wine-growers leave grape juice to ferment in contact with skin and pips for no more than 15 days. The Mouton cellar masters believe that a great wine requires lengthy *cuvaison*. Consequently the must (juice, wine and pips) is left to macerate for some 20 days after fermentation. This practice, together with a very high proportion of Cabernet Sauvignon, makes for a vigorous, chewy wine which ages very slowly in the bottle, but is truly memorable when tasted. Robert Parker writes of the 1982 vintage, which he rated 100 out of 100, that it will achieve full maturity some time between 1999 and 2040.

Publicity, too, played an important part in the drive to have Mouton classified a *premier cru*. In 1934, labels began to specify how many bottles had been produced from that year's harvest, while from 1945 a different artist was commissioned every year to illustrate them. In 1962 Philippe de Rothschild opened a museum devoted to wine and art, which boasts an unique collection of objects including drinking vessels, furniture spanning civilisations, and works of Dutch masters. The great *chai* – the first of its kind – is designed to impress visitors who marvel at the new oak barrels where the wine is developing. In the private cellar below are 100,000 bottles of other renowned chateaux, the oldest of which goes back to 1859 and whose corks are changed every 25 years.

Finally, after countless skirmishes with government offices and wine-growers' organisations, Philippe de Rothschild succeeded in changing the seemingly immutable 1855 classification. In 1973, Château Mouton-Rothschild was officially declared a *premier cru*. A legend in his lifetime, Philippe de Rothschild died in 1988, but not before the Mouton motto had changed to '*Premier je suis, second je fus, Mouton ne change*' – 'first I am, second I was, Mouton doesn't change'.

Preceding pages: the gardens are steeped in a sense of majesty. Baroque flamboyance and Zen-like tranquillity combine to form a beautifully fashioned space, Baron Philippe de Rothschild's tribute to a true premier cru.

Right: wine is born to age. An important quality in a great classified wine, especially if it is a premier cru, is its capacity to age in the bottle. The property's cellar is a treasure trove of wines, boasting bottles of Mouton which have been ageing since the end of the 19th century. Gazing at these testimonies to man's industry, one cannot but wonder, like Saint Augustine in his Confessions, 'Quid est essim tempus?' (What is time?).

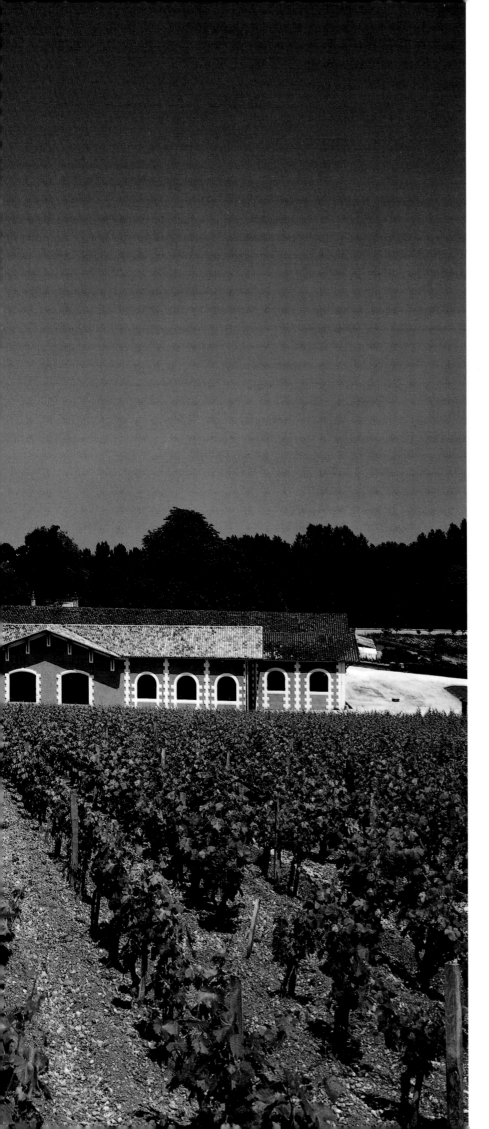

If, to quote the great 20ᵗʰ-century French writer *Paul Claudel, 'wine is a professor of taste and, by teaching us how to attend to our inner selves, it frees the mind and enlightens intelligence', then Château Lafite is a requirement for fine minds. The work that Eric de Rothschild, on the advice of Professor Emile Peynaud, has rigorously applied in both* cuvier *and cellars, has restored Lafite to its rightful, lofty rank.*

Overleaf: the majestic circular chai, *which houses the second-year ageing barrels, was built in 1987 by Catalonian architect Ricardo Bofill. It has ushered in a new era for winery buildings throughout Bordeaux.*

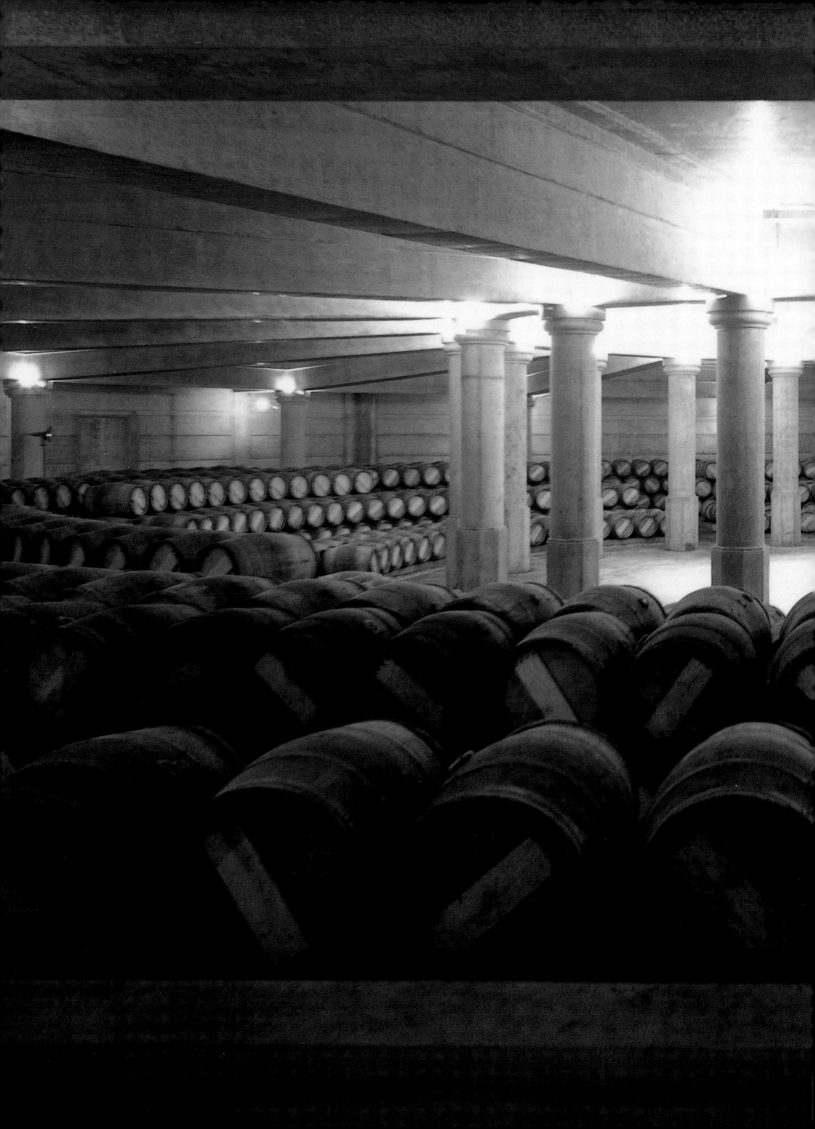

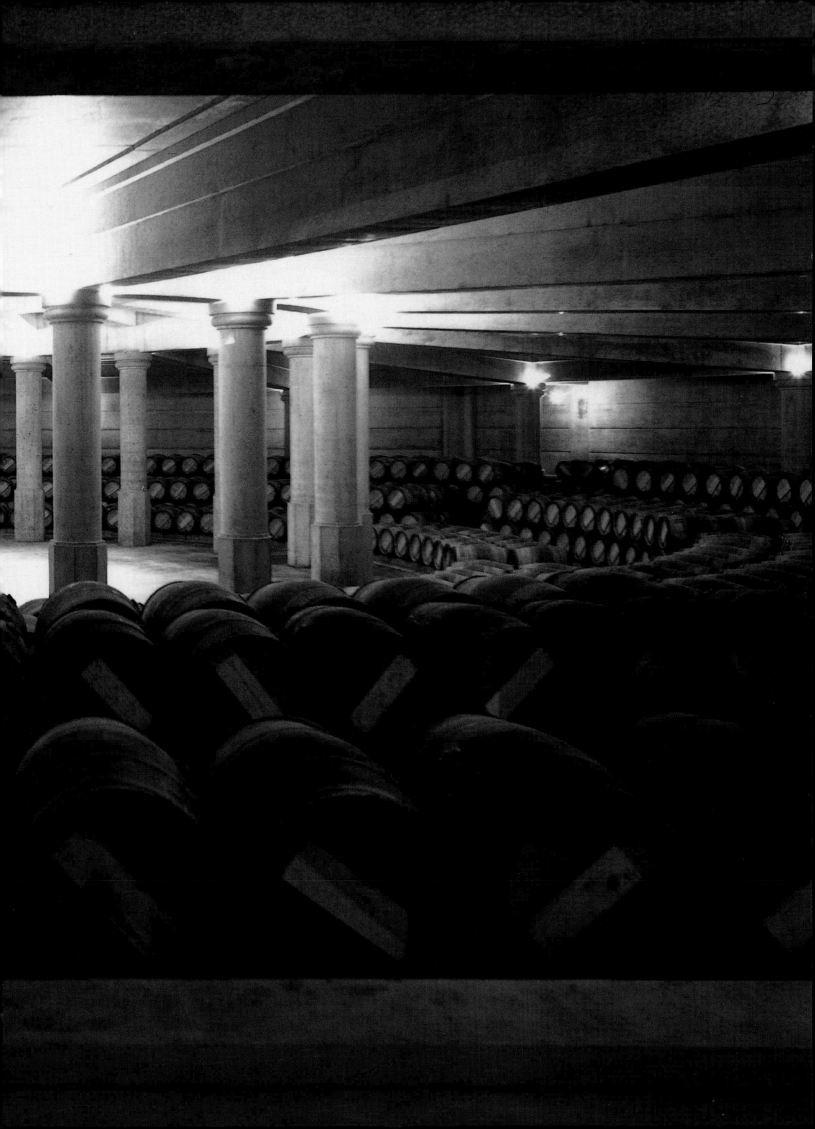

Appellation
SAINT-ESTEPHE

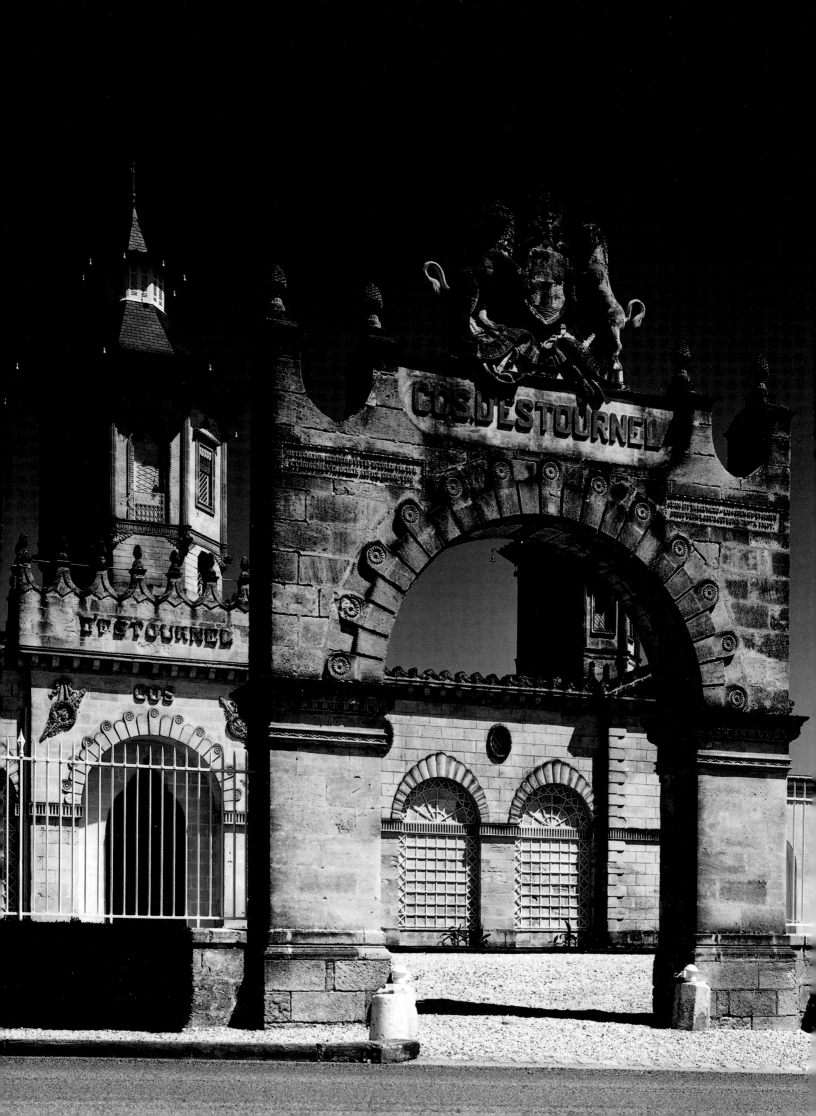

COS D'ESTOURNEL

Above: comfortably settled on the rise which overlooks Lafite-Rothschild, this classified second growth can be appealing but never flattering.

Left: 'This highly elegant edifice of bright yellow colour truly has no one style: it is very gay and is of a somewhat Chinese genre.' From Voyage à Bordeaux, *by Stendhal.*

Opposite Château Lafite, on the other side of the road that divides Pauillac from the St. Estèphe *appellation*, stands Château Cos d'Estournel. It is a sort of Oriental Gothic folly built by the property's original owner, Louis Gaspard d'Estournel, a single-mindedly eccentric winegrower.

He began in 1810 by planting vines in the family property at Cos. The new vineyard soon began producing fine wine that d'Estournel used as means of payment for the Arab steeds which, as a horse trader, he bought in the Middle East. On one trip, a shortage of horses compelled him to return home with much of his wine. He discovered the wine had so improved that he resolved to send all his wines on a round trip to Arabia to mature them. As a fitting tribute to the vital role the Orient played in his winemaking, he set about building an 'Oriental château'. He completed it only 20 years later, during which time he sold the property then bought it back. When it was badly damaged during World War II, Bruno Prats did not just restore it, but also added a carved door from Zanzibar at the main entrance.

Just as Bruno Prats readily acknowledged Arabia's place in Cos d'Estournel's identity, so he accepts new trends in winemaking. He puts his wine through extensive filtration to make it look clear and bright, for example. But he has resisted giving wine '200% new wood', i.e. ageing and racking it in a succession of new oak casks to give it the oaked structure which is so much in vogue.

The wine reflects Cos d'Estournel's equidistance from the heartlands of St. Estèphe and Pauillac: with its 40% of Merlot, it is lighter and more supple than other St. Estèphe wines, but remains rich and fleshy. Robust and rounded, aromatic and tannic, it is distinctive in its own right, as the following story makes clear.

According to 19th-century wine writer, Bertall, a fanatical wine-taster was thrown from his carriage in a collision, cracked his skull and lost consciousness. A bystander rushed home to fetch a bottle of his oldest wine in the hope it would revive him. As the wine trickled into the injured man's mouth, he came to, smiled and murmured, 'Cos d'Estournel 1848.' They were his last words and he was right.

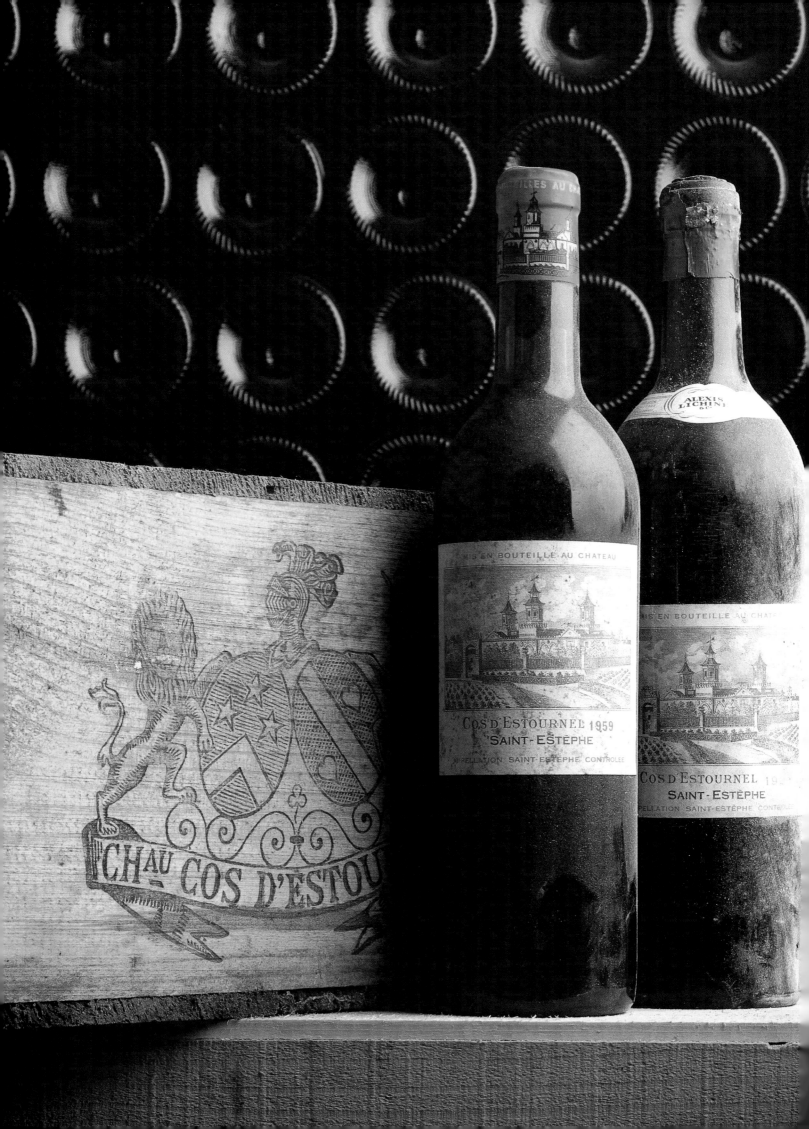

*Cos d'Estournel is filtered prior to barrel-
ageing and again before being bottled.
It deserves to be left alone to age quietly.*

COS LABORY

Cos Labory's vineyard is divided into three parcels of land, each with different soil types. The finest vineyard lies to the west of the château and would, on its own, produce wine similar to Cos d'Estournel's. A second, larger plot stands next to a fourth-growth château, Lafon-Rochet. It faces south and looks on to Lafite, while the third faces west. Cabernet Franc, which adds zest, is grown in relatively high proportions (15%), as is Merlot (30%). The percentage of Merlot is less than that of Cabernet Sauvignon (50%); it is, crucially, a higher-yield grape, which means half of the fermentation must is probably Merlot. Hence the wine's extreme suppleness.

Winemaking facilities are scattered, too. Lack of space and the decision to bottle the wine on the estate meant that new *chais* had to be built a good kilometre from the château. The casks used are generally old Lafite casks, though the Cos Labory does buy new ones. The wine is barrel-aged for between 12 and 18 months, a relatively short period for a *grand cru*, but one which is suited to rendering a wine whose grape varieties lend themselves to fruitiness rather than body, and suppleness rather than tannin.

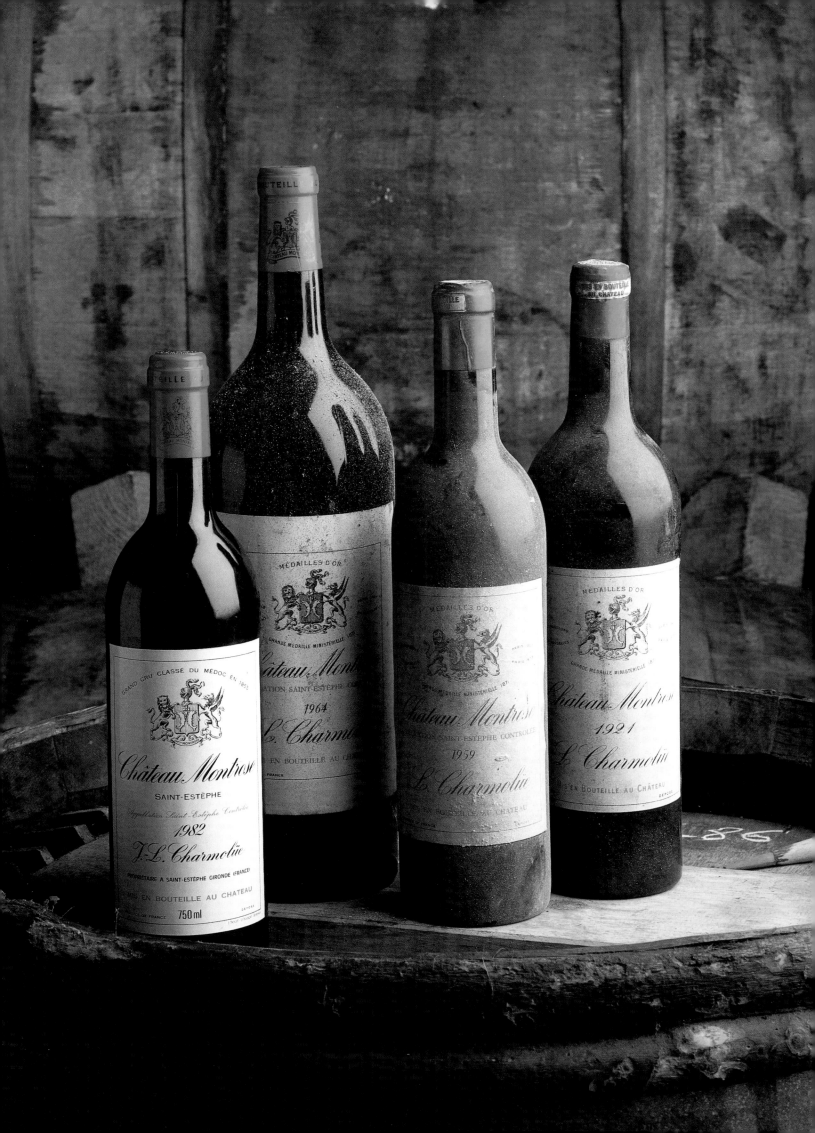

Château MONTROSE

Above: a stately home for a wine which makes stately progress towards full maturity.

Left: Château Montrose is made to be drunk only after it has aged for at least 10 years. This is particularly true of the 1990, 1995 and 1996 vintages, which were well-balanced, had an ample, fat taste and lingering fruit and tannin in their finish. This is perhaps the best of the St. Estèphe clarets.

The well-documented history of the Château Montrose vineyard records that it was created and developed by three families. The Desmoulins bought the land in the late 18th century, built the château in 1815 and planted the first vines. In 1886, Mathieu Dollfuss took over, building modern, highly functional *chais* still in use today. Dollfuss was also ahead of his time in his attitude towards his employees. He introduced profit-sharing, health insurance and paid maternity leave. Thirty years later, Louis Chamoulüe became the new owner. Over 100 years later, the Chamoulües still run the domain, making a second-growth claret that is round and fat, almost black in colour and has a fine, fruited nose redolent of blackberries.

What strikes visitors to Château Montrose is orderliness and cleanliness. The lanes between the employees' houses have names, the floors in the *chais* are tiled for reasons of hygiene, and improvements are constantly made to the domain's buildings, including the *chais* and the living quarters.

The owners are just as organised in their approach to their vines and wine. Grape proportions are classic (65% Cabernet Sauvignon, 25% Merlot and 10% Cabernet Franc), while the vines are south facing and planted at one-metre intervals. The Chamoulües believe that a great wine should age well. To ensure that a wine made today is still excellent in 40 years, it is subject to the most stringent selection: estate employees drink an annual 2,000 litres (529 gallons) of wine not considered to meet Château Montrose's standard. The old vines that supply the grapes are meticulously husbanded to ensure that fruit is fully mature and the yield low. Plants are cut back to eight to twelve buds at the most, slowly maturing clusters are removed to enhance concentration in riper ones, while careful canopy management optimises exposure of fruit and leaves to sunlight.

Curiously, the Chamoulües did not begin to bottle all their wine at the château until 1969. Before then, part of it was bottled by importers, part at the château. The result was bottle-variation, with estate-bottled wines coming off worse in an odd lapse in Montrose's mathematically precise scheme of things.

CALON-SÉGUR

Documentary evidence of taxes levied on the Calon-Ségur vineyard in the 13th century lends credence to the view that Calon-Ségur is the oldest vineyard in St. Estèphe and, possibly, in the Médoc. Its bottles once bore the motto, *Premier Cru de Saint-Estèphe*. The owners possibly intended *premier* in a chronological sense. Other St. Estèphe growers took it to mean the best, as in *premier cru*. They demanded the removal of the motto, as Calon-Ségur is a *troisième cru*.

Calon comes from an old word meaning 'wood' and *Ségur* from the Marquis de Ségur, who married into the property in the 18th century. Known as the 'Wine Prince' (see *Château Latour*), he also owned such domains as Latour, Lafite, Mouton and De Pez. The marquis spoke of his wine dominion in these terms: 'I make wine at Latour and Lafite, but my heart is at Calon'. The heart shape on the label is an allusion to his words.

Calon-Ségur has a high percentage of Cabernet Franc, which usually acts as a complexing element in an overall claret blend. But at 15% it adds freshness, while Merlot (20%) brings suppleness and Cabernet Sauvignon (65%) provide the robust backbone. Maybe not a *premier cru;* but better than a *troisième cru*.

Appendices

Tasting

We drink because we need liquid to survive. We drink fine wine because pleasure is an essential part of life. Although the enjoyment and understanding of wine is an acquired knowledge, there is no need to obtain a degree from a university of oenology. The wisest approach is to take every opportunity to educate your nose and palate and so build up an experience of aromas and flavours. Cultivating your sense of smell and taste involves cultivating your memory for smells and tastes, be they pleasant or unpleasant. In this way, you acquire a memory for the names and characteristics of the wines you drink. Look, smell, taste. Again and again.

Two pieces of advice. The first is to know yourself. We all have our penchants and preferences, being more partial to floral fragrances than to animal scents, to a soft Margaux than to a muscular St. Estèphe. This is not a bad thing. It is a very good thing, because it helps you get your bearings in the wide world of wines.

The second piece of advice is to use straightforward, accurate vocabulary to describe your wine-tasting sensations. Be profound or poetic, by all means; but not over-the-top or affected. Be sober, for getting drunk on your own words means you have lost all taste.

'And if it may be put thus, he listened, for an instant, to himself savouring the wine's bouquet.'

Eugène Sue, 19th-century French novelist

Tasting Terms

Acid: Wines need acidity, some more than others. Acid levels in Bordeaux wines should be low. The critical factor, however, is balance within the overall structure of a wine.

Appeal: A wine whose colour, bouquet and palate are agreeable. 'Early appeal' suggests fast-maturing, pleasant fruition but a possible lack of depth and complexity.

Alcohol: The backdrop of a wine. Level of alcohol is not critical per se. What is critical is balance: excessive alcohol makes a wine hot, inadequate levels make it thin and lacking in body.

Aroma: Scent, nose, bouquet. Aromas are described by analogy with fruit, flowers, spices and wood as well as animal, balsamic, burnt and earthy notes.

Astringent: Tart, sharp-edged sensation caused by tannin and acidity.

Balance: Harmony between the component parts, i.e. acidity, texture (tannin), richness. Balance is the ultimately sought-after goal in wine appreciation and the defining characteristic of great wines.

Bright: Clear, light appearance. A wine 'falls bright' when it becomes clear and stable prior to bottling.

Body: Weight and volume of wine in the mouth, e.g. full-bodied.

Chewy: Texture which is so full, sinewy and muscular in the mouth that it feels as if it could be chewed.

Closed: A wine which has not yet opened to release its bouquet. Mute.

Colour: Depth of colour indicates a wine's age, acidity and fullness of flavour.

Complex: Used to describe a wine which has a wide, unfolding range of suggestive flavours and aftertastes.

Density: Concentration of flavour and texture.

Elegance: Distinctive class, pedigree.

Fat: Full, rounded, unctuous.

Finish: The flavours of a wine which linger after the final swallow.

Fleshy: Soft, round, weighty.

Grippy: Used to describe the harsh, dry feel of tannin on the tongue.

Hot: Excessive alcohol.

Jammy: A warm, cooked-fruit flavour.

Light: Said of a slight-bodied, but balanced and brightly coloured wine which should be drunk early.

Long: Used for a wine whose flavour lingers in the mouth.

Mouthfeel: The textural sensation of a wine.

Palate: Flavour of a wine.

Profound: Used for wine with great depth of texture and complexity of flavour.

Richness: A fundamental component of wine, richness is fullness of flavour. It is a combination of the warmth of alcohol, residual sweetness and the many flavours extracted from the grape skin.

Robust: A powerfully tannic, weighty wine which slowly matures to fruition.

Rough: Abrasive, hard, harsh in texture.

Round: Said of a wine whose stiff contours have softened, then rounded out with maturity.

Stiff: Unyielding structure of an early wine.

Smooth: Said of a wine which is mellifluous and so soft it has almost no definable texture.

Structure: The way in which the component parts of a wine hold, or fail to hold, together as a whole.

Supple: In a supple wine, softness overrides tannin, but not at the expense of texture, which remains clearly palpable.

Tannin: Tannin, extracted from grape skins, is texture, one of the three basic components in the overall balance of a wine.

Thin: A thin wine has low acid, low tannin, and no fruit.

Glossary

Appellation: The named locality from which a wine originates. The locality can vary in size from an entire winegrowing region like Bordeaux to tiny localities like those covered in this book. The smaller the locality, the higher the quality of the wine. Why? Because an appellation guarantees more than just a locality. Appellation – short for *appellation contrôlée* – is a legislative term which governs grape varieties, minimum alcohol content, viticultural practices, quantities produced and vinification specific to a winegrowing area and its soil type. It follows, therefore, that a claret labelled *Appellation Margaux Contrôlée* – e.g. Palmer or Lascombes – has had to comply with far more stringent standards than wine in a bottle labelled *Appellation Bordeaux Contrôlée*, which could have been produced anywhere in Bordeaux within a 80-kilometre (50-mile) radius of the city.

Assemblage: Literally 'assembling', assemblage is the blending of the newly-fermented wines derived from each grape variety.

Barrel-ageing: See *Élevage*.

Canopy management: Training vine plants and trimming their leaves so that both leaves and fruit gain maximum exposure to sunlight and airflow.

Cap: The thick crust of grape pulp and skin which floats to the surface of the must during fermentation. The cap, which can be between 60 cm and one metre thick, imparts tannin and colour.

Chai: The cellar, usually built above ground level, in which wine is barrel-aged after fermentation and blending. Most estates have two *chais*, one for barrel-ageing the newly made wine and another for ageing the second- and third-year wines prior to bottling.

Chaptalisation: Adding sugar to enrich must. The aim is not to obtain sweet wine, because the sugar will be fermented into alcohol, but to increase alcohol so as to give the wine a little more stuffing. Chaptalisation is named after the French chemist, Jean-Antoine Chaptal, who invented it.

Cru: Means 'growth' and has come, by extension, to mean wine. *Grand cru*, therefore, effectively means 'great wine', because it comes from a 'great growth' in a vineyard of quality. A *grand cru classé* is a 'great classified growth' officially categorised as such by the famous 1855 classification, which divided them into first, second, third, fourth and fifth growths (*premier cru, deuxième, troisième, quatrième, cinquième*).

Glossary

Cuve: Large vats, or containers, made from wood, stainless steel or concrete, in which the newly picked grapes ferment and turn into wine. This process - and, by extension, the time it takes - is called *cuvaison*, while the cellar which houses *cuves* is called the *cuvier*. *Cuvaison* lasts between 10 days and one month. Shorter *cuvaison* periods produce light, supple wines, while longer ones produce tannic, slow-maturing wines.

Élevage: Literally 'bringing up', *élevage* is the initial ageing, or developing, of the newly-fermented wine in barrels, large old oak tuns or stainless steel or fibreglass vats and tanks. Although each container has its own merits, the most highly favoured receptacles are small oak barrels. They impart tannin and oaky, vanillin flavours as well as allowing the wine to breathe a little, so softening it. *Élevage* lasts between 18 months and three years.

Extraction: Extraction refers to the maceration of skins, before or after fermentation, to extract tannin, colour and flavour. Warm fermentation extracts more from skins, while cool fermentation extracts less.

Fermentation: Fermentation happens twice. The first time is when yeasts convert sugar in the must into alcohol. This is alcoholic fermentation. To produce early-drinking, aromatic, fruited wines, winemakers ferment must at low temperatures (25 °C to 28 °C), while slow-maturing, tannic wines will be the result of high-temperature fermentation (up to 34 °C).

The second fermentation is malolactic fermentation, or 'malo' a process whereby lactic bacteria convert sharp, nippy malic acid into soft lactic acid. In practical terms, malo smoothes out the edges in red wine, so winemakers often like to start malo right after alcoholic fermentation.

Filtering: Filtering is the last step before bottling. It consists of passing wine through a physical barrier to remove remaining particles. Over-filtration can strip a wine.

Fining: A fine wine must be clear. Before bottling, therefore, a coagulating agent is added to collect suspended particles and take them to the bottom as deposit. This is fining. The most common fining agent is egg white.

Must: Fermenting grape juice.

Oenologist: A wine taster and technician.

Parcel: A plot of vineyard land.

Press wine: After fermentation, the newly-formed wine – *vin de goutte* – is drawn, which leaves the skins and pips. They are pressed to obtain what is known as 'press wine', so heavily tannic that it is undrinkable. But its very tannicity makes it invaluable to the winemaker, who uses it for *assemblage* and for liqueurs.

Racking: Transferring developing wine from one cask to another to expose it to the air, so helping it age and to lift its sediment.

Village: During barrel-ageing, wine evaporates, creating a space in which the wine comes into contact with the air, thus allowing bacteria to develop and creating acidity. *Ouillage* is both the gap caused by evaporation and the practice of topping up the cask with wine to ensure it stays full.

Vinification: Winemaking.

Vintage: Derived from the French *vin d'âge*. It has come simply to mean 'year'. A good year is a good vintage, a bad one a bad vintage.

Guide to the Châteaux

Apart from the names of the châteaux, their classifications, addresses and telephone numbers, we also give the areas of their vineyards and the proportions of different grape varieties grown. In a winegrowing region dominated by Cabernet Sauvignon, knowing a particular vineyard's percentage of Merlot can be a useful indication as to the characteristics of the wine it produces. We also supply the names of the second wines - safe bets at a time when speculation has led to a tripling in price of the 1995 and 1996 vintages. The dwindling availability of the main château wines can doubtless be ascribed to the boom in speculation. But it could also be the result of a deliberate decision on the part of producers, who claim that their stringent selection policies limit the quantities of their first wines. Such a ploy is a way of pushing to the fore finely crafted second wines on which meticulous attention has been lavished.

The surface area of a vineyard on which vines are grown and percentages of different grape varieties only acquire their full significance when taken in conjunction with the appellation to which the vineyard belongs. Each appellation governs a set of specific viticultural and vinification requirements. How each château grows and makes its wine within this framework determines the originality and personality of its wine.

Five grape varieties are cultivated and can be used and combined to achieve a desired result:
Cabernet Sauvignon (CS)
Merlot (M)
Cabernet Franc (CF)
Petit Verdot (PV)
Malbec (part of only one of Médoc's classified growths, Château Gruaud-Larose).

The percentages of grape varieties grown are not necessarily the same as those which are eventually chosen to go into the blending of a classified growth wine, as proportions vary according to the year's crop and how the *cuvaison* evolves. They are nevertheless valuable pointers as to what makes each wine distinctive.

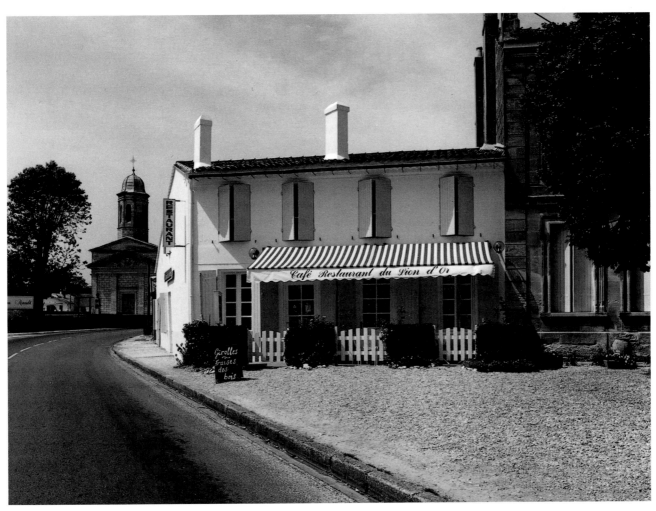

The Lion d'Or boasts not only the finest table in Médoc, but also the finest wine cellar. The owners of a number of châteaux store selected bottles here, so that their guests may taste great vintages as they savour the restaurant's gourmet cuisine.

Château Batailley

Classified fifth growth
Appellation: Pauillac
Surface: 50 ha (124 acres)
Varieties: 70% CS, 25% M, 3% CF, 2% PV
Second wine: Château Lynch-Moussas
Address: 33250 Pauillac
Tel: 05 56 59 01 13 – Fax: 05 56 52 29 54

Château Beychevelle

Classified fourth growth
Appellation: Saint-Julien
Surface: 90 ha (222 acres)
Varieties: 60% CS, 28% M, 8% CF, 4% PV
Second wine: Amiral de Beychevelle
Address: 33250 Saint-Julien-Beychevelle
Tel: 05 56 73 20 70 – Fax: 05 56 73 20 71

Château Branaire-Ducru

Classified fourth growth
Appellation: Saint-Julien
Surface: 50 ha (124 acres)
Varieties: 74% CS, 23% M, 3% PV
Second wine: Château Duluc
Address: 33250 Saint-Julien-Beychevelle
Tel: 05 56 59 25 86 – Fax: 05 56 59 16 26

Château Brane-Cantenac

Classified second growth
Appellation: Margaux
Surface: 85 ha (210 acres)
Varieties: 70% CS, 20% M, 10% CF
Second wine: Le Baron de Brane
Address: 33460 Margaux
Tel: 05 57 88 83 33 – Fax: 05 57 88 72 51

Château Calon-Ségur

Classified third growth
Appellation: Saint-Estèphe
Surface: 94 ha (232 acres)
Varieties: 65% CS, 20% M, 15% CF
Second wine: Marquis de Ségur
Address: 33180 Saint-Estèphe
Tel: 05 56 59 30 08 – Fax: 05 56 59 71 51

Château Cantemerle

Classified fifth growth
Appellation: Haut-Médoc
Surface: 67 ha (165 acres)
Varieties: 45% CS, 40% M, 10% CF, 5% PV
Second wine: Le Baron de Cantemerle
Address: 33460 Macau
Tel: 05 57 97 02 82 – Fax: 05 57 97 02 84

Château Cantenac-Brown

Classified third growth
Appellation: Margaux
Surface: 52 ha (128 acres)
Varieties: 65% CS, 25% M, 10% CF
Second wine: Château Canuet
Address: 33460 Margaux
Tel: 05 57 88 81 81 – Fax: 05 57 88 81 90

Château Chasse-Spleen

Cru bourgeois
Appellation: Moulis
Surface: 80 ha (200 acres)
Varieties: 70% CS, 25% M, 5% PV
Second wine: Ermitage de Chasse-Spleen
Address: 33480 Moulis-en-Médoc
Tel: 05 56 58 02 37 – Fax: 05 57 88 84 40

Château Cos-d'Estournel

Classified second growth
Appellation: Saint-Estèphe
Surface: 54 ha (133 acres)
Varieties: 60% CS, 40% M
Second wine: Château de Marbuzet
Address: 33180 Saint-Estèphe
Tel: 05 56 73 15 55 – Fax: 05 56 59 72 59

Château Cos-Labory

Classified fifth growth
Appellation: Saint-Estèphe
Surface: 18 ha (44 acres)
Varieties: 50% CS, 30% M, 15% CF, 5% PV
Second wine: Le Charme Labory
Address: 33180 Saint-Estèphe
Tel: 05 56 59 30 22 – Fax: 05 56 59 73 52

Château Ducru-Beaucaillou

Classified second growth
Appellation: Saint-Julien
Surface: 49 ha (121 acres)
Varieties: 65% CS, 25% M, 5% CF, 5% PV
Second wine: Château La Croix
Address: 33250 Saint-Julien-Beychevelle
Tel: 05 56 59 05 20 – Fax: 05 56 59 27 37

Château Giscours

Classified third growth
Appellation: Margaux
Surface: 83 ha (205 acres)
Varieties: 55% CS, 35% M, 5% CF, 5% PV
Second wine: La Sirène de Giscours
Address: Labarde 33460 Margaux
Tel: 05 57 97 09 09 – Fax: 05 57 97 09 00

Château Grand-Puy-Lacoste

Classified fifth growth
Appellation: Pauillac
Surface: 45 ha (111 acres)
Varieties: 70% CS, 25% M, 5% CF
Second wine: Lacoste-Borie
Address: 33250 Pauillac
Tel: 05 56 59 06 66 - Fax: 05 56 59 22 27

Château Gruaud-Larose

Classified second growth
Appellation: Saint-Julien
Surface: 82 ha (203 acres)
Varieties: 59% CS, 32% M, 5% CF, 3% PV,
1% Malbec
Second wine: Sarget de Gruaud-Larose
Address: 33250 Saint-Julien-Beychevelle
Tel: 05 56 73 15 20 - Fax: 05 56 59 64 72

Château d'Issan

Classified third growth
Appellation: Margaux
Surface: 30 ha (74 acres)
Varieties: 70% CS, 30% M
Second wine: Blason d'Issan
Address: 33460 Cantenac
Tel: 05 57 88 35 91 - Fax: 05 57 88 74 24

Château Kirwan

Classified third growth
Appellation: Margaux
Surface: 35 ha (86 acres)
Varieties: 40% CS, 30% M, 20% CF, 10% PV
Second wine: Les Charmes de Kirwan
Address: 33460 Cantenac
Tel: 05 57 88 71 00 - Fax: 05 57 88 77 62

Château Lafite-Rothschild

Classified first growth
Appellation: Pauillac
Surface: 90 ha (222 acres)
Varieties: 75% CS, 20% M, 4% CF, 1% PV
Second wine: Domaine Les Carruades
Address: 33250 Pauillac
Tel: 05 56 73 18 18 - Fax: 05 56 59 26 83

Château Lagrange

Classified third growth
Appellation: Saint-Julien
Surface: 113 ha (279 acres)
Varieties: 66% CS, 27% M, 7% PV
Second wine: Les Fiefs de Lagrange
Address: 33250 Saint-Julien-Beychevelle
Tel: 05 56 73 38 38 - Fax: 05 56 59 26 09

Château La Lagune

Classified third growth
Appellation: Haut-Médoc
Surface: 72 ha (178 acres)
Varieties: 55% CS, 20% M, 20% CF, 5% PV
Second wine: Château Ludon-Pomiès-Agassac
Address: 33290 Ludon-en-Médoc
Tel: 05 57 88 82 77 - Fax: 05 57 88 82 70

Château Lascombes

Classified second growth
Appellation: Margaux
Surface: 50 ha (124 acres)
Varieties: 55% CS, 40% M, 5% PV
Second wine: Chevalier de Lascombes
Address: 33460 Margaux
Tel: 05 57 88 70 66 - Fax: 05 57 88 72 17

Château Latour

Classified first growth
Appellation: Pauillac
Surface: 65 ha (161 acres)
Varieties: 80% CS, 15% M, 4% CF, 1% PV
Second wine: Les Forts de Latour
Address: 33250 Pauillac
Tel: 05 56 73 19 80 - Fax: 05 56 73 19 81

Château Léoville-Barton

Classified second growth
Appellation: Saint-Julien
Surface: 45 ha (111 acres)
Varieties: 70% CS, 20% M, 10% CF
Second wine: La Réserve de Léoville-Barton
Address: 33250 Saint-Julien-Beychevelle
Tel: 05 56 59 06 05 - Fax: 05 56 59 14 29

Château Léoville-Las Cases

Classified second growth
Appellation: Saint-Julien
Surface: 97 ha (240 acres)
Varieties: 65% CS, 19% M, 13% CF, 3% PV
Second wine: Clos du Marquis
Address: 33250 Saint-Julien-Beychevelle
Tel: 05 56 73 25 26 - Fax: 05 56 59 18 33

Château Lynch-Bages

Classified fifth growth
Appellation: Pauillac
Surface: 90 ha (222 acres)
Varieties: 73% CS, 15% M, 10% CF, 2% PV
Second wine: Haut-Bages-Averous
Address: 33250 Pauillac
Tel: 05 56 73 24 00 - Fax: 05 56 59 26 42

Château Margaux

Classified first growth
Appellation: Margaux
Surface: 78 ha (193 acres) planted, 87 ha (215 acres)
Varieties: 75% CS, 20% M, 2.5% PV, 2.5% CF
Second wine: Pavillon rouge
Address: 33460 Margaux
Tel: 05 57 88 83 83 - Fax: 05 57 88 31 32

Château Montrose

Classified second growth
Appellation: Saint-Estèphe
Surface: 68 ha (168 acres)
Varieties: 65% CS, 25% M, 10% CF
Second wine: La Dame de Montrose
Address: 33180 Saint-Estèphe
Tel: 05 56 59 30 12 - Fax: 05 56 59 38 48

Château Mouton-Rothschild

Classified first growth (1973)
Appellation: Pauillac
Surface: 75 ha (185 acres)
Varieties: 80% CS, 10% CF, 8% M, 2% PV
Second wine: Le Petit Mouton de Mouton-Rothschild
Address: 33250 Pauillac
Tel: 05 56 73 20 20 - Fax: 05 56 73 20 44

Château Palmer

Classified third growth
Appellation: Margaux
Surface: 45 ha (111 acres)
Varieties: 55% CS, 40% M, 5% PV
Second wine: Réserve du Général
Address: 33460 Cantenac
Tel: 05 57 88 72 72 - Fax: 05 57 88 37 16

Château Pichon-Longueville-Baron

Classified second growth
Appellation: Pauillac
Surface: 68 ha (168 acres)
Varieties: 70% CS, 25% M, 5% CF
Second wine: Les Tourelles de Longueville
Address: 33250 Pauillac
Tel: 05 56 73 17 17 - Fax: 05 56 73 17 28

Château Pichon-Longueville-Comtesse-de-Lalande

Classified second growth
Appellation: Pauillac
Surface: 75 ha (185 acres)
Varieties: 45% CS, 35% M, 12% CF, 8% PV
Second wine: Réserve de la Comtesse
Address: 33250 Pauillac
Tel: 05 56 59 19 40 - Fax: 05 56 59 29 78

Château Pontet-Canet

Classified fifth growth
Appellation: Pauillac
Surface: 78 ha (193 acres)
Varieties: 63% CS, 32% M, 5% CF
Second wine: Les Hauts de Pontet
Address: 33250 Pauillac
Tel: 05 56 59 04 04 - Fax: 05 56 59 26 63

Château Poujeaux

Cru bourgeois exceptionnel
Appellation: Moulis
Surface: 52 ha (128 acres)
Varieties: 50% CS, 40% M, 5% CF, 5% PV
Second wine: Charme de Poujeaux
Address: 33480 Moulis-en-Médoc
Tel: 05 56 58 02 96 - Fax: 05 56 58 01 25

Château Prieuré-Lichine

Classified fourth growth
Appellation: Margaux
Surface: 69 ha (170 acres)
Varieties: 53% CS, 40% M, 5% PV, 2% CF
Second wine: Château de Clairefort
Address: 33460 Cantenac
Tel: 05 57 88 36 28 - Fax: 05 57 88 78 93

Château Saint-Pierre

Classified fourth growth
Appellation: Saint-Julien
Surface: 17 ha (42 acres)
Varieties: 70% CS, 20% M, 10% CF
Address: 33250 Saint-Julien-Beychevelle
Tel: 05 56 59 08 18 - Fax: 05 56 59 16 18

Château Talbot

Classified fourth growth
Appellation: Saint-Julien
Surface: 102 ha (252 acres)
Varieties: 66% CS, 24% M, 3% CF, 5% PV, 2% Malbec
Second wine: Connetable de Talbot
Address: 33250 Saint-Julien-Beychevelle
Tel: 05 56 73 21 50 - Fax: 05 56 73 21 51

The Classification of 1855

A sacrosanct historical monument, the Classification of 1855 (see *Château Mouton-Rothschild*) has been – and still is – the subject of fierce debate between wine professionals and *grand cru* wine lovers alike. All claim to have the true answer. And all do, each in his/her own way. But the truth of their answers is fleeting, their certainty fashioned by the circumstances of the moment, their objectivity swayed by impassioned opinion. The great merit of the 1855 classification and of those which came before it – the earliest categorisation of châteaux dates back to 1745 – lies in the fact that it chose the most concrete criterion, i.e. the judgement of the marketplace. Rather than establish a qualitative hierarchy, it took the prices at which merchants were trading as a *fait accompli*. With the hindsight of over 150 years, during which fashions have come and gone, the 1855 classification of the greatest of the great has, despite its shortcomings, stood the test of time. It has become the benchmark, the touchstone without which any assessment would be unthinkable. That some people, prompted by the excellence of such-and-such a vintage, even over a length of time, should at times seek to revise it, is a perfectly natural concern and an incentive to strive for perfection, not to mention an incentive to speculate. Take Mouton-Rothschild. Is it a greater wine for having risen from second growth to first growth in 1973? Has it sold for higher prices? It has, but – a big but – it must now live with the stern consequences of failing to living up to its rank. Which acts, in turn, as an endorsement of wine officialdom's principled stance not to revise the 1855 classification. It is an understandable position, but then so is the value or enjoyment of drawing up one's own list. In the end, however great it is, a wine is only a wine! It is sometime strong, sometimes weak. Only the soil in which it grew is unchanging. It is in this light that we propose the list below: although it complies with the long-standing hierarchy, it breaks with usual practice in presenting the 1855 classified growths by appellation. It puts them where they belong.

APPELLATION

Haut-Médoc

Classified third growth
La Lagune ★

Classified fourth growth
La Tour-Carnet

Classified fifth growth
Belgrave
Camensac
Cantemerle ★

APPELLATION

Margaux

Classified first growth
Margaux ★

Classified second growth
Rausan-Ségla
Rauzan-Gassies
Durfort-Vivens
Lascombes ★
Brane-Cantenac ★

Classified third growth
Kirwan ★
D'Issan ★
Giscours ★

Malescot-St-Exupéry
Ferrière
Boyd-Cantenac
Cantenac-Brown ★
Palmer ★
Desmirail
Marquis d'Alesme-
Becker

Classified fourth growth
Pouget
Prieuré-Lichine ★
Marquis-de-Terme

Classified fifth growth
Dauzac
Du Tertre

APPELLATION

Saint-Julien

Classified second growth
Léoville-Las Cases ★
Léoville-Poyferré
Léoville-Barton ★
Gruaud-Larose ★
Ducru-Beaucaillou ★

Classified third growth
Lagrange ★

Langoa-Barton

Classified fourth growth
Saint-Pierre ★
Talbot ★
Branaire-Ducru ★
Beychevelle ★

APPELLATION

Pauillac

Classified first growth
Lafite-Rothschild ★
Latour ★
Mouton-Rothschild
(1973) ★

Classified second growth
Pichon-Longueville-
Baron ★
Pichon-Longueville
Comtesse-de-Lalande ★

Classified fourth growth
Duhart-Milon-
Rothschild

Classified fifth growth
Pontet-Canet ★
Batailley ★
Haut-Batailley

Grand-Puy-Lacoste ★
Grand-Puy-Ducasse
Lynch-Bages ★
Lynch-Moussas
Mouton-Baron-
Philippe d'Armailhac
Haut-Bages-Libéral
Pédesclaux
Clerc-Milon
Croizet-Bages

APPELLATION

Saint-Estèphe

Classified second growth
Cos d'Estournel ★
Montrose ★

Classified third growth
Calon-Ségur ★

Classified fourth growth
Lafon-Rochet

Classified fifth growth
Cos Labory ★

★ *wines featured in this book*

Bibliography

AMERINE, MAYNARD *A Bibliography on Grapes, Wines, Other Alcoholic Beverages, and Temperance,* University of California Press, Berkeley, 1997

BRIGGS, ASA *Haut-Brion,* Faber and Faber, London, 1994

BROADBENT, MICHAEL *Michael Broadbent's Winetasting,* Mitchell Beazley, London, 1998

CLARKE, OZ and STEVEN SPURRIER *Clarke and Spurrier's Fine Wine Guide,* Little, Brown, London, 1998

— *Encyclopedia of Wine,* Little, Brown, London, 1999

— *The Wine Atlas,* Little, Brown, London, 1995

COATES, CLIVE *Grand Vins: the Finest Chateaux of Bordeaux and their Wines,* Weidenfeld Nicolson, London, 1995

DOVAZ, MICHEL *Bordeaux: a Legendary Wine,* Abbeville Press, NY, 1998

DUIJKER, HUBRECHT *The Wine Atlas of France,* Mitchell Beazley, London, 1997

DUIJKER, HUBRECHT and MICHAEL BROADBENT *The Bordeaux Atlas,* Ebury Press, London, 1997

JOHNSON, HUGH *Hugh Johnson's Cellar Book,* Mitchell Beazley, London, 1998

— *Hugh Johnson's Wine Companion,* Mitchell Beazley, London, 1997

— *The World Atlas of Wine,* Mitchell Beazley, London, 1994

JOSEPH, ROBERT *The Ultimate Encyclopedia of Wine,* Prion Books, 1997

Larousse — the Wines and Vineyards of France, Ebury Press, London, 1989

MARKHAM, DEWY *1855: A History of the Bordeaux Classification,* John Wiley Inc, NY, 1998

MOLYNEUX-BERRY, DAVID *Sotheby's Guide to Classic Wines and their Labels,* Dorling Kindersley, London, 1990

PARKER, ROBERT *Bordeaux,* Dorling Kindersley, 1998

PEPPERCORN, DAVID *Bordeaux,* Faber and Faber, 1991

— *The Mitchell Beazley Guide to the Wines of Bordeaux,* Mitchell Beazley, London, 1992

— *Wines of Bordeaux,* Mitchell Beazley, London, 1998

PEYNAUD, EMILE *The Taste of Wine,* John Wiley Inc, 1995

ROBINSON, JANCIS *Jancis Robinson's Wine Course,* BBC Books, London, 1999

— *The Oxford Companion to Wine,* Oxford UP, Oxford, 1999

Sotheby's Wine Encyclopedia, Dorling Kindersley, London, 1999

SPURRIER, STEVEN *Academie du Vin Guide to French Wines,* Macmillan, NY, USA, 1992

UNWIN, TIM *Wine and the Vine,* Routledge, London, 1996

VINE, RICHARD P. *Wine Appreciation,* John Wiley Ltd, 1997

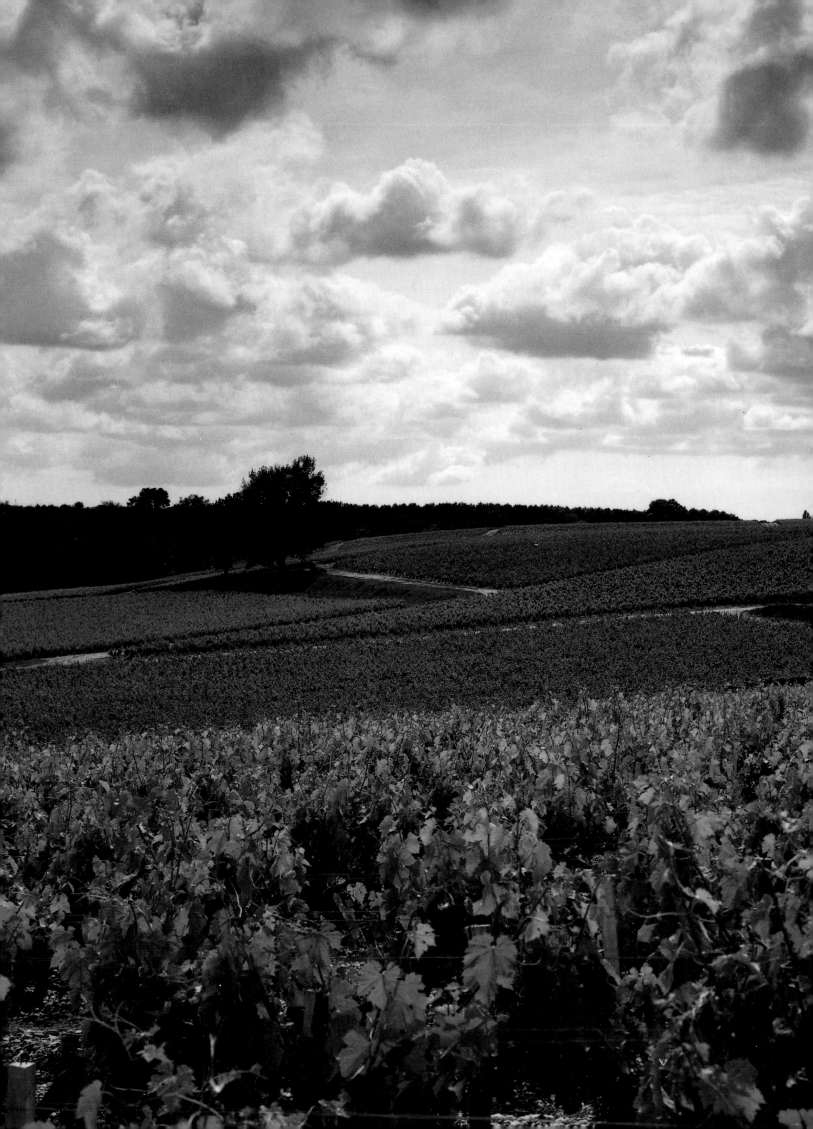

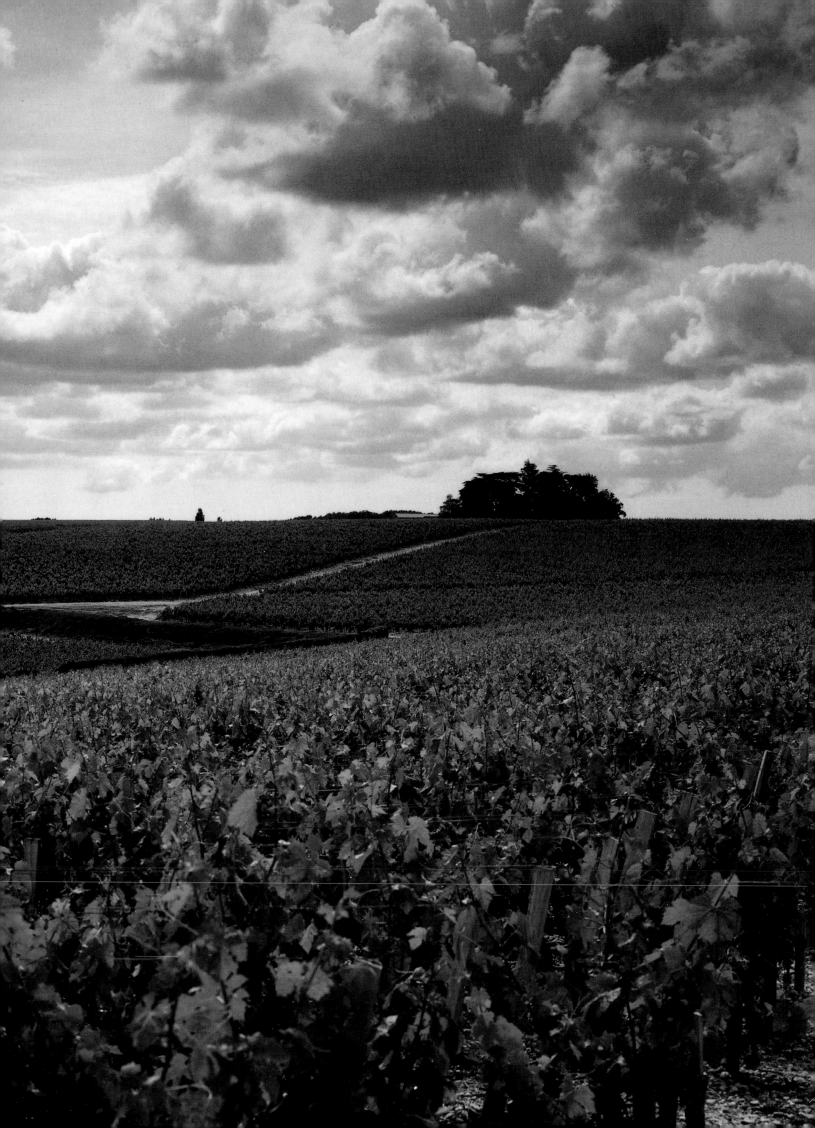

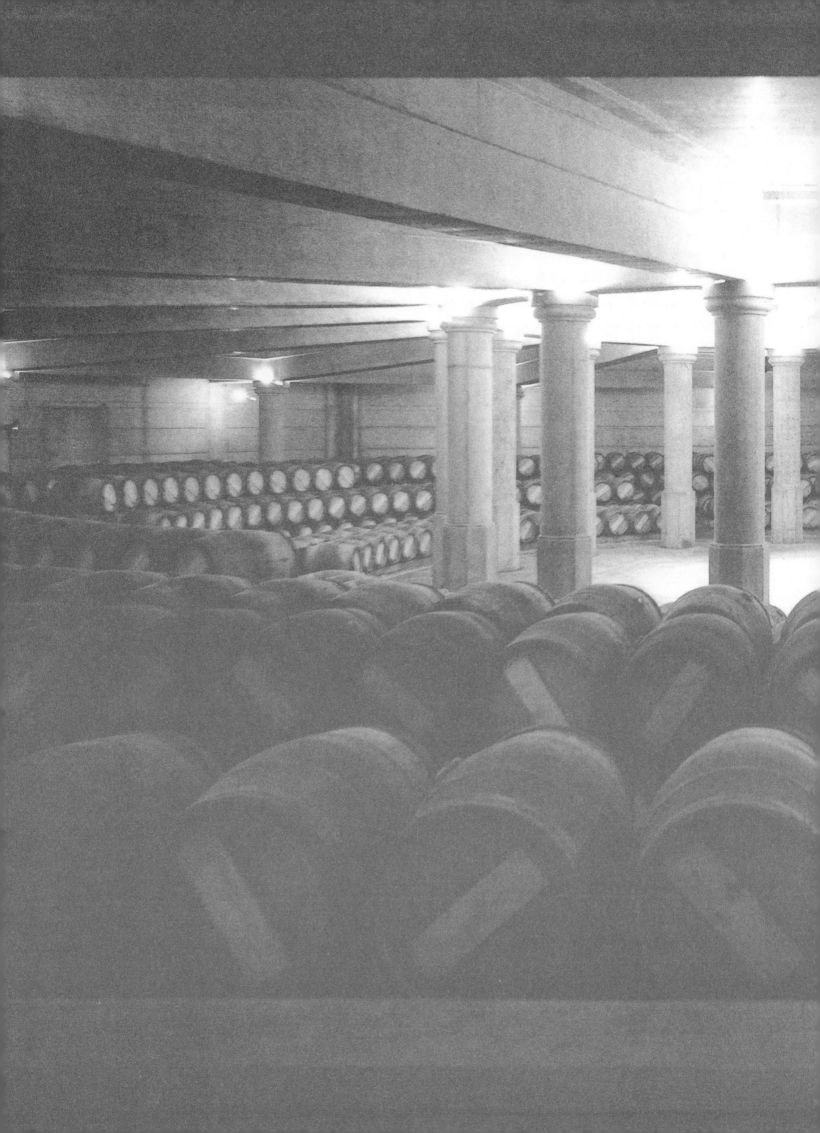